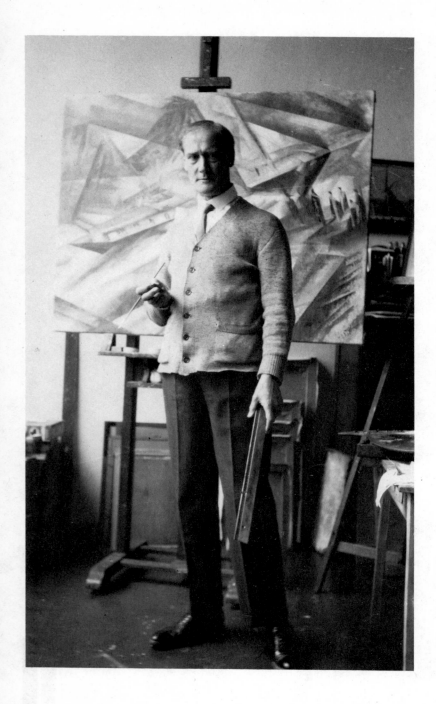

Documentary Monographs
in Modern Art
*general editor:* Paul Cummings

# Lyonel Feininger

*edited by*
June L. Ness

Allen Lane

*Frontispiece:* Lyonel Feininger in his studio, Dessau. Late 1920's.

## ACKNOWLEDGMENTS

The author wishes to thank those listed below for granting permission to reprint: *Art News,* New York; Houghton Library, Harvard University, Cambridge, Mass.; Kubin-Archiv Kurt Otte, Städtische Galerie im Lenbachhaus, Munich; and Jane Wade, New York.

**PHOTO CREDITS**

Geoffrey Clements
Peter A. Juley & Sons
O. E. Nelson

The Marlborough Gallery, New York, generously provided the majority of the illustrations for the book.

To Patricia and Andrew

First published in the United States of America
in 1974 by Praeger Publishers, Inc., New York

Published in Great Britain in 1975

Allen Lane
17 Grosvenor Gardens
London SW 1

ISBN 0 7139 0591 3

Printed in the United States of America

# contents

# list of illustrations

# preface

The importance of publishing this comprehensive selection of the letters and other writings of Lyonel Feininger lies in the fact that they are original documents that reveal art as part of life. They convey in a direct manner the personal qualities of the artist in his relations to those close to him, as well as his attitude toward specific problems of painting.

The greater part of the letters included in this book have never been published before. T. Lux Feininger, son of the artist, generously lent me his copy of the transcript of the letters of Lyonel Feininger to his wife Julia. In making a selection from these letters I have included those that pertain to his thoughts about art and his relationship with important art movements of the time—Herwarth Walden's Sturm circle and the Bauhaus and its members. All of Feininger's letters to his wife Julia were translated and edited by her. There is a copy of the transcript in the Feininger Archive of the Busch-Reisinger Museum of Harvard University.

In addition, the letters of Lyonel Feininger to the artist Alfred Kubin appear in print for the first time, courtesy of the Städtische Galerie im Lenbachhaus, Munich, Germany (Kubin Archiv–Kurt Otte). I wish to thank Dr. Kurt Otte for making the letters accessible to me. I have translated the letters from the original German. For encouragement and help with the initial translations of these crucial letters concerning Feininger's reflections about art, I wish to thank my good friend Hanna Zellers.

Feininger's rare formal statements about art—his letter to the art critic Paul Westheim, his letters to the poet Adolf Knoblauch (which were originally published in the periodical *Der Sturm*), and the letter to Dr. Johannes Kleinpaul—are printed here for the first time in English translation.

Above all, I have been most fortunate in having the kind assistance and understanding cooperation of T. Lux Feininger throughout the preparation of this work. He provided me with little-known publications in German and English that have been a valuable source of background material. In addition, Mr. Feininger read all my translations from the German, making many significant contributions. For his advice and help, I am indeed grateful. I am very grateful to Andreas Feininger for providing photographs from his collection.

I wish to thank Butler Coleman of the Archives of American Art for giving me access to letters and photographs pertaining to Feininger's early years. I also wish to thank Ralph Colin, who, as representative of the Feininger estates, facilitated the collection of the material in this book.

I wish to express my appreciation to the staff of the Houghton Library, Harvard University, for making available to me the four volumes of letters in German and the boxes of newspaper clippings in the Feininger Archive.

To Paul Cummings, the general editor of the Documentary Monographs in Modern Art series, I wish to extend my special thanks for his invaluable guidance and knowledgeable suggestions as to where and how to track down sources.

And finally to John Hochmann and Ellyn Childs of Praeger Publishers, I wish to extend my thanks for their cooperation and assistance in the final stages of the publication of this book.

<div align="right">

*June L. Ness*
*October, 1973*

</div>

# introduction, chronology

# introduction, chronology

# Introduction

The letters of Lyonel Feininger open the way to a deeper understanding of his art. They place his paintings and graphic work in the stream of his experience of life in both Germany and the United States.

Feininger's letters are valuable as human documents, giving glimpses of his alternating despair and joy in his struggle to achieve what he called "ultimate form." They record his successive triumphs in the world of art despite the physical and psychological hardships he suffered in Germany during World War I. The reader becomes a witness to the creation and daily life of the Bauhaus, the school of art and design in Weimar, and shares with Feininger his delight in the new Gropius-designed master houses (houses for the staff) of the Bauhaus in Dessau. The letters reflect Feininger's concern over the menacing rise of Hitler and the National Socialist Party and his final decision to find refuge in his native land, the United States.

An artist of international fame, Lyonel Feininger was honored in Germany, before the advent of Hitler, as one of the country's foremost avant-garde painters[1] and in the United States as one of the leading American artists of the first half of the twentieth century.[2] Born in New York in 1871, Feininger lived in Germany from 1887 until 1937, when he returned to America to live and work until his death on January 13, 1956.

Independent, creating his unique style in painting and graphic work, Feininger made clear in his letters that he believed a painting should not be mere imitative representation or the result of a momentary impression. He felt that the artist must break away from naturalistic form and "overcome nature in order to create freely." He wrote that a painting "serves as the expression of our innermost spiritual state at the time and of the urgent, imperative need to find liberation through a corresponding creation in the rhythm, the form, the color, and the mood of the painting."[3]

Feininger insisted that the artist must seek out and portray his own inner vision to find his own most profound expression. The goal of the painter should be the "complete and direct expression of the spiritual in art."[4] He wrote that "art is not a profession but the highest expression, the greatest necessity."[5]

He explained in these terms his method of working:

I draw quite spontaneously and almost instantaneously whatever interests me; however, never with the intention of making paintings out of these drawings. No, first the irresistible longing for a particular composition must manifest itself in me and *then* sometimes, years later, there may be a painting which for me represents reality as I experienced it—while

the "real reality," if by chance I encounter the same situation again, in contrast to my picture, looks very dreary to me and contaminated with unsympathetic associations. . . . Paintings have to sing, must enrapture, and must not stop at portraying an episode.[6]

Although true art, according to Feininger, was intensely personal and spiritual, the images in his paintings and the references in his letters carry a weight of meaning because they grow out of the artist's experience of the real world of his time. Feininger's admiration for medieval towns and Gothic churches and his paintings of them relate to the revival of interest in Gothic art and architecture in Germany.[7] Intellectual leaders such as Wilhelm Worringer, author of *Form in Gothic* (1912), looked back upon the country's medieval past with feelings of national pride. They honored their own nonclassical, spiritual tradition. Feininger's paintings of steamships, viaducts, and bridges find their source in the new age of technology in transportation and travel ushered in by the rapid development of the railroad and ocean-going steamships in Germany and America in the late nineteenth and early twentieth centuries.[8]

Perhaps Feininger's most universal theme was that of the shore, the sky, and sailboats on the sea. In the mid-1920's, the artist turned away from the troubled everyday world of the Bauhaus in Dessau and remained aloof from the critical political uncertainties of a defeated Germany to seek refuge in the study of the secret laws of nature, the wind, the clouds, and the sky.[9]

In the United States from 1937 until his death in 1956, Feininger again took up his interest in depicting architectural space. Towering skyscrapers of Manhattan replaced soaring Gothic steeples of Germany in a final series of paintings.

Feininger's life experience was unusual in that it bridged two centuries and two continents. Born on St. Marks Place in New York City, Feininger was the son of American parents of German heritage.[10] His father was a well-known virtuoso violinist and his mother was a concert singer and pianist. Young Leo, as Feininger was then called, was destined to become a musician. Beginning at the age of nine, the boy received violin lessons from his father. At the age of twelve, he appeared in public as a child prodigy giving violin recitals. Music remained a compelling lifelong interest. An admirer of Bach and Buxtehude, Feininger played their compositions on the organ and in the 1920's composed a series of thirteen fugues that were given public performances in Germany. Often Feininger spoke of paintings in terms of music: "Music is as much my life as air and creating in paint. My pictures are ever nearing . . . the synthesis of the fugue."[11]

In 1887, Feininger's parents sent the sixteen-year-old Leo to Ger-

Lyonel Feininger

many to continue his studies in music. After arriving in Hamburg, he decided to study art instead. With his father's permission, he enrolled in the Kunstgewerbeschule (School of Arts and Crafts) in Hamburg. He continued his studies of art in the Berlin Academy and passed the required examination brilliantly.

To earn a living, Feininger began his career by illustrating stories and drawing caricatures and political cartoons for German newspapers such as *Ulk, Narrenschiff,* and *Lustige Blätter.* He wrote that it was a constant torment to meet the demands of the publishers even halfway.[12] Nevertheless, in 1901, Feininger was cited as the outstanding cartoonist of Berlin.[13]

When a contract to draw two comic strips weekly for the American newspaper the *Chicago Sunday Tribune* gave him the financial freedom to leave Berlin for a two-year sojourn in Paris, he was overwhelmed with a feeling of liberation. He felt that at last he had met up with the "world of art."[14]

"For the first time I was able to think, feel, and work for myself. . . . Everything that had previously been merely intuitive in me and had become atrophied (even suppressed because of having to work with the publishers) began to unfold."[15]

In Paris again for three weeks in 1911, Feininger made the decisive discovery of Cubism: "All at once . . . I saw the light. 'Cubism!'— 'Form' I should rather say, to which Cubism showed the way."[16] Thereafter he began to transpose Cubism into his own prismatic, spiritual style.

The first two decades of the twentieth century were years of artistic renewal and radical innovation in Germany. Artists such as the Brücke and Blaue Reiter members, as well as Feininger, began to put emphasis on expressing their inner emotions rather than portraying the objective world. Herwarth Walden, author, editor, and publisher, organized the Sturm Gallery and the first German Autumn Salon (Herbstsalon) in Berlin, where he exhibited the new Expressionist paintings of the avant-garde artists of Russia, France, and Germany, including paintings by Feininger.

In 1918, Feininger took up the woodcut medium. He wrote that for six months he neither painted nor drew but instead produced over 190 blocks. The most celebrated of Feininger's woodcuts (and the most famous woodcut of the second decade of the twentieth century) is Feininger's cover design for the first Bauhaus manifesto, *The Cathedral.*[17]

The Bauhaus in Weimar, organized in 1919 by the architect Walter Gropius, was the school that succeeded a former academy of art and an arts-and-crafts school. The first Bauhaus manifesto and the symbolic *Cathedral* woodcut emphasized the ideal of the unity of all the creative

arts under architecture and the reconsideration of the merits of training artists in handicraft work.[18] Gropius hoped to break away from slavish, routine imitation of past styles to establish new values based on avant-garde design and upon the cooperation of artist, craftsman, and architect working toward a common goal. Feininger, as Germany's foremost avant-garde artist and leading Cubist, was Gropius's first appointment to the staff of the new school.

In the fall of 1919, Gropius named Feininger Form Master in charge of the graphic workshop, assisted by Carl Zaubitzer as Master Craftsman. Feininger had no formal teaching duties, but his exemplary presence, his personality, and his own paintings and graphic work were an inspiration to his students.[19] His letters reveal his friendship with Gropius, his willingness to help students set up exhibitions and prepare portfolios of graphic work, and his continuing participation in the countless *Meisterrats* (council meetings of the staff). His was an active, central role in the Weimar Bauhaus.

When the Bauhaus moved to Dessau in 1925, Feininger preferred to be an artist-in-residence without remuneration in order to be free to work on his own paintings, which were in great demand. Feininger always remained faithful to the ideals of the Weimar period of the Bauhaus, with its stress on the supreme importance of art and the artist's reacquisition of handicraft fundamentals. As early as 1923, following a shift in the Bauhaus's emphasis from the dominance of art and training in craftsmanship to the subordination of art to design for industry, Feininger objected. For him, art was a crucial, spiritual expression. He felt that art should not be forced to bow to the requirements of mass production. However, his personal loyalty to the Bauhaus staff, to Walter Gropius, and to his good friends Paul Klee and Wassily Kandinsky never faltered.

From 1924 until 1935, Feininger spent every summer in West-Deep (Pomerania), a rugged seashore refuge on the Baltic coast, far from civilized city life. By 1935, swastika flags had been hoisted on the beach. The lonely dunes began to bristle with newly built fortifications. In the cities, art galleries were forced to close. Art exhibitions were curtailed, and art criticism was prohibited. In the museums, directors were dismissed and modern paintings were seized by the Nazi government. Over 300 of Feininger's works were confiscated, and many were exhibited under the designation "degenerate art."[20]

In 1937, Feininger and his family sought refuge in America. The artist, famous in Germany, arrived in his native country virtually an unknown painter. Curt Valentin of the Buchholz Gallery and Marian Willard of the Willard Gallery exhibited his paintings and graphic work, and for the World's Fair held in New York in 1939, Feininger received

commissions to design murals for the Marine Transportation Building and the Masterpieces of Modern Art Building.

With the acquisition of the prize-winning painting *Gelmeroda XIII* by the Metropolitan Museum of Art in 1942 and with the large retrospective exhibition held in the Museum of Modern Art in New York in 1944, Feininger's reputation as a leading American painter was assured. His influential late style, graphic lines on fields of burnished colors, pointed the way for younger artists to abstract art.[21]

## Notes to Introduction

1. In 1931, Ludwig Justi, the director of the National Gallery in Berlin, honored Lyonel Feininger by arranging a comprehensive retrospective exhibition.
2. The Museum of Modern Art in New York held a retrospective exhibition of Feininger's work in 1944 (with Marsden Hartley), and the Boston Institute of Contemporary Art exhibited a large collection of Feininger's work in 1949 (with Jacques Villon).
3. Feininger to Paul Westheim, March 14, 1917. Originally published in *Das Kunstblatt,* no. 15 (Potsdam-Berlin, 1931).
4. Feininger to Adolf Knoblauch. *Der Sturm* 8, no. 6 (Berlin, September, 1917).
5. Feininger to Alfred Kubin, December 11, 1912.
6. Feininger to Kubin, January 21, 1913.
7. Peter Selz, *German Expressionist Painting* (Berkeley and Los Angeles: University of California Press, 1957), pp. 12–16.
8. Ernst Scheyer, *Lyonel Feininger, Caricature and Fantasy* (Detroit, Mich.: Wayne State University Press, 1964), pp. 14–15.
9. For a discussion of Feininger at the seashore of West-Deep, Germany, see T. Lux Feininger, "Feininger in West-Deep," *Baltische Studien,* Neue Folge, vol. 49 (1962–63): pp. 101–20.
10. Feininger's father was born in Germany and brought to the United States at the age of four. Feininger's mother was born in the United States.
11. Feininger to Alfred Vance Churchill, March 13, 1913, in the Archives of American Art, Smithsonian Institution, Washington, D.C. First published in Ernst Scheyer, *Lyonel Feininger, Caricature and Fantasy, op. cit.,* pp. 166–70.
12. Feininger to Kubin, Christmas Day, 1912.
13. Georg Hermann [Borchardt], *Die deutsche Karikatur im 19 Jahrhundert* (Bielefeld and Leipzig: Velhagen and Klafing, 1901), p. 127.
14. Feininger to Kubin, Christmas Day, 1912.
15. *Ibid.*
16. Feininger to Kubin, September 28, 1916.
17. The original title of *The Cathedral* woodcut was *The Cathedral of Socialism.* Hans Hess, *Lyonel Feininger* (New York: Harry N. Abrams, 1961), p. 319, G 14.
18. Hans M. Wingler, *The Bauhaus: Weimar, Dessau, Berlin, Chicago* (Cambridge, Mass.: MIT Press, 1969), p. xviii.
19. Lothar Schreyer, *Dokumente und Visionen* (Munich: Albert Langen–Georg Müller, 1957), p. 10.
20. Peter Selz, "The Precision of Fantasy," Marlborough-Gerson Gallery exhibition catalogue, April–May, 1969, p. 7.
21. Feininger always maintained that his paintings were not abstract in origin but were based on nature. See the letter on page 61 to the American Abstract Artists group in which Feininger declined their invitation to become a member of their organization.

# Chronology

<table>
<tr><td>1871</td><td>Born on St. Marks Place, New York City, on July 17 to Karl Feininger, violinist and composer, and Elizabeth Lutz, singer and pianist. Lives in New York until 1887. Visits Sharon, Connecticut, and Columbia, South Carolina.</td></tr>
<tr><td>1880–87</td><td>Studies the violin with his father until 1887. Gives concerts at age twelve.</td></tr>
<tr><td>1887</td><td>Leaves for Germany to study music, lands in Hamburg. Decides to give up musical career. Studies at the Kunstgewerbeschule in Hamburg.</td></tr>
<tr><td>1888</td><td>Passes examination at the Kunstakademie in Berlin. Studies under Ernst Hancke and Waldemar Friedrich.</td></tr>
<tr><td>1890</td><td>Illustrates short stories; makes humorous drawings for Berlin newspapers. On September 2 begins to attend the Jesuit College, St. Servais, in Liège, Belgium, where he studies French.</td></tr>
<tr><td>1892</td><td>Goes to Paris. Works for about six months in the life class at the Atelier Colarossi.</td></tr>
<tr><td>1893</td><td>Lives in Berlin. Active as political cartoonist and caricaturist for publications Ulk, Narrenschiff, and Lustige Blätter.</td></tr>
<tr><td>1901</td><td>Marries Clara Furst. First daughter, Lore, born December 14.</td></tr>
<tr><td>1902</td><td>Second daughter, Marianne, born November 18.</td></tr>
<tr><td>1905</td><td>Meets Julia Berg (née Lilienfeld). Leaves Clara.</td></tr>
<tr><td>1906</td><td>First son, Andreas, born December 27.</td></tr>
<tr><td>1906–7</td><td>Goes to Paris to live for two years. Draws illustrations for Le Témoin. Receives contract to draw two pages of comic strips weekly, The Kin-der-kids and Wee Willie Winkie's World, for the American newspaper the Chicago Sunday Tribune.</td></tr>
<tr><td>1907</td><td>Contract with the Chicago Sunday Tribune ends. In the spring begins to paint. Decides to give up cartooning. Sees pictures by Van Gogh and Cézanne at the Bernheim-Jeune Gallery.</td></tr>
<tr><td>1908</td><td>Returns to Germany, to Zehlendorf-Mitte on the outskirts of Berlin. Makes two visits to London, where he admires paintings of J. M. W. Turner. Marries Julia Berg.</td></tr>
<tr><td>1909</td><td>Second son, Laurence, born April 5.</td></tr>
<tr><td>1910</td><td>Third son, Theodore Lux, born June 11.</td></tr>
</table>

Lyonel Feininger

| 1911 | Goes to Weimar in the spring. Visits Paris in May. Six of Feininger's paintings on exhibit at the Salon des Artistes Indépendants. Meets Robert Delaunay. Sees the opening exhibition of the Cubists. |
|---|---|
| 1912 | Friendship with Alfred Kubin begins. Meets the Brücke artists Erich Heckel and Karl Schmidt-Rottluff. |
| 1913 | Explores villages of Thuringia. Paints first picture of the church at Gelmeroda. Invited by Franz Marc to exhibit with the Blaue Reiter group (Kandinsky, Marc, Klee, and others) in the first German Autumn Salon (Der erste deutsche Herbstsalon) organized by Herwarth Walden. |
| 1917 | First one-man exhibition at Herwarth Walden's Der Sturm Gallery. Exchange of letters on art between Feininger and Adolf Knoblauch published in the September issue of the periodical *Der Sturm*. |
| 1918 | Joins the Novembergruppe. Meets Walter Gropius. Begins to execute woodcuts. |
| 1919 | Walter Gropius founds the Bauhaus in Weimar. Feininger is appointed first Form Master. His woodcut *The Cathedral of Socialism* is made for the First Bauhaus Manifesto. |
| 1919–20 | Is appointed Form Master in charge of the graphic workshop. Makes drawings of Thuringian villages near Weimar, including Gelmeroda and Vollersroda. |
| 1921 | Composes first of his thirteen fugues for the organ. His fugues are subsequently performed publicly in Germany. |
| 1922 | At Timmendorf, a resort on the Baltic Sea, with Gropius and Kandinsky. |
| 1924–34 | Blaue Vier (Blue Four) group—Feininger, Klee, Kandinsky, and Jawlensky—organized by Galka Emmy Scheyer. Works exhibited in Germany, New York, California, and Mexico. |
| 1924–35 | Summers at West-Deep, Pomerania, on the Baltic Sea. Draws seascapes during the summer and paints from these studies during the winter months. |
| 1926 | Moves to Dessau with the Bauhaus. In 1925, the school in Weimar had been forced to close by the government. Agrees to position as artist-in-residence with no teaching obligations. |
| 1929 | Paintings shown at the Museum of Modern Art exhibition, New York, *Paintings by Nineteen Living Americans*. |
| 1929–31 | Lives for several months each year in Halle in a tower studio in the Moritzburg Museum. Paints pictures of the churches and streets of Halle. Eleven paintings and twenty-eight |

drawings purchased by Halle for the Moritzburg Museum. One painting presented to the city of Magdeburg.

1931   Large retrospective exhibition at the National Gallery in Berlin, in the Kronprinzen Palais in honor of Feininger's sixtieth birthday.

1932   One-man shows in Hanover, Leipzig, and Hamburg.

1933   Bauhaus in Dessau is closed. Returns to Berlin.

1935   Last summer in West-Deep. Receives invitation to teach at Mills College, Oakland, California.

1936   Teaches summer course at Mills College, then returns to Berlin.

1937   Paintings confiscated by the Nazi government and exhibited by Nazis in the exhibitions of "degenerate art." Returns to the United States to take up permanent residence.

1938   Lives in New York, 235 East 22nd Street. Summer spent at Falls Village, Connecticut. Executes murals commissioned for the Marine Transportation Building and the Masterpieces of Modern Art Building in the New York World's Fair, 1939.

1939   Summer in Falls Village, Connecticut. Winter in New York.

1940   Summer in Falls Village. Autumn and winter in New York.

1941–54   Exhibits regularly at the Buchholz Gallery (Curt Valentin, director), New York. Summer, 1941, in Falls Village.

1942   Wins acquisition prize for *Gelmeroda XIII* at the New York Metropolitan Museum's *Artists for Victory* exhibition. Summer in Falls Village.

1943   Wins Worcester Museum of Art prize. Summer in Falls Village.

1944   Large retrospective exhibition at the Museum of Modern Art, New York, together with Marsden Hartley. Summer in Falls Village. Autumn and winter in New York.

1945   Teaches summer course at Black Mountain College, North Carolina. Autumn in Stockbridge, Massachusetts. Winter in New York.

1946   Summer in Stockbridge, Massachusetts. Autumn and winter in New York.

1947   Summer in Stockbridge, autumn and winter in New York. Elected President of the Federation of American Painters and Sculptors.

1948   Summer in Stockbridge. Autumn and winter in New York.

1949   Summer in Center Moriches, Long Island, New York.

Autumn in Boston. Exhibition with Jacques Villon at the Institute of Contemporary Art in Boston. Winter in New York.

1950   Summer in Cambridge, Massachusetts. Autumn in Plymouth, Massachusetts. Winter in New York.

1951   Summer in South Lincoln, Massachusetts, in the house of Walter Gropius. Late summer in Plymouth. Autumn and winter in New York.

1952   Summer in Cambridge. Autumn in Plymouth. Winter in New York.

1953   Summer in New Haven, Connecticut, in Josef Albers's house. Autumn in Plymouth. Winter in New York.

1954   July in Stockbridge. Receives visit by Mark Tobey.

1954–69   Paintings exhibited regularly at the Willard Gallery, New York.

1955   Elected Honorary Vice-President of the Federation of American Painters and Sculptors. Elected member of the National Institute of Arts and Letters.

1956   Dies in New York, on January 13.

# ‖ thoughts on art
## and art theory

# Credo of Expressionism: Letter to Paul Westheim

Zehlendorf-Mitte
March 14, 1917

The principle of Expressionism in painting is fundamentally different from that of Impressionism. We exclude nature as the guideline and criterion for comparison in the formulation of a work of art. We have to overcome nature in order to be able to create freely. In each case, the single work serves as the expression of our innermost spiritual state at the time and of the urgent, imperative need to find liberation through a corresponding creation in the rhythm, the form, the color, and the mood of the painting. Hence the diversity of form found in the works of one and the same painter that, judged by the standards currently in use, leads to the misconception that this work contradicts itself. In music, the composer permits himself to juxtapose allegro, scherzo, andante, and grave movements; to compose orchestral works, sonatas, songs, the fugue, the cantata, the requiem, and the opera. He employs all time measures and keys. The more able the composer, the more varied is his work. In Expressionism, we have consciously broken with the tendency toward naturalistic form, not in order to set up a new artificial formula that might be generally valid and rationally and uniformly construable; we have elevated imagery to the level where it can function as the most sensitive dynameter of our emotion, and the form of the picture must necessarily vary each time with the expressive requirement. The Impressionist halts anywhere out of doors, unpacks his painting gear, and, following a sudden impulse, begins to reproduce the scene which compels his attention. On the other hand, the Expressionist is driven by a gradually increasing longing (which finally becomes unbearable) for a specific configuration, and he must formulate his imagery as a release from pain. Of this nostalgia I could relate much.

We live in a state of perpetual longing and no release, only the stimulus to begin the work can come from outside ourselves. Nature is our inexhaustible treasury of form, but most of us are not able to create a truly authentic image in the presence of the natural scene. An element of rational representation always remains in a painting painted from nature. Our first task is to overcome this tendency, for we must seek out and portray our inner vision, find our own ultimate form uninfluenced by nature in order to express our longing. Not an approximation, nothing short of the final, ultimate form, stated in the clearest manner of which we are capable. In my opinion an artist is to be evaluated according to this ability only. All incidentals, any "charm of representation" are to be omitted as elements opposed to the attainment of this sole re-

quirement. For much too long a time the mission of painting has been thought to be "charming," "alluring" if you like. But painting is not "entertainment"; its final goal is to achieve the realization of the most profound expression; my artistic fanaticism aims at this end. All else is a matter of indifference to me.

I have been moved to write these lines in the fear that the other day I may not have made myself sufficiently clear in this matter. Modern man is indeed a troubled, fragmented, and differentiated being, and the lofty goal, the attainment of the simplest form for enduring and valid pictorial expression, is incredibly hard to achieve. Hence, in my work the strong swing of the pendulum from utmost rigor of form to a new release through movement, the swing between monochromatic and coloristic attitudes, such oscillations indicate states of the soul and are not the result of a predetermined program.

The frightful world events weigh on us and leave their gloomy traces upon my work, as you know. What is more natural than my constant struggle to achieve pictorial joy, my striving to oppose movement and cheerful color to the gloom as a means of release? And yet, the human being behind all these works, so unlike in appearance, is always the same. In the happiest as in the most resigned works the goal remains identical: to give the final form to one's conception. Always the final form! For only this form endures, and for me painting is anything but a matter of the moment.

LYONEL FEININGER

Originally published in *Das Kunstblatt,* no. 15 (Potsdam-Berlin, 1931), pp. 215–20. Paul Westheim was editor and publisher of the periodical.

## Open Letters: Dialogue with Adolf Knoblauch

### I

Not for nothing have I become a painter as the last possible way of expressing myself; and, at that, a senselessly self-tormenting one, failing in hundreds of attempts. In the quiet of my studio I am fighting desperate battles; every morning I rise, inspired by new hope, to resume the struggle; every evening all courage is gone; I end in a state of resignation. But the older I grow—and therefore I praise aging—the more I become aware of my will also growing stronger.

At this time I am totally absorbed by the problem of deepening expression as an act of the will; lacking, for carrying out this task, perhaps every single one of the "painterly," "amusing" talents of contemporary artists.

Lyonel Feininger

People who know longing understand me. Longing never wants to be amused. Since my childhood, the themes of the church, the mill, the bridge, the house, and the graveyard have filled me with feelings of deep reverence. These themes are of course symbolic; but only since this war began have I understood why I must use them over and over again in my paintings.

In the course of time I am gradually succeeding in eliminating qualities of torment and fragmentation from my work. Final form can be attained only through complete pictorial balance.

What is alive today is the art of the ego and vanity; it becomes rudderless where it fancies itself to be creative.

Many consider me a revolutionary, whereas I am conscious only of a boundless reaction against our time. You are right: remembrance—to be rooted in one's childhood years throughout one's entire life; the future—yearning, longing; the present—the work! To whom among us is it granted to enjoy the moment that passes? Yes, in music, most of all. But music is also "forgetting" of the affairs of the day.

## II

God deliver us from "emotional" artists. You must have divined what there is of malice in my work. After laboring at devout, deeply felt religious works, I indulge in orgies of scurrilous compositions.

People are really too stupid, myself included. But I should be incapable of directing my malice against a specific foe—only against myself. In the others I am not, but "this carcass I know!"

What is art: self-revelation.

I do not want to be compulsive. Besides, for profoundly sensitive artists, sarcasm is the thorny epidermis that protects against the world.

In general I do not care for an explosive, abrupt quality in art. Once the fireworks have gone off, what remains? All this is titillation, mere entertainment, exaggeration, surface values, hysteria.

Let us not be petty in our works, at least.

Since the New Year I have become very happy in my work. I have thrown off a great deal of ballast and am in a position to approach things which I love more calmly than before. I owe this happiness chiefly to having seen again, after nearly two years, the old masters of Cologne and Swabia and the glorious Van Eyck, Breughel, Lucas Cranach the Elder.

How unsurpassable are these paintings and how timeless! How the painters of today sidestep before such strength and uprightness, with their artificiality and fussiness; scattering charms in order to divert the spirit from the goal ahead.

This happiness has not come to me overnight—it has lain deeply hidden in me since time began, always longed for and aspired to, but

always overgrown again by our modern "milieu"—but revealing itself as attainable after the unholy leaven has been digested and eliminated. I do believe that this time I have received greater impetus than heretofore.

## III

I spoke of "people" and I admit frankly that I have been concentrating too much upon myself to take others to task where there is a question of human errors and weaknesses.

But most decidedly I must reject the imputation of arrogance on my part toward contemporary artists, also any assumption that I deem myself able to evaluate them fairly—for even though they do not suit my personal point of view and my exaggerated longings, I do recognize their qualities and, in many instances, their enormous talent—which, again, on the other hand, I am sadly aware to be lacking in myself.

Do not overestimate me, do not consider me to be anything but a human being fighting, most of all, against his own shortcomings. However, it would be pretending to be far poorer than I really am, if I were to deny that I often sense enormous powers in me. I feel myself brimming over with a whole world, which to express adequately I have so far only been very insufficiently successful. And when I declare that I refuse the consolation—and the temptation—of giving a mere representation of the fugitive beauty, instead of a true account of this real [inner] world, in a display of technical skill, as many do, I mean that only in the complete work is there release, because it aims at the innermost core, and only in this work is there life, because it has become "timeless."

A little self-reliance cannot do any harm!

Often enough one is filled with self-destructive tendencies and doubts concerning one's future earthly destiny.

In the last analysis this art is my affair and only concerns myself, and I create solely in order to attain that little bit of perfection that can perhaps be reached during the brief span of one's existence by means of continual striving, no matter in which form or art.

My misfortune (if you wish) is that, perhaps, I still withhold too much of myself in my work. But I am fully confident that I have by no means reached my limits as yet, that through each problem I advance further, and that I am guided by the thought to give of myself more and better than before.

## IV

Like a weak swimmer I am apt to be overwhelmed by a whirlpool of sensations. My need for communication is so great that I am unable to express it in words. I often sit down at the organ and seek release in

Lyonel Feininger

Bach's mighty tones. Then a fugue or a choral prelude rises from the organ in a radiance in which the world vanishes. As to writing—the best time for it would probably be when the work goes badly. But when it goes well (that pervading gauge of everything) one wants to hang on to the success and one longs to write every minute out of sheer exuberance, but yet delays in order to save up one's thoughts to have still more to communicate. Finally one ends up by writing only when the next hangover has set in.

On the easel before me is a newly begun painting, fresh and vigorous, painted with glowing color in broad, daring strokes. I have been intoxicating myself with the sight of it for three days. And just now I pulled out two or three pictures from these last terrible, tormented winter months and am comparing them with the new child of fortune. Well, what do you think? The picture of fortune falls apart. It is mere bravura —and the paintings wrought from sorrow are transfigured—it is as though by a stroke of magic the tortured children of dark times have become diamond-hard, imperishable visions, filled with hidden beauty. These are not pictures from the time that is now. The picture of fortune is of today.

There is only one art—timeless art. Everything that stops halfway on the road to final form and ultimate depth of meaning must become outmoded. Because the soul, having recognized its own infinite need, can never allow itself to be satisfied with anything less than the final, the highest, as well as the most profound, meaning.

But the child of fortune shall be developed further and shall remain a work of fortune. For I am still too young and am still too much under the sway of senses to mortify them altogether. When I reach seventy, I intend to detach myself from their rule and, until my hundredth year, shall live as pure spirit.

Shall I give another report of the "favorite" picture? It has gone down in the mud and slime of impure color and no longer exists but is being painted over as a ground for a future, "serious" picture. On the other hand I have forced myself with severe wrath to recommence the same composition and have set myself the strictest of standards. Only now will it become a picture which, disciplined and firmly structured, may eventually become a new picture of fortune.

A tragic fate has destroyed by fire Marc's picture *Tierschicksale* [Animal Destinies]. If ever an artist of our time created great and noble works, and was himself great and noble, it was Franz Marc.*

* *Tierschicksale* (1913), by Franz Marc, was not destroyed but merely damaged at the lower edge and top in a warehouse fire, and was later restored by Paul Klee in an exemplary manner. It is now in the Kunstmuseum in Basel.

# V

I write egotistically under the pressure of the moment and not for the record. Nothing is so subject to fluctuation as the state of mind of a painter at work; what seems like a final truth now may, one hour later, be flatly refuted.

So long as I have the power to make pictures, I shall not let myself be counted among those painters who write and lecture. An individual can attain a conception truly his own solely through many years of human and artistic development. Only those whose nature is akin to mine can benefit in any way from my remarks and opinions, because they find in them a confirmation of experiences acquired by themselves. A foreign artistic conception cannot readily be transferred to others, who can become artists in the true sense only through their own experiences.

As for me, I must continue to work in silence and seclusion; my paintings alone will give evidence that I was right to paint only in this and not in any other way. After my death, possibly, those of my written remarks having a bearing on my positive life's work might be collected to give a clearer insight here and there.

But before this can happen I owe the world something really great in the way of art.

I am not a superinnovator but a man who has to break with his own time in order to be able to live. If that means that I am behind the times, what is that to me! The only fundamental cultural and artistic truths date back to the dawn of time, and modern brains could never have formulated them. Just look at the spiritual state of our contemporary world!

What does all tendentious art aim at: differentiation and instantaneous effect; optics and mechanics; sentiment and excitement; symbolism (but of what?) and aestheticism. These are all things which I detest and in which I am immersed with my fellow-damned because I was born too late in this time.

I know of some who have primeval power. They are not celebrities today, but they will endure long after their names have been forgotten.

# VI

Most artists today lack one thing: the forming through of a work of art to the final stage of completion.

No sooner is the theme, the general cast of a composition successfully established and a certain effect achieved, than they stop developing their artistic formulation of the work when actually only a beginning has been made. But he who files and burnishes his creation, wanting to reach perfection of final form, will be dismissed as "cold" and "deficient in temperament."

How I hate the word "temperament" applied to artistic conception! Those who have not gained mastery over themselves, who do not bridle their vehemence, who hasten after instant effects, are praised as being "temperamental." It is called "the warm human breath" of the work.

I have no need to see pictures in museums. Any collection of even mediocre reproductions of paintings of the 14th or 15th centuries, especially of the Italian pre-Raphaelites, leaves me deeply moved by the perfection of both intention and form in all works. Many avant-garde artists are reviving a concern for craftsmanship. This constitutes a great gain and offers perhaps our best hope for a renascence of the art of painting (but too much of what we see remains exclusively artistic aspiration). The transition toward internalization and to complete and direct expression of the spiritual in art is very difficult.

Adolf Knoblauch, Expressionist poet and member of Herwarth Walden's Sturm circle, was a frequent contributor to the publication *Der Sturm*. The exchange of letters between Feininger and Knoblauch appeared in *Der Sturm* 8, no. 6 (Berlin, September, 1917): pp. 82–86.

## Letters to Alfred Kubin

Zehlendorf-Mitte
November 27, 1912

Highly esteemed colleague:

Many thanks for your friendly lines of November 25th. I am extraordinarily honored by your wish to own a drawing of mine. For my part, I have been an admirer of your art for years and am indebted to you for many pleasures it has given me. As a matter of fact, I also live a little in your mysterious country (*Die Andere Seite*).* It is very real to me. I, too, have a world of my own.

I gladly consent to your proposal; you will receive a selection of drawings from me, of which you will keep the one you like best. None has been published up to now. I believe that you are the only one who has ever asked for one.

Through our mutual friend Grossman I feel that I know you already personally. Among other things, I know that you love the organ above all, and I play Bach and Buxtehude daily. Tonight I am going to an organ recital; Sittard of Hamburg is playing, and he *can* play! How many play the organ as if it were a piano, without any feeling or under-

* *Die Andere Seite* (*The Other Side*), a novel by Kubin, is often cited as a precursor of the novels of Franz Kafka.

standing. And then the people scream that the organ is an uncouth instrument.

Eventually we may meet face to face. Do you ever come to Berlin? If so, please visit me.

I, too, love locomotives. (You see we do not lack common interests and could talk to each other famously.)

<div align="center">With cordial greetings and handshake,</div>

<div align="right">Your devoted,<br>LYONEL FEININGER</div>

Feininger's letters to Kubin are published with the permission of the Städtische Galerie im Lenbachhaus, Munich (Kubin Archiv–Kurt Otte). Alfred Kubin (1877–1959), Austrian master draftsman, composed thousands of visionary pencil sketches, pen-and-ink drawings, and lithographs.

<div align="right">Zehlendorf-Mitte<br>December 11, 1912</div>

My dear Mr. Kubin:

Your letter gave me great joy—many thanks! It is certain that we understand each other, and that we create our works in a similar way from a feeling of deepest longing—what more can I say? Whatever I may have to give you, whatever might do you some good, shall always be cordially yours; but your best strength you will find in your own nostalgia.

I live just for myself, and I am by nature a sociable and communicative person. People like us cannot live gregariously; I therefore erect a brazen barrier around myself as soon as collective art interests encroach upon me. I feel that I am a private being, and art is not a profession for me but the highest expression, the greatest necessity. A folk art is no longer possible. It has definitely been killed by the machine and even more so by the so-called mass culture. Professional art is, after all, something handmade, which could also be done with a camera. Most people even prefer the camera, if they are honest.

But, dear Mr. Kubin, art cannot perish! Only we have slowly come to realize that a new set of standards will and must be set up. On the one side there is art as a personal expression, a personal necessity; on the other side, professional art, which is learnable and produces objects for sale, a commodity, incorporating, after all, very estimable skills: only the essential is lacking.

Just now, better times are imminent. I believe that at no previous period have there been such conscientious and passionate battles fought

in order to destroy the false concepts of art, which have been the standard for so long, and to reach new heights after a lapse of so many centuries.

Culture is now accessible to the masses. The general level of education is rising, becoming at the same time more monotonous, more thoughtless, more materialistic (with all the new learning drills), more lacking in imagination. Let us leave the masses alone, who, unlike formerly, have their say in everything. Happily, they now have an art that they can understand growing from their own impersonal midst. The great danger for a country like Prussia is that through a general, uniform, drill-type of culture, the minds are fixed in definite preconceptions, which they can hardly ever hope to shake off again. However, hope is everywhere, even in Prussia.

I spent my first sixteen years in America (I am an American from New York). I have lived in Paris, in France, in Belgium and England. Wherever there are still inequalities, it is beneficent to live. The naïve, purely personal knowledge of the un- (pseudo-) cultured common man may contain a divine spark. Where do you find a divine spark in Prussia? Ignorance may suddenly be transmuted into understanding, inspiration. But the half-educated are hopeless because they think that they know everything and view with distrust and arrogance those who are different. But semi-education is all that can be achieved at school by the contemporary, plagued, average citizen; and later in life he has not time, inclination, or energy for truly educating himself.

By way of contrast, how fortunate is he who, like ourselves, loves his work, but better still, carries his burning longing in his heart. Thus, let us not complain. For my part I still need years of undisturbed development before I can meet my own requirements. Why should I yearn to be understood by outsiders when I am persuaded of their dullness? . . .

Zehlendorf-Mitte
Christmas Day, 1912

. . . I am rereading your book these days. I do not have the urge, nor perhaps even the necessary education, to draw conclusions concerning your personality from your work, to "figure you out" in order to explain the creation in terms of the creator—but I marvel at the depth and maturity of your logical and psychological findings, at the development of the story itself toward its conclusion. Those who know only my exhibited work seem to get the impression that I must be malicious,

perverse, intentionally disgusting, and take pleasure in being so. What asses! I do not give a damn for this German pretentiousness of wanting to explain the artist in terms of the man; surely it is the other way around.

I approach my work in a mood of the most serene joy, with an infinitely optimistic outlook, in almost ecstatic exuberance and delight in the beauty of color and form (of course my own concept of beauty, I couldn't do anything else), and then the dry, unimaginative, totally sterile snoopers, grown fat on their arrogance, maintain that this is the way things are!

I am not going to wait any longer but shall send you a selection of my drawings, also an etching or two, and some photographs of paintings, although of the older, earlier ones. (All told, the development only began five years ago.) When you come here at last I shall show you the pictures themselves. I am looking forward to your arrival enormously! How old am I? You may be surprised, but years are purely external. I am forty-one and a half years old, which even to me seems improbable, for I count myself among the youngest, the very youngest. I often see myself as even younger than any of them because they are so terribly advanced and much cleverer than I. Whenever I am in company with others I think that I must be the youngest, the least mature, and behold! I am nearly always the oldest, sometimes by as much as ten years. All I can say is that I find my greatest joy in creating and forming my visions; I work only for myself because I must: because of my unspeakable yearning. For a long time I have given no thought to others. I only pray that I may live long enough to paint everything I yearn for.

My history is very peculiar. I worked as an illustrator for nearly fifteen years, because I had to earn my living. And although it was a constant torment to even halfway meet the demands of the publishers, I had acquired quite a handsome reputation—around six to eight years ago. Then suddenly came liberation! A contract with Chicago made it possible for me to move to Paris and to meet up at last with the world of art. For the first time, I was able to think, feel, and work for myself. It is only five years since I began to learn what art could and must become for me! Since that time my awakening and development have progressed rapidly and forcefully. I have never consciously followed others, but nonetheless I did gain from them acquaintance with art, and everything that had previously been merely intuitive in me and had become atrophied (even suppressed because of having to work for publishers) began to unfold. Strange—from that time on I have seen all my commercial connections gradually disappearing. Today there is not a soul in all Germany who would give a nickel for the best of my work.

Artistically speaking, I am a fellow of bad repute. All right, there are some two, three, or four who have a high opinion of me. That is sufficient. Oh, this I can bear cheerfully! I am not conscious of presumptuousness, although I have, in general, a colossal self-reliance. No! I simply have no choice to do otherwise. It is my life itself that I give in my work. It does not matter for whom. Totally! But since I could not thus love without knowing how to hate, I hate the mercenary spirit of our time, but this is completely outside my range of concerns. I could even pity this wretchedness bearing the proud name of "culture" which is supposed to represent progress. (Changes are coming! They are coming for sure!)

After the holidays I shall mail you the package, dear Mr. Kubin! The very latest work I cannot send you because for months I have only been composing for paintings, and my drawings only serve to give structure, in charcoal—unfinished, for the completion is to be carried out in the painting.

With cordial greetings,
Your friend,
LYONEL FEININGER

Zehlendorf-Mitte
January 21, 1913

Dear Friend:
At last my work was sent off to you today, this time without incident in the strict post office. As you will see from the contents of the package, I have selected samples of everything; it was important to me to show you some of my work from nature, so that you may see what mainly interests me outdoors; all my nature studies are drawings; I cannot bring myself as yet to paint out-of-doors. How could I? Even the best work, directly from nature as the final goal (i.e., painted as a picture) would appear boring and useless to me. This attitude of mine is resented enormously hereabouts.

I draw quite spontaneously and almost instantaneously whatever interests me: however, never with the intention of making paintings out of these drawings. No, first irresistible longing for a particular composition must manifest itself in me and then, sometimes years later, there may be a painting which for me represents reality as I experienced it— while the "real reality," if by chance I encounter the same situation

again, in contrast to my picture looks very dreary to me and contaminated with unsympathetic associations.

The explanation for my living gladly and happily, as you write, lies in the fact of my consciousness' being a collecting point for such inspiring ideas which life awakens in me. Other than this I am, if anything, rather introspectively minded, disinclined to participate in everyday activities. If I enjoy such things as sailing or bicycling it is not for purely physical reasons but for the impressions which I receive when so engaged. At that, my body loves exercise; I have trained myself since childhood in rowing, walking, running, and bicycling, and consequently I have good endurance; for instance, the monotony of pedaling while bicycling is, to me, wonderfully relaxing and gradually causes something like a bodily intoxication carrying me onward, where others, even though stronger, will experience fatigue.

But on the whole, my joy of life lies in my work, and life is much too short for all that I should like to do.

But now let me thank you with all my heart for your kind letter. It made me happy beyond measure. You wrote so cordially and generously about my "pictures" and you have accurately defined my longing. For it is this longing for the unprecedented, in movement and in color composition, which wholly fills me. It makes me happy that even photographs of my pictures communicate this to you. Generally my pictures have little "content"; some of my drawings a little more so. In drawings I can combine the expression of philosophical or other thoughts with formal ideas, but not in my paintings. Paintings have to sing, must enrapture, and must not stop at portraying an episode.

Many of my drawings, which I should very much like to show you, are framed and under glass and some are hanging in the homes of relatives who have taken pity on them. But when you come! When!

Enough talk about myself. Why do I do it? (Only because you have struck responsive chords with your extraordinary kindness.) My preoccupation with my work makes me behave like a semi-fool!

How I should like to gain greater insight into your work. Your creations are incredibly rich, visually and intellectually, and you live completely in your own world, in this plausible, unheard-of world which you reveal in such a visionary manner free from all academicism. Surely you and I constitute poles of the same great and unquenchable longing —I toward the formal, you toward the thoughtful and visionary side; essentially, no single mind could combine both aspects; hence this feeling of complementing each other which we both have. What marvelous luminosity, what an atmosphere of the most mysterious, otherworldly light informs your work!

Am I really your optimistic American friend? I want to be, as I have

told you before, but we are both lonely people. As long as we are full of love and keep alive the yearning for form, then nothing can get us down. Why should we care for the opinions of the general public? They are just what we condemn and avoid. But lonely we are indeed, and I am sometimes sad to death from sheer happiness. Then it is so good to welcome a friend, or to visit one; even some trifle can sometimes get one back on the track; at least, it is so with me.

You live in a part of the world quite unknown to me. I feel that the surrounding landscape speaks through your work. I know this is the case with me. I know of villages in our vicinity which make me so terribly sad that I could bawl. I form them into pictures that strike the public as "jolly." At the bottom, one is—a jester. When I chance to be in a place I love and which enchants me in form and color (for instance, Belgium and parts of France) I only take in impressions, I assuage my hunger for a long time to come; but when I am back in this desert spot, these almost hateful surroundings of Berlin, my total resistance to it is aroused, and then to re-create what is past is liberation from hostile influences, and I work, form, without interference. Of course, after a while, the capital is eaten up, the stimulus gone!

. . . In your letter you touch upon the theme of Cubism. We shall accept the term, although it is inadequate and although I detest every kind of "ism"—but what you say about it is important, and in my judgment there is nothing that can stand without form (and I don't mean imitation of natural forms!). For the sake of this single but capital theme alone, I desire so much to be able to talk with you, and I have not yet given up hope that you may come here. In your work Cubism is strongly active, too. Without it your pictures could not be so magically luminous. No more than you, could I resort to purely abstract form— for it would be the end of advancement. What we are after is probably something like a thorough reformulating of Impressionism. Once the eye has been refined to serve in an intense investigation of light problems, problems of volume and of light and color, one recognizes that the laws of nature are just as inescapable as any mathematical law that we humans are able to deduce. Isn't it comical that artists who proceed this way are viewed with contempt and suspicion in this country, because they think—in this renowned "Land of Thinkers." But Germans have basically little feeling for form and are, in general, not creative by inclination.

. . . Lately I have spent hours deciphering, on my harmonium, a wonderfully naïve, sophisticated, primitive, modern, but above all, an elemental and visionary old musician, Buxtehude: immediate predecessor of Bach, although still contemporary with him, from whom Bach took over many ideas, carrying them further to a glorious development

and maturity. Buxtehude is a desperately enigmatical musician; it is unspeakably hard to unearth the treasure lying in his music. I love him tremendously, but I shall never be able to comprehend him completely.

<div style="text-align: right">Affectionate greetings, dear friend,<br>Your loyal FEININGER</div>

I shall return your drawings shortly.

━━━━━━━━━━━━━━━━━━

<div style="text-align: right">Weimar<br>June 15, 1913</div>

Dear Kubin,

. . . We are so sorry that you had so much trouble and excitement. Things go better when one lives as I do: for ten weeks I have lived all by myself in a single large room (with all the attractions of good lighting, a homelike atmosphere, etc.) and completely free of household worries. And yet, constant solitude is not good. For eight days my wife and sons have been here, too, but living in an adjacent street, as I could not rent a suitable apartment in this house. Like this, I am not disturbed but no longer alone, and thus can devote myself more to my family than when we constantly bumped into each other. Weimar is infinitely dear to me. I have known it from old, when we lived here seven years ago, all alone, just the two of us. Then it was a sort of fairytale existence and even today this old enchantment lives in us.

The villages—there must be nearly a hundred in the vicinity—are gorgeous. The architecture (you know how much I depend on it) is just to my liking. So inspiring—here and there uncommonly monumental. There are some church steeples in God-forsaken villages which belong among the most mystical achievements of so-called civilized man that I know. . . . You ought to see some of them. I stand before them for hours, seeking to surprise and take from them the secret of their form. Brutal frontal assault is out of the question here. It is a desperate kind of love which makes me infinitely patient. Each time a new step forward is made. I am at present painting a picture of this kind, and what you saw here in February has by now been developed a good deal further. The laws of nature which we uncover when we are able to create, are and remain unimaginable for the others. Our sensibility, our faculty for receiving impressions, our longing reveal new laws of nature, visible only to our eyes. You want to travel? Where to? I do not know. But I am infinitely content to be here. I long to see Belgium again (marvelous old, old, cities!), or Normandy, or Brittany, so

<div style="text-align: center">Lyonel Feininger</div>

long as there is architecture, even if it is embodied only in stone huts. Come to Weimar! . . .

. . . Since I came here I have not read the newspapers, but from correspondents I have heard that the Secession* has broken up. Two days ago I submitted my resignation of membership. I can't be part of such doings. If there had been just a few members of any significance for me and my ways! But the assumption that I paint talentless pictures and for that reason will vote against [Paul] Cassirer is a little bit too much. Besides, what have I or you to do in an organization of approximately 200 members, all trying to compete to make the most money? That's it, money—with your art! All right, one has to be fair. They have to live. But there are other ways. If the Secession is a commercial organization, it ought not to be fussy about membership; but if it is an institution serving art it has to be pitiless and to eradicate from the ranks all who are not capable of meaningful growth; this is what Cassirer wanted to do, the only one with any judgment. By itself, the high percentage of mediocrities would not have hurt anything; there was room enough—but they persistently voted against any real talent. Perhaps they were honestly unable to recognize it, and it is because of them that the standards became so low as to be a disgrace.

Dear friend, here everything is to my liking. I never step outside without some happy anticipation. Whichever way I turn, I find some inspiration. The people are agreeable; life in Weimar is very gay; there are so many young people, all hopeful in some way or other. The pettiness of small town life is never disagreeably manifested; almost daily the town is dressed in flags.

I bicycle from one village to another, exploring. I never return home depressed. The park is world-famous, a real refuge for all seeking peaceful contemplation, with magnificent trees, motifs like old engravings, tree-lined avenues like church vaultings. I have rented a small *quetsche* [harmonium] and thus shall not be without music, as I have been in past summers. . . .

Weimar
September 17, 1913

My dear friend Kubin:
. . . You said something very meaningful in your postscript about the "goblin" of despair, whose presence I also experience often and

* The Berlin Secession was a group of artists who withdrew from exhibitions held by the Verein Berliner Künstler. Under the leadership of Max Liebermann, the group, primarily German Impressionists, held independent exhibitions.

painfully. Yet I believe that this goblin should not be lacking in our makeup. I have probably been through just such a period myself, and during such times writing becomes inhumanly hard for me. I have calmed down considerably, but I still miss being able to compare my new paintings with the stack of older ones in my studio at home in order to recognize clearly whether or not I have made progress. I believe that I have—but possibly only intellectually. The pictures of this spring and summer are still too new and, besides, have been left purposely unfinished until some later time. But I won't be able to resume work on them until after I have left the present environment, where I have received so many impressions, and have returned to my hermitage. By the end of September I shall be back home in Zehlendorf.

How can I thank you, you kind person, for what you have arranged for me, namely, that I am to exhibit in company with those with whom I am predestined to feel at home, at the Herbstsalon with the Blaue Reiter, those ardently passionate champions of the new Expressionism. Perhaps it is even a little sooner than I would have chosen myself, but I shall do my best with some of the more recent pictures. I believe that you know them all from your former visit, especially the *High Houses,* which you liked so well. I shall not attend the opening, but my wife will tell me about it. Later, of course, I shall visit the exhibition after I get back to Berlin.

Marc's invitation reached me on my 42nd birthday, July 17, and seemed of all the presents the most promising. Be that as it may, I felt at once a fresh impulse, because of the responsibility. But my calm shall not be shaken by the publicity. All I can do is to continue to work for myself.

. . . In me you see the type of the confident person full of exuberance and elasticity. However, I am just as much a "way up, way down" type; if it weren't so, what would one amount to? Right, dear Kubin? But around March–April things got to be awfully bad, I may say. In part it was not the fault of the painter or artist in me, but the human being conceiving doubts about his usefulness in a world judging everything by monetary success. . . .

═══════════════

Zehlendorf-Mitte
October 5, 1913

I have just returned from my first visit to the Herbstsalon at the Sturm Gallery. I am happy and excited and I want to tell you about it while my impressions of it are still vivid. But first, my sincerest thanks for your dear letter which I received today. Those who call you "diabolic"

Lyonel Feininger

(and heaven knows what other beautiful titles) when they write about your works, do not know *my* Kubin at all! Your drawings strike me as being full of love, I receive the most fervent impressions from them; today and always I recognize in them the yearning, abundantly rich creator of visions. I deeply share in your joy with every page—perhaps my pleasure is even greater than yours—for the supreme satisfaction with our own productions is denied us. There always remains a residue of pain, doubt, and melancholy in us; we must turn at once to new and higher aims. This is purely critical. So far as it is given me to judge, I observe that lately your form has matured in comparison to earlier work. You have achieved firmly jointed structure and great rhythm without losing any of the fabulous luminous quality which you have always had; your thought has become formal vision, free from all merely anecdotal content. You hold your own with ease in the company of your neighbors in the exhibition. I had a feeling as if I were seeing your pictures with new eyes. Let us be glad that the impossible promiscuity of the Secession has caused its collapse. It was becoming unbearable. The Herbstsalon is a great page in the history of German art. The total impression is nothing short of brilliant! Splendid rooms, splendidly hung, excellent lighting, despite its being side light—but this corresponds to the actual lighting of wall spaces in present-day apartments. Thus, even in the manner of lighting there is nothing artificial (although I should prefer each picture to have its own light source). But in such large exhibitions, overhead lighting has a deceptive effect; side lighting is much more uncompromising.

You ask about Marc, Kandinsky, and Klee in your letter. Until today I have seen the work of the young Germans only in reproductions. The impression I received was powerful and hard to evaluate after a single exposure to what I have seen. The nature of Kandinsky's work, for instance, is quite foreign to my own. Remember my certain hardness and, as you wrote, my coolness, clarity, and order—and, on the other hand, the utter freedom from formal fetters in a Kandinsky! It would be wrong to make a final judgment today. For the time being, K. gives me a lot to think about and to mull over. What he expresses is exactly what I do *not* want to express—almost exactly the opposite from what I am after. I *have to* admire him and I also enjoy what he does, but for the moment it is the enjoyment one experiences in something utterly exotic. A purity of intention I sense in everything, a noble and beautiful purpose. Of Marc I received a direct and immediate impression, a truly grandiose concept; great power is in his pictures. In particular, his *Tower of Blue Horses* is a beautiful and transcendental vision, gorgeous in both form and color. I intend to revisit the exhibition soon. Today I have seen too little, that is to say, too much; I have absorbed too little because of the sheer wealth of impressions. Next time I shall tell you more about your

works; I had to note some particular traits. I cannot say anything today about Klee's works, as I had to leave before I had really seen them. One can't do the whole show in one visit, as is possible in an ordinary exhibition. . . .

―――――――――

[Fall, 1913]

. . . I firmly believe that I will and must strive only for expression, and this purpose fills my entire being and thought. But whether herein I am fanatical, I do not know. Ever since my childhood my way of seeing and feeling has gone in a certain direction, and all my efforts are bent on the realization of my irrepressible longing. I seek to recognize laws in nature, but as a goal, the representation of nature is excluded and no longer exists for me, the moment that I have deciphered these laws. The outer garb is not enough: new art comes into being only with the emergence of one's own, unflinching personality. Through my present relationships with other truly creative artists I observe, for the first time, at once the weaknesses and the particular qualities of my work. The thought of belonging to a party has always been abhorrent to me. But the consciousness of kinship with others, each of whom desires to achieve his own innermost expression, is a feeling that gives strength, especially in an environment of such devastating philistinism, where the imagination of artists has already been treated in brochures by doctors as a pathological symptom. This has happened in Germany!

Dear Kubin, it would really be quite wonderful if we could see each other again here this winter. You wrote that you were planning to come here if at all possible.

The autumn exhibition at the Cassirer Gallery on Kurfürstendamm starts November 1. The announcement is signed by Cassirer but behind it is the Gurlitt Gallery. A real game of hide-and-seek, and these are the gentlemen who cry murder against Walden,* accusing him of pursuing unfair aims with his exhibitions. In my view Walden is acting with especial courage and openness, deserving all kinds of thanks.

The Sturm exhibition has been prolonged until December 1, which I find very cheering. In this way even the ignorant can make their comparisons between the two salons. Hatred and envy, of course, cannot be converted. And to be sure, there are a number of wretched also-rans in the Sturm, but then they are everywhere nowadays.

A great collection of beautiful pictures has been assembled, astonishingly inspiring. But for one of the big names I have little understanding,

* Herwarth Walden was the director of the Sturm Gallery and editor of the publication Der Sturm.

Lyonel Feininger

and I see in Delaunay's work only sterile and misguided experiments with purely physical light problems, not even totally clarified. An instrument would give a much clearer and more valuable spectral analysis. Besides the pretentious mise-en-scène of these works, one recognizes a poverty of invention which indicates a completely mechanized inner life. Nonetheless it is possible that this theorizing might have a productive effect for others possessing sufficient power to arrive at true creations. After all, it is a good thing that in our time uncounted ways are open to the artist. Thus it can happen that the work of one artist constitutes the necessary research for another.

Now good-bye for today. I just wanted to tell you something about the exhibition in this letter. By the way, the show was copiously attended. . . .

Zehlendorf-Mitte
December 1, 1913

Kubin, dear friend:

Now the exhibition is over, and the day before yesterday I saw the pictures there for the last time. *How* outstanding this First German Herbstsalon was is evident probably only to a very few people, even to its friends. I eschew a priori the "nothing but" Cubists and the purely programmatical painters. I am speaking only of the colossal wealth of inventive and formal power, and of the superb painterly qualities assembled there. With a few exceptions, the French could have been spared; certainly, Northern painters can still learn from them, but I venture to state modestly that, in my opinion, German and Russian art has at last realized its gift of vision and has reached a state of vigor and unconventional individualism, in recognizing the inescapable essentials of form, which gives more and will be more lasting than the purely theoretical perfection of the French. This type of perfection has already become mass production, an end in itself, but it hardly adds to the concentration of expression. Rather, it seems to me, it is as though any over-all, unifying control were being progressively lost. I cannot say what art "ought to be," but in my estimation, expression, monumentality, but likewise concentration are the highest values in a work of art. It goes without saying that craftsmanship is essential in this formal approach. Form and color, both not naturalistically rendered but carried to a new formal relationship—this always was, and surely will continue to be, art, not a short-lived matter of fashion, a pastime—but eternity.

Kubin, dear friend,

It bothers me a lot that I have not written to you in such a long time. I have even had dreams about it and you appeared repeatedly in them! But it is not because of negligence; I could have written to any indifferent person without much trouble. But you correctly expect from me that I write about the inner man and that one was not in very good shape. But now everything is all right again. For about two weeks I did nothing but make toys for my boys for Christmas—toy trains— and this change, this different sort of constructive activity, is good for me and makes me ravenous to undertake pictures that have been germi- nating within me in the meantime. When I begin to paint again after Christmas, there will be completely new things without the need of pro- tracted soul searching.

In the meantime the Sturm exhibition has closed. It was really ex- tremely good. I always left the exhibition with a feeling of enrichment. In your last letter you asked me to write about Klee, what I thought about him. Absolutely splendid! Piquant and exciting with startling expressiveness and originality of form. The way I experience it, his work has the same power which lies hidden sometimes in children's drawings. That can make one quite sad inasmuch as it is not possible for adults to achieve this consciously. Does Klee *paint?* I would be curious to know! That he plays the violin is obvious to me. To conjure up a world of sound from four strings is like conjuring up a *Weltanschauung* with strokes of a pen and with crosses and triangles.

The picture which you saw at my house and which you liked so much is sold and I send you a photograph of it as a souvenir. I have not yet been able to take new photographs of my pictures; neither have friends who have the necessary equipment had the opportunity until now—I shall have to wait a little while with that, even though I should love to show you something new.

I have just sent six completely new pictures to the First Expression- ist Exhibition at the Gallery Arnold in Dresden. The fear that I had in the fall of not being able to attain the level which I had previously achieved has somehow abated. In any case I have made progress. Mere ability alone does not create a work of art. . . .

This far I got seven weeks ago, and tried to continue writing in be- tween. I wanted to comment on some of your drawings, for example the

Lyonel Feininger

*Gypsies,* which I consider a perfect pen painting, fabulously coloristic and beautiful; also the *Field Hands* with the pig on the lower left as a light corner, and everywhere the closely knit outlines fused intimately with the surface planes! There were many others that filled me with enthusiasm. And lately your lithographs for Panniza! I constantly discover new delight in them.

Why did I dig up this ancient letter? I want you to have a greeting. I want to tell you that I am happy; I also feel that I have not sufficiently thanked you for the lithographs! The other day I sent you two drawings; as I implied, their date of origin is for me already far distant. Perhaps I can send you something better soon. It seems like an impossibility for me to work as a free-lance illustrator. And therefore my drawing fares no better than, in its time, my playing the violin. I have to avoid wasting energy on it in order to economize my strength for painting. And yet I recall how happy I used to be when drawing! How I used to love to compose one picture after another. The more I undertook, the richer and better they became. I often had as many as six to eight drawing boards going at the same time with work in progress. . . .

Zehlendorf-Mitte
January 15, 1915

. . . During the past months I have written letters only to America, to my father who lives there. As far as I can learn, not one of them has reached him. The English censor must have seized all mail from Germany and probably destroyed it. Writing these letters was very difficult for me, as I tried to enlighten my poor father about events here, and to point out that such reports as England might graciously permit to pass, constitute lies. This could not be done quite dispassionately. At times I think it is better that these letters were lost. Time makes many things clearer. We who serve art have an especial obligation to remain free from partisan chauvinism. How many of our honored public figures, artists, writers, scientists, have let themselves go in vile abuse and invective; on the one hand, how few of the recognized intellectual leaders have evinced, in public utterances, a truly objective and restrained attitude! Whenever that happens, whether by an Englishman, a Frenchman, Russian, or German, how beneficent are such statements, how thankful one feels for proving their greatness!

As I said earlier, I have written only to my father, and since early October to no one at all. I have separated myself from all company and extraneous activity and have worked only for myself, and it has been infinitely difficult to carry on because it seemed that everything

died under my hand. I still do not know whether even a single one of the twelve to eighteen new pictures will survive when I shall be able to compare them with paintings of a happier time. But I have indeed gained a new ability to deepen my painting; figure painting seemed an impossibility. I have done nothing but profoundly serious landscapes and architecture, imposing upon myself an unspeakably severe formal restraint. Where I formerly radiated movement and unrest, I have now tried to sense and to express the total and brazen stillness of objects, even of the circumambient air—the world that is the farthest removed from the one that exists. . . .

Art, Kubin, is not luxury but necessity! If one like ourselves has the choice between life and death, I choose life only if there is art. There is no such thing as comfortable, cheerful work. The world is overpopulated with those who accept such standards. Only bitter, hard work, completely spiritualized efforts, will do it. . . .

---

Zehlendorf-Mitte
September 9, 1916

Kubin, dear friend:

For a long time I have been afraid to ask how you are. Ascribe it to the war that I have not written for probably twenty months, but do not suspect me of forgetting you, dear brother. What is there to write about? Only this, that, as ever before, the fight for form goes on day after day; that one works, in order not to perish, but that nevertheless one is destroying oneself, for without some cheer there can be no advance upward; all repetition is ruinous, nowhere more so than in art. And yet I am full of hope. I belong to the imperturbable ones. So long as I have breath, I shall be like that. Lately I have been able somewhat to resist the depression caused by the war—one becomes hardboiled. After the war, I expect that I shall have to visit my dear fellow-countrymen on the other side, but hopefully only for a short time. But Kubin, is it not an inconceivable thought that there should still be a place where there is no war? . . .

---

Zehlendorf-Mitte
September 28, 1916

Dear friend Kubin,

Just to have heard from you, just to have learned that you are not in the war,* was an enormous relief from my misgivings about you that

---

* Kubin had been living in Austria since 1906.

were becoming more and more fantastic—but the contents of your letter were gladdening, exciting, stimulating. . . . What you say shows me how, a few years ago, I experienced a quite similar, fundamentally new orientation in my art. The tendency, the basic longing, remained unchanged, but almost imperceptibly I realized my dissatisfaction with all that I had previously produced. All at once, during my three-week visit in Paris in the spring of 1911, I saw the light. "Cubism!"—"Form" I should rather say, to which Cubism showed the way. Afterward it was amazing to find that for years I had been on the right road. In some quite old drawings, of twelve to fourteen years ago, Cubism is definitely discernible. But in Paris only I saw and heard for the first time that such a thing existed. I never set myself an example in anyone else, never studied the work of others—be that a fault or not—but solely from an indefinable inner urge and, above all, from drawing from the inexhaustible treasury of nature and its laws, I have battled my way through to my present-day position. I have made drawings and studies from nature for close to thirty years (although I have never painted directly from nature), so that, today, I have unbounded confidence in myself. I have mastered almost undreamed of natural phenomena of light refraction, perspective (but not the one taught in books!), and the coordination and harmonizing of masses. I do not even exploit this kind of knowledge, for any form of "rationalism" is worlds apart from my creative will, but I have recognized that nothing exists or can exist, in this or any world, due to chance and not subject to some law, without form and rhythm. Why then in art? Must not art, in which the human creative will is revealed, be particularly informed by law and spirit? Even chaos is full of order, the fugitive shadow of a bird flitting over a meadow is unalterable! Only our perceptions of objects in nature are mystical. Therefore we must have, and give, the form to express this mystical quality. The mere object is nothing; seeing is everything! And here I want to say that art can only progress with increasing understanding, with the inner growth of the artist. It is the incredible folly of our times to pretend that any artist who is young, i.e., 20 to 30 years old, is ipso facto an accomplished artist. In no art has mere youth produced its main works compared to the work of more mature years. Or, if they were so considered (I am speaking of genuine artists), it was based on a false concept of genius, because of the theme, the temperament, etc. Later on, one has always been amazed to see how little such works have stood the test of time. Art demands a powerful will and unheard of yearning, and inhuman discipline. All three together! Where, as a youth and up to the age of 30, I could (and had to) labor whole days and nights producing works which remained artistically abortive—because I was unconscious of the true goal—at my present age of 45, I have a real rage to create with my disciplined strength. It is bliss to be paint-

ing, and each stroke is full of power; nothing is superfluous. I husband my strength. I have to do it because I need it for my craft, today more than ever in my youth. Some of the young hold that everything spiritual in art is a crime. *Only* the spiritual can endure. Any so-called primitive lavishes the utmost of his intensity on the figure which he is carving— *love of craftsmanship*. . . .

---

Zehlendorf-Mitte
[1918]

Dear Brother Kubin:

If you can forgive me for not hearing from me for such a long time, write to me again! I was too unhappy. It came over me almost suddenly. Unfortunately you already know this trait in me. I have been better these last few months. I have swallowed and digested what is inevitable in the horrible world events as far as my mind is concerned. What matters now is to live, in spite of and because of it all, for the sake of my art which continues to gain in depth. Without art I might as well croak. My life would have no goal that I could see. The frightful feeling of isolation in which I lived for so long has been mitigated by a comforting and strengthening relationship with some people who have found access to my work and who understand me. The dark, oppressive wall around me has receded, and I can "breathe" again.

How full of happiness in our work and how full of buoyancy were our letters of September, 1916! But as I see it, I have achieved, since then, out of the melancholy of battling for the creation of my world, deeper and more meaningful work than I ever had in times of happiness. Art is a matter of the most inwardly human, desperate wrestling, without mercy and let-up, and it is not a question of enjoyment as common mortals think. Joy may well radiate from such works, but it will be the unconscious product of cognition and pain. . . .

---

March 23, 1918

Your kind letter has done me an infinite amount of good. It reached me during the terminal stage of my crisis. I don't believe that I have really conquered the grief of the past thirty-six years, but I have at least damned well pulled myself together. I have come back to myself and to my artistic standards. I have stopped immolating myself to be devoured by Art, as you so rightly remark. For the past ten days I have been

Lyonel Feininger

working with a liberated spirit, calling on my craft, setting myself purely painterly goals, and am engaged in successful work at quite new pictures. I definitely shall not let it happen again, to torment myself as I have done. At the outbreak of the war I fell into a psychotic state, like an overpowering, totally paralyzing self-hypnosis. This was of no help to anyone and pushed me almost to the brink. Nothing but will was left, but the kind that kills off all creative effort as though with murderous weapons. I trained myself in fortifying my will as an end in itself, and completely forgot about any permissible or even vitally necessary exuberance. Rejecting any kind of respite, I knew only boundless toil with gritted teeth. Painterly functioning was reduced to an act of mortification by a decree of the will. I wanted to suffer—I have suffered. I did not want to miss my share in general involvement with kindred spirits, out of a sense of what I deemed to be my duty toward the boundless agony all around me. Profundity counted more with me than the work to be achieved. Of what was done, little enough has survived this period of bedevilment, but such as it is, it bears the stamp of the times of suffering. But there shall be no more of that from now on. Last summer was still quite good. My connection with the Sturm Gallery opened new perspectives. I finished some pictures in time for the September exhibition which were above average. But then, suddenly everything stopped again. No salvation could be hoped for from the outside. On the contrary, I first had to build up resistance to the Sturm with its manifestations and tendencies, in some ways quite contrary to my own aims. And for six months, from September to March, not a single work was completed. Everything died under my hand. Even after good beginnings, some of the most promising compositions withered away. Part of the fault lay in the unsuitable and deteriorated state of my technical equipment, but of this I only became aware later. I had adopted the pernicious habit of violating the material, the color, in my dramatic striving for conclusiveness and completion. The picture itself was reduced to secondary importance. It is nearly impossible to discuss this at length at this time. I have radically discarded everything which might cause technical limitations.

As you may have noticed, I have become more of a public figure during this past year. I am unaccustomed to the situation and felt at first very uncomfortable. I was finally able to muster an attitude of composure which enables me to meet the annoyances arising from professionalism, which could not be sidestepped any longer. "Successes" which celebrate and promote exactly the opposite of what we consider to be important, can be the greatest evil. A young artist is almost inevitably corrupted by such success. How harmful is all this publicity to our 20- to 30-year-old talents. The trouble it causes—hardly one of them resists the temptations and maintains his own course. The modern

use of internationalized media has made it disastrously easy for any beginner to achieve great external success right from the start, after only a few years. Only from the age of forty upward do I find that genuinely individual attitudes are able to hold their ground. . . .

As to Paul Klee, he is really a fabulous person and artist, the most individual and the subtlest of them all. About no one else has more nonsense been chattered and scribbled. Well, I have had some experience in this line myself, some of it funny enough. You wrote about it, too: "the 'Spitzweg' of Cubism."* Westheim, that good soul, is so much in love with his discovery that he used it repeatedly in art reviews: "Feininger, the Spitzweg of Cubism," until I stopped it by giving him a piece of my mind. What a way to be launched into public life, with this stupid stigma! I could bear being called a bad artist, if I am one, but please under my own flag! . . .

January 5, 1919

My dear Kubin, dear friend,

I am really most delighted with your little portfolio. Your thought of giving me this rare and precious work gives me great happiness. The idea of taking my "revenge" with a dedication to you is not so much the motivation as the heartfelt desire to send you something that might give you similar pleasure. Please accept it as it is intended. For the past two years I have made no drawings, only charcoal compositions for my paintings, but these are rather sketchy and not beautiful in themselves. Therefore I had to choose something from a former period.

I was glad to have your letter; you divined my meaning in what I wrote concerning the time since my return from Weimar, but I do not take these times as tragically as it might perhaps appear. By now I know from experience that we can never know exactly when we have made especially good progress in our work; we must rely on the distance which time brings to judge a given phase of our work.

Melancholy seems to be a necessary part of being happy. Our deepest visions grow only out of our longing. Autumn always makes me desolate. Winter is better as soon as it has become really *wintry* with a blanket of snow and radiant air, but what a miserable climate we have here at present! A continual dismal southwest wind, rain, and slush, with almost the same temperature as the past few summers when it was

* Karl Spitzweg (1808–85) was a German artist well known in nineteenth-century Germany. Like Feininger, he had worked as an illustrator of such German satirical magazines as the *Fliegende Blätter*. Although he was noted during his lifetime as a painter of genre scenes, Spitzweg became a landscape painter during the latter part of his life.

so cold and rainy. During the winter months I live mostly indoors, which is not too good, but the days are too short for painting to be able to be outdoors as well and thereby sacrificing daylight hours.

As soon as I get photographs made of my last paintings, you shall have them—you first of all, dear friend.

I have at present six paintings in Dresden at the Expressionists' Gallery Arnold. Are you represented there? I have heard at least that the Blaue Reiter is participating. What will our bright Saxons make of our exhibition? I am somewhat doubtful. I believe that they are even worse than the Berliners.

Dear Kubin, don't let yourself be perturbed by any doubts in your way of working. You have the world within you, your own precious world of visions, and you express and build it with a vigor and profundity without compare, such as no other mortal could experience or create. I renounce any merely external formula which anyone can learn to copy. But the inner image—that is our very own, and it discovers its necessary expression without resorting to an external formula. This is our innermost self! I can make a statement only in color and rhythms where these elements combine into paintings of firm, concentrated construction.

My talent for observation does not extend to individual characterizations in life. . . . I have a longing for certain localities; that is why I paint landscapes. Figures are, for me, accessories, machinery. I love to portray them as such. *You* have a very different faculty for penetrating the spiritual depths of mankind. This is the reason why you cannot be bound by a rigid dogma or limit yourself by formal rules. I, on the other hand, am a puritan by virtue of my upbringing and a romantic by instinct (strange contradiction) and incline, on the one side, toward dogma but, on the other hand, cannot deny a tendency toward the demonic. Certainly I am no psychologist. I am instinctively on guard against the world of humans. I was never interested in making the closer acquaintance of the dark side of humanity. The strict polyphonic form of music seems to me to be the loftiest expression of our longing for supreme purity, and surely painting can be brought to the same perfection, once we have stripped off the merely objective. A beginning has certainly been made by some, and toward this goal I, too, am striving. We can become truthful artists only if we are building on our own individual basis, not by adhering to any given art as the only example and law. But just in this manner the majority become "artists." You know how the term is meant! All I have written here was intended to urge you to dare to be yourself and to continue imperturbably on your way. It is odd but true that we all need an occasional word of encouragement from others who know us and understand us.

There is only one truth: art must grow from within us! Human judg-

ments will stand and fall, come and go, change every decade. There is only one art, that which purely grows from within us and outlasts all these judgments. It has as many shapes as there are and personalities in whom it can live! . . .

Zehlendorf-Mitte
March 13, 1919

My dear Brother Kubin:

Today I shall try to write you a few lines. How often have I wanted to write, and send you many things, woodcuts, photographs of paintings; so much that I wanted to tell you of and, most of all, to thank you for your two dear letters! The notion that my letters are going to be read [by the censor] is absolutely fatal. It robs me of the faculty to write as I should like to. One is not permitted to send enclosures in letters. I was told at the post office that censorship is even stricter than during the war. But a sign of life you shall have today, and if this letter gets to you, I shall write others soon, for I am deeply in your debt as to communications.

I am basically all right. I have begun to live again, now that peace is imminent. A better mood has returned, and I have begun to be interested again in the outside world and to want to know about my fellow creatures. For two years I have led a completely unsociable life. I must tell you briefly what I did during this last year. I hardly painted at all, nor did I draw. I took up the medium of woodcuts and in about six months made over 190 blocks. This technique gives me the greatest possible satisfaction, and for its sake I have let everything else go. But lately I have resumed painting most vigorously. Of course, I feel (as you can imagine) the absence of any outdoor studies made in the summer of 1914. Also, I have a great longing to travel and to be able to spend entire months outdoors, working as I used to do. But travel seems out of the question for this summer. I shall have to stay at home and see how I can get through with it and push my work as best I may. For May a large retrospective exhibition of paintings, drawings, and graphic work is planned in Berlin. This is chiefly due to the urging of my friends. I have become well known and have many friends, museum people, architects, and critics, and they insist on showing me to the public. If the times were halfway normal, I could sell a great deal and we all could live magnificently. But as it is, I do not know what the future will bring. I am longing to get away from Berlin as soon as possible, to the country, or rather to some nice little town situated in a richly countrified setting. Weimar comes to my mind at once. In any

case we must leave the expensive metropolis and consider going some- where where life is modest and unpretentious. The war has devoured almost our entire fortune. How may you have fared, dear brother? We often think of you. How I would love to visit you. It would be wonder- ful to meet again. Dear Lord, you live in such isolation. Surely I am vastly better off, but I still detest the commotion around me. Your let- ters were full of stimulus. I was delighted with your praise of my prog- ress. Indeed, it is curious that, despite my paralyzed condition, I was able to advance further. At any rate I have reached some profundity and I do not think it possible for me to become shallow again. But a little more energy and good cheer would do no harm. . . .

## Memorandum to Walter Gropius

*The question under consideration in this memorandum, writ- ten around December, 1921, was whether or not the pre- liminary course in artistic theory* (Vorkurs) *was to be kept as part of the curriculum of the Bauhaus.*

I cannot find much to say, if I am to be frank and speak as I feel. How- ever, the little that I have to say seems important to me and to include all else.

It seems to me that the acquisition of the technical foundation of craftsmanship precedes in importance all other considerations; thorough training in accordance with present-day standards must be the basic requirement for anything else to follow.

Before we explore new methods, we must see to it that generally valid fundamentals of craft are transmitted to the students.

I ask myself whether our present demands for creativity on the part of complete beginners do not constitute a departure from our declared principle of avoiding at all costs the fostering of artistic pretentiousness, before students have acquired any basis through craftsmanlike disci- pline. It is a fact that we allow a great deal of freedom to improvise, even to students with very little technical background. It may well be doubted whether we have a right to do this. In any case, the resulting responsibility is considerable. In my opinion, there are cases where theoretical education was begun prematurely. Wherever possible, edu- cation in theory should progress along with practical training. I consent to the proposal for a technical-theoretical experimental area of studies. This will be an experiment in more than an external sense. Likewise, the "play instinct" should be given scope in its proper place.

I vote for ending obligatory formal instruction as soon as the student has been definitely accepted. Contact with the Form Master may be continued upon application by the apprentice.

The foremost duty of our workshops is to teach the respective craft according to severely practical principles. This includes *orderliness:* during work hours this must be positively insisted on. This is obvious.

I have no doubt that the composition of our faculty of Form Masters makes it possible to accommodate all exceptional cases in the broadest sense of the word. Each one of us harbors his dose of Utopia. A half-way creative mind will not be damaged by having to learn practical craftsmanship. Our prime task and responsibility is to teach the students the most thorough craftsmanship in as wide a variety of disciplines as possible. The struggle to become artists remains their own private concern.

LYONEL FEININGER

Published with the permission of the Bauhaus-Archiv, Sammlung Gropius, Berlin, Germany. First published in the original German by Marcel Franciscono in *Walter Gropius and the Creation of the Bauhaus in Weimar: The Ideals and Artistic Theories of Its Founding Years* (Urbana and Chicago: University of Illinois Press, 1971), Appendix F, pp. 285–86.

## Letter to Dr. Johannes Kleinpaul

February 26, 1932

. . . Since I began to paint, I have never cared about what other artists are doing, nor do I know how "nature" is painted nowadays (or what the current conception of it may be). We are more concerned with the picture than with reproducing nature, which never is a picture. Certainly, nature is our inexhaustible storehouse of form and the incentive to all creation, but pictorially speaking, nature is only a point of departure for the composition with plane surfaces. To give an example: there is a physical reason for blue shadows in nature. A sunlit landscape is warm in tone, arched over by a sky which is more or less blue. All objects reflect light to some extent. In sunshine all colors are illuminated by warm light, but the interference of a shady surface causes an effect of reflection to appear, which otherwise would be negated by the brightness; the intense blue of the sky overhead has an especially strong effect, and the blue of the zenith tinges, or is reflected by, the shaded ground; so that the ground takes on the blue of the sky. As a painter, I am not

normally fond of blue shadows. For instance, in studies made directly from nature they appear crude and destroy the total effect by their downright unwanted colorfulness. Here you have a small example of the supremacy of pictorial form over natural forms, of the need to simplify and correct natural effects. The artist must master his color scheme and concentrate upon the essential picture elements. . . .

The original letter is in Dresden's Staatliche Kunstsammlung, Graphische Samm-lung. A photograph of the sheet was published by Henner Menz in his article "Briefe und Zeichnungen von Lyonel Feininger," in *Festschrift Johannes Jahn* (Leipzig: E. A. Seeman, 1957), p. 332. Dr. Johannes Kleinpaul of Meissen (1870–1944) was a journalist and writer.

## Letter to Walter Gropius

*This letter was probably written on the occasion of Gropius's fiftieth birthday.*

West-Deep
May, 1933

My dear Gropius,

Dearest esteemed friend! How I should like to be with you at the festivities tomorrow! I feel compelled to express in writing, in spite of all my inhibiting shyness, my very deep feelings and to tell you this *one time* how wholeheartedly and completely I approve of your work; how highly and with how much admiration I regard it, considering it to be the purest and most lofty spiritual expression of the new German will-to-form. Each one of us who has worked with you at the Bauhaus knows how complete your dedication to this work has been, how you gave all of your strength to transform this cultural conception into actuality in the most genuine way, disregarding any selfish goal. And, as happens in this world, you fared badly enough on account of it; in the struggle with political party interests your work has been exposed to all kinds of at-tacks. Only lately have the artistic supporters of the new spiritual will been discovered in this country, among the "moderns," who have been so maligned up to now. Your work, which had as its aim the gathering of all artistic creative forces of the new postwar Germany, must be recognized. Not one of us who has worked in the Bauhaus could have reached his present strength and his advanced stage of development. All who were together with you are indebted to the years at the Bauhaus

for our immeasurable progress and inner growth! Thus, our feelings are so profound and warm that we hope that you will be allowed to keep on creating with complete and triumphant success in the most important years of your life to come. I embrace you and, together with my family, I remain bound to you in true friendship.

<div align="right">
Your loyal<br>
LYONEL FEININGER (alias Papileo)
</div>

Transcript, Feininger Papers. Printed with the permission of the Houghton Library, Harvard University, Cambridge, Massachusetts, MS Ger 146 [1445], vol. 3.

## Letter to Marian Willard

<div align="right">
Berlin, Siemerstadt<br>
January 12, 1937
</div>

Dear Miss Willard,

Thank you very much for your letter of December 28th and also for the interesting newspaper clippings from the *New York Sun* and the *New York Herald Tribune,* which gave me quite an insight into the present trend of art exhibitions in the city. There is doubtless much to be said in support of the standpoint of the critics concerning the invasion of other than purely painting and constructive principles in modern art. But the field is at last quite open to imaginative creation—and that is, after all is said, a release from hackneyed pictorial conventions and artistic (?) "behaviorism." It had been my intention to enclose a number of criticisms of my more recent exhibits here, and to include a few catalogues, but upon second thought, I prefer very decidedly to begin my American career of public exhibiting without commentaries of an entirely different and decidedly foreign character. And since it has been decreed, a few weeks ago, that art criticism is no longer permitted, such publicity as I had hitherto been favored with here is now a thing of the past.

It pleased me very much to hear that the *Architectural Record* is going to publish several of my pictures shown in your gallery.* I took note of the other projects including examples of my work and do hope that for a "first appearance" the exhibit you gave it has not been entirely a disappointment or put too great a burden upon the young enterprise!

Did some photos I sent of the weekend in Meudon last June reach

* Willard Gallery, then the East River Gallery, New York City.

you? I am not sure that I addressed them to the right number, but I hope that they reached you all right.

With cordial greetings from Mrs. Feininger and myself,

Very sincerely yours,
LYONEL FEININGER

Archives of American Art, Smithsonian Institution, Washington, D.C. Willard Gallery Papers, N/69-114 (85–86).

## On Art Instruction

*In 1942, Feininger wrote to Galka Emmy Scheyer that he had been asked to contribute an article for publication to The Art Appreciation Committee of Brooklyn, New York. Among Feininger's papers is the partly typewritten, partly handwritten draft for the article, which he probably composed in 1939. An excerpt of the draft appears below. The article was never published.*

The more profound the experience of nature, the more vigorous and convincing will be the resulting abstraction and the more expressive, in every respect. After all, this is perhaps the chief criterion of true artistic creation.

### A Few Notes Regarding Art Instruction

While fully appreciating the value of a thorough knowledge of the laws governing pictorial composition, I am convinced that theoretical instruction should proceed individually. Art theories can be taught to practically anyone. Art itself cannot be taught. Art is above all dependent on observation and intensive experience of the visible world we live in. Our capacity for achieving art is dependent on our interest in, and spiritual reaction to, the surroundings we live in. The first, imperative task before the beginner is to gather through study and unceasing observation of nature as great a fund of knowledge as possible. The further he advances, the greater will be the ability of the artist to translate his vision into terms of art values. The student should not be subjected to any cut-and-dried theoretical instruction. I mean this very seriously, inasmuch as the present tendency is toward instruction in so-called abstractions and non-objectivity in art, thereby feeding the student on an instruction-diet of set formulas, on set precedents. In my experience in leading the art class at a large college in the West in 1936–37 during summer sessions, I found much talent among the students, male and female. I found a great deal of sophistication and an

appalling collection of mannered, careless, and insincere studies after nature, all of it meaningless, without expression, and in the worst possible taste. The students had formerly been stuffed with theories at the hands of an artist, a man of profound knowledge and high achievement in his profession. I found the students only too eager to continue. Had I desired to continue on such a line, I could have done nothing for them. The majority were practically blind to the tritest facts of visual observation. The rich and thoroughly admirable creations of the modern European masters have been the result of decades of individual experience in deciphering and translating the inexhaustible formal wonders of nature. I have witnessed personally the intensity with which every artist of world-wide fame has studied, and still continues to study. Take Paul Klee, one of the artists of greatest abstraction. There is an inimitable subtlety and delicacy of rendering in his early sketches and studies after nature. His least lines, the merest thumbnail scratch-note, is imbued with expression and vitality. This subtle and expressive quality is to be found in his abstractions. The same is to be said of Picasso, who, increasingly in his later work, shows immense power in rendering after nature. This power of the consummate draftsman is always evident, at the bottom of his most astonishing distortions and grotesques. Braque, Derain, Léger, Juan Gris (not to mention some of the minor Surrealists), and a host of others, all without exception went, at the beginning, through an academic course of nature study before they broke away from traditional forms of expression. With regard to methods of interesting and instructing a class of students, I suggest drawing still life during the forenoon, with composition, design, color analysis, and experiments in space in the afternoon . . . also meticulous drawing of flowers, various leaves, insects, small objects of different shapes and structure. Drawing from memory is to be encouraged; following careful study and drawing of an object, the student should reproduce the subject freely from memory, striving rather for expression than for accuracy—expression being at the root of all art. The great thing is to keep interest and achievement keenly alive.

In the course of my activities as instructor, I have never made the attempt to develop a program course of lectures. Taken into full account were: careful compositions of subjects and their arrangement, dynamics, light and shade, concentration of values, experiments with shifting objects. Mannerisms, meaningless makeshifts, insincerities, and banalities were rooted out. The fact that most young people had never developed any active interest in accumulating experience other than at second hand was discouraging, but the result of our mutual endeavors was, at the close, all the more gratifying.

Far above all representation, we seek a new canon of beauty, a more complete and satisfying musicality of color, form, and rhythm. With

Lyonel Feininger

the increasing knowledge of construction and spatial theory, we do not desire to sink into mechanical methods, but to clarify and to intensify, and to give structural support to our creations. All true art was, and is, abstract, aloof from mere imitation of our great instructress: nature. A word from Goethe, to conclude these notes: "The highest duty of each and every art is to give the illusion of a greater reality in the portrayal of reality. A false aspiration would be to render an illusion of reality so closely that finally only a commonplace 'reality' remains."*

Feininger Papers. Published with the permission of the Houghton Library, Harvard University, Cambridge, Massachusetts, MS Ger 146 [1445] 1939 irregular 1, vol. 4.

## Letter to the American Abstract Artists Group

[1942]

American Abstract Artists
358 East 57 Street
New York City

Dear Brother Artists:

Forgive please, this retarded answer to your cordial invitation to become an active member of your organization.

If I have so long delayed in responding, it is because I have been deeply revolving the question in my mind. And I have reached the conclusion that I cannot conscientiously join your faith, for the reason that I would at best be an incomplete co-worker.

My artistic faith is founded on a deep love of nature, and all I represent or have achieved is based on this love. I understand fully that all that I admire in the theory of a nonobjective art is outside of my capabilities—and that I should become inarticulate, which would be the worst fate that could befall an artist. We all must work out our own salvation in our own way.

With warm thanks for your invitation, and greetings,

Cordially yours,
LYONEL FEININGER

Archives of American Art, Smithsonian Institution, Washington, D.C., American Abstract Artists Papers 1936–1963, N/69-137 (279).

* Feininger gives the quotation from Goethe in German: "Die höchste Aufgabe einer jeden Kunst ist, durch den Schein die Täuschung einer höheren Wirklichkeit zu geben. Ein falsches Bestreben aber ist, den Schein so lange zuverwirklichen, bis endlich nur ein gemeines 'Wirkliches' bleibt."

## Letter to Curt Valentin

Falls Village, Connecticut
September 3, 1943

Dear Curt,

. . . You write that you were thinking the other day of a Feininger exhibition under the heading "Old Architecture." I think that that would be a misleading title, for whatever architecture I have ever painted was certainly never accurate portrayal, but entirely subordinated to my formal requirements and avoiding all "actuality," even in the Halle series. It might be better, if at all recommended, to make an exhibition of "Manhattan." But I am still working cautiously on preliminary and tentative compositions of "Manhattan" space. . . .

Affectionately yours,
LYONEL

Published courtesy of Jane Wade. Miss Wade worked with Curt Valentin from 1948 until 1954, the year of his death. Miss Wade then ran the Buchholz Gallery for another year until it was closed and the estate settled.

## Letters to Dorothy Cahill Miller

*Dorothy Miller and Alfred H. Barr, Jr., were involved in arranging the exhibition of the work of Feininger and Marsden Hartley at the Museum of Modern Art, New York, in the fall of 1944.*

Falls Village, Connecticut
August 22, 1944

Dear Miss Miller,

Thank you very much for the list of selections made from the group of oil paintings at the Willard Gallery. All in all, I think the choice is very good. . . .

You will have seen in perusing the excerpts from my letters, it is characteristic, to a degree, of my approach to themes to attack them repeatedly and always from a new side. The Manhattan paintings are a strong example of *serial* efforts and of the paintings the *Manhattan III* (1944) is possibly the concluding example.

[*On verso of the page in handwriting in ink*].

Lyonel Feininger

You know how many series there are among my paintings (Dunes, Gables, Gelmerodas, Zirchow, Halle) and now at last Manhattan. Manhattan is the only series you would have at your complete disposal. Now I am not suggesting that you should show them all, but at least please don't leave out *Manhattan (Dawn)*. . . .

Feininger Papers. Published with the permission of the Houghton Library, Harvard University, Cambridge, Massachusetts, MS Ger 146 [1447].

Falls Village, Connecticut
September 13, 1944

. . . Would it be of interest to mention that all the above one-man shows in museums in Germany were *before* the commencement of the Nazi regime, in order to ward off any possible suspicion that I had been a pet of those gentlemen? As a matter of fact, my paintings were shown after 1933 in all Nazi exhibitions of "Degenerate Art" and most scurvily treated. . . .

Feininger Papers. Published with the permission of the Houghton Library, Harvard University, Cambridge, Massachusetts, MS Ger 146 [1445], vol. 4.

# ||| letters to
# julia feininger

*During frequent intervals over the years, Feininger felt the need to be absent from his wife and three sons in order to find the necessary solitude to concentrate on his painting. Almost every day of his absence was marked by a letter. To Julia Feininger, who had been an artist and understood this need, Feininger could confide his hopes and doubts about his work in his letters. In 1913, from April until September, he rented a studio in Kurthstrasse in Weimar. He also spent the summer of the following year in the same studio. When World War I broke out in August, 1914, he returned to his home and family in Zehlendorf-Mitte, a suburb of Berlin. During the year 1916, Feininger again lived alone for part of the summer, in Wildpark near Potsdam.*

*As a member of the staff of the Bauhaus in Weimar from 1919 until 1925, Feininger was anxious to have his family with him. Yet at first it was impossible for him to find lodgings for his wife and sons in Weimar, which was crowded with members of the National Assembly of the Republican government and their retinue.*

*From 1924 until 1935, the Feininger family spent every summer in West-Deep on the Baltic Sea. Feininger usually departed from his home in the spring, stayed in West-Deep alone for several weeks, and then was joined by his family during the summer months.*

*During the Bauhaus years in Dessau, Feininger was invited by his friend Alois J. Schardt, the director of the Moritzburg Museum of Halle, to paint views of the city of Halle. There Feininger occupied the tower room, as his studio in the museum, for a few months each year from 1929 to 1931.*

*During all these absences, Feininger corresponded with his wife. After 1935 the letters to Julia cease, for Feininger and his wife were together.*

*In the letters of Feininger to Julia, I have omitted only those portions that relate to very personal matters regarding the health of the family. The letters have been edited for the sake of clarity.*

Lyonel Feininger

# The Period as a Caricaturist and Cartoonist (October 14, 1905–February 10, 1906)

<div align="right">October 14, 1905</div>

. . . I've sent you a very bad print of my page to appear in the *Lustige*. It looks very different from what I intended. It is always very discouraging and monstrously inappropriate that, with these periodicals, important finishing effects are left to insufficiently trained workers. Please do not, for a moment, believe that I ever attempted a sky as blackish and heavy, and a face for King Edward resembling a putrified peach. Yet with all its defects I think the page has a certain unconventional quality. Unfortunately the work I do now is coarse and lacking in finish but I could "if," and we shall see one day that I *will* do. It is not ambition which prompts me; from a conviction deep within me I write this to you. Pouf, Bum! as the French say if one utters big words. My dear, I feel better now. I've thrown my lemon and onion against the wall, it stopped raining, I don't bother any more about my lousy (pardon) unfinished 20-German marks drawing at which, sinful creature that I am, I've been working over two days without success, and in 20 minutes I'll have a letter from you. . . .

Excerpt from a typewritten transcript, courtesy of T. Lux Feininger. Translated by Julia Feininger. All the letters in this section were similarly obtained and translated.

<div align="right">October 16, 1905</div>

. . . a lively gale blowing all day has swept away all the clouds and the spider webs from my brain; there is nothing but sunshine and blue sky. If, now, I can't produce a good page for the *Ulk,* then my name is McGinty. (The last one was so bad that I thought I'd rather not send it.) But with such stuff I have to earn my living. I have to take what I get (sometimes something better is offered) and must even be thankful, and we won't quarrel with what brings us materially closer to the goal we are striving for. My work is very uneven and I am clumsy. Many things which for others are child's play are a torment for me. Your criticism the other day, though hitting like a whip at first, brought liberation and enlightenment; it made me get rid of all sorts of hallucinations and idiosyncrasies. I found confirmation for the way to work that is really my way: surface plane and line. . . .

. . . I was up at six (also yesterday), and I've been working well until now, 11 A.M. I have regained faculties which I had thought lost long ago, and grieved at the loss. My line, once more, is vital, forms are becoming strong, expressive, buoyant, and the making does not give me pain. New conceptions for pictures are forming. Today again it is lovely and sunny; yesterday was even warm. October has been a good month for me. I earned 846.70 German marks. This multiplied by 12 would give me 1016.04 German marks per annum. But it should be better, much better still. It will be difficult, though, with the two periodicals alone; therefore, I shall attack the *Simpli,** making a page in the hope that they will use it; if not I don't give a hang, I'll simply sell it somewhere else. I feel deeply to what extent we are contributing to shape our destiny. If, for certain reasons, some bricks in the edifice of our happiness should get broken, what does it matter? Soon now, the sun will come around, shining into my room, casting a golden shimmer over my black desk, and the pen steeped in India ink with which I am writing, and then over your flowers, the yellow ones and the reds. All the buds are opening, new flowers developing out of tiny globules. And "Buddha" is sitting in the background with his hands raised in benevolence, enchanted and enchanting.

Forenoon, November 1, 1905

. . . The letter I got from you yesterday evening has stirred me deeply, and behold the result—good work today, a drawing created with vigor. Love craves for happiness beyond words or utter despair; indifference only kills it. In grief or bliss, if only they were intense, I've always been able to work well. However, I'm too utterly stupid for a reasonable letter today, ergo let's go ahead merrily, all the more since I have sworn to myself not to comment on anything. When does your lithography class start? You do go, don't you? And also you take the course in etching. You can learn a lot with regard to technique and methods in a short time and then you'll teach me. I would like very much to do lithographs of old towns, a number of such motifs, besides a locomotive series. When the time comes, we shall study together, and travel to see the world and strange people: that is what I have been longing for all my life. Later, whatever happens I see us both in a huge studio, a gigantic place, *our* studio! We shall paint there, make etchings and litho-

* *Simplicissimus,* a Berlin publication featuring humorous cartoons.

graphs, weaving, drawing, and perhaps pottery and sculpture. **Of course**
there will be music and you will read to me aloud. Our last meeting has
given me strength and peace of mind. Only now I am able to do better
work continuously. The level of my production is higher, I'm getting
back confidence in myself. It is extremely difficult to bridge over the gap
between the will to achievement and the capacity for carrying it
out. . . .

Early (8:20), November 2, 1905

. . . After many seemingly endless weeks of rain, at long last the sun
has come into his rights once more. We have a marvelous Indian sum-
mer. Every morning I see a picture from where I'm sitting behind the
yellow café-curtains in my room in the ground floor: opposite to the
right and left as far as the eye reaches, the lower parts of houses in the
cool shadow of morning, while higher up the tints are getting warmer.
The windows below yawning darkly, above they mirror the sky, silvery
or intensely blue. The top stories of this long, clifflike row of façades
is in the sun, and I get its glory reflected on my table, on the sheet of
paper, in gold and violet hues like an opal. "Reflecting windows" . . .
pieces of sundown in the west unexpectedly set like jewels in the dusky
eastern sky, the Good Night sky. For me this forcible opposition always
was full of magic beauty. I am so joyfully eager it crazes me to do so
much, and I shall be able to master a lot. At such times I don't feel like
one of a baker's dozen—all this through you.

About your lithographs: don't elaborate the outline in the contour
stone. Make as much use as they will allow, of the color-and-tone
stones, without overmodeling. Leave large spaces blank. The whole
must be controlled like an orchestra, or else there will be no magic
attained, no integration of spotted color and tone. It would remain an
illuminated outline drawing. The limitation of means is an artistic pre-
supposition. . . .

8:30 A.M., February 9, 1906

And now I have to announce an event of enormous consequence, some-
thing which I have waited for as for a call, my future in America. The
editor-in-chief of the biggest newspaper in Chicago, the *Chicago Tribune*,
came to see me, and he wants me to work for them. He looked at my

drawings, and we talked for a good hour and a half, he wants to settle with me on Sunday. Now, my darling, don't be afraid, I shall not accept it. I cannot do it. Possibly I might persuade him to renew this offer in two or three years, though he stresses the point that he is in a hurry, *à brûle-pourpoint* as he said he has traveled 7,000 miles for the purpose of discovering new recruits for the huge concern, something quite different, for the daily comics. That is work which means very good pay if one is so fortunate as to appeal to the public. But—it doesn't tempt me. I've told the man my reasons, and his reply was that he would wait until Sunday for a definite answer. Still! It did me good to have had his visit. Somebody from the *New York Times* who knows my work well, and values it, pointed me out to the man.

Yesterday evening in the snow I felt just like you, sad to death, and overwhelmed by an apprehension of I don't know what. It seemed as if all our happiness and life together were to evade me at the last moment. I have no words to describe it.

To talk of something else: I have made the composition for a large new page in the *Lustige,* it is conceived strongly I think. I did eight or ten small preparatory sketches in charcoal which I spread out for comparison, and then I used the best to work on. The slightest difference in relative proportions creates enormous differences in the resulting monumentality and intensity of the composition. Monumentality is not attained by making things large—how childish—but by contrasting large and small in the same composition. On a postage stamp one can represent something gigantic, while yards of canvas may be used in a smallish way and squandered. . . .

Early Saturday, February 10, 1906

. . . In case the discussion [with the *Chicago Tribune*] tomorrow should hold very advantageous propositions, maybe I should not dismiss it entirely. If, for instance, I could settle for 24,000 German marks (that is, $6,000) a year, our monetary problems would be over, solved once and for all. In that event I'd come to see you for a few days in order to talk things over. Don't be alarmed that I mention this at all. We would have to renounce much that we've been dreaming about for the future, our hopes of artistic achievements. Oh dear, we would not be gone forever. But in two or three years over there we could get further than here in ten. Please send me word if you absolutely cannot face it, then I shall not commence any negotiations whatever. I have to be in the hotel at 12, so I should get whatever you write in time. . . .

Lyonel Feininger

# The Early Years as a Painter (August 29, 1907– August 26, 1913)

. . . Already I visualize quite different gradations of light and variations of form, different possibilities for working out compositions. But it is nearly impossible to free oneself from the accepted reality of nature. That which is seen optically has to go through the process of transformation and crystallization in order to become a picture. . . .

---

8:15 P.M., Monday, September 2, 1907

. . . If I try while at work to submit to the influences of others and to digest a vision other than my own, I feel completely paralyzed. I still have to learn so many basically important things. I have to preserve faith in myself in order not to be plunged into fainthearted brooding and unproductive doubts. A finished work may be criticized, condemned and thrown over. Toil even wrongly persisted in is as imperative to me as the air I breathe. I have to get to the bottom of my own findings before I can stand criticism without the feeling of being frustrated in my impulses. You shall see for yourself. Not without good reason does one start to paint at the age of 36, a jolly patriarch, and sticks to it for eight to ten hours a day. . . .

---

Weimar
7:30 P.M., April 15, 1913

. . . Today without interruption it was just lovely. At 9 A.M. I started on my bicycle. I wanted to see the villages behind Oberweimar on the road to Jena. Through the Belvedere Allee I went, and over the bridge of Oberweimar, where for you the world is at an end, for you never got any farther. There are Taubach, and Mellingen, and Benshausen, and Schwabhausen, one always more beautiful than the other. The churches of these villages have retained the character of the periods in which they were built, and especially in Schwabhausen I came across a wonderful motif. Seen from afar the church looms up high, dominating the village which itself is situated on a minor hill. The church seems gigantic. Next

to it, on the slope, stands a huge tree, centuries old, with roots above the ground stretching far and wide. When I got near I saw that it was only a miniature village church, but by unfailing instinct the old builders knew how to get their effect, and with the most modest means. I was downright delighted. . . .

---

Weimar
Sunday, May 18, 1913

. . . The picture I have been working at for over two weeks grows into a unit, is full of new things which surpass by far rational understanding. My spirit and soul striving for expression now find salvation in creative work. My heart is all yours and, once more, I am open to human reactions. Oh dear, if only I never again reach such a low as these last winter months. Solely through creative striving can I attain harmony. Whether I so will it or not, it seems to be a law within me to which I have to capitulate.

About the painting, I want to tell you that it represents high houses in Paris condemned for wrecking. The composition was made in 1908 for the first time, but done again, and improved in 1910. Lately here in Gelmeroda, Vollersroda, and other villages I have conceived still more venturesome pictures which I shall start soon. Until now I did not dare hope to be able to absorb impressions and do creative work at the same time. Hitherto I was able only in my graphic work to get to such a climax. Sketching out-of-doors these last days I got into a sort of ecstasy. At the end of an afternoon my whole being was functioning instinctively, my capabilities were increased to the utmost. I stood on one and the same spot drawing the same motif three or four times until I got it according to my vision. That goes beyond mere observation and recording by far. It is a magnetic coordinating, liberating from all restrictions. . . .

---

Weimar
7:20 P.M., August 21, 1913

. . . Today I made a composition for a painting: *Bathers on the Beach.* I aimed at divesting the subject of all episodical and trite elements, but to communicate through rhythms and form the monumental and otherworldly spirit which I always felt at the beach. I anticipate starting painting tomorrow, with the purest and simplest of colors. This after-

Lyonel Feininger

noon (it is after seven now) in the park again. I cannot get away from the loveliness of the greens, and this little river Ilm holds me spellbound. I stood on the bridge for a long while looking down into the water, which is very high now; a few inches more and the meadows in front of the castle would be flooded. The river is so beautiful now, this muddy grayish brown-green; like a veiled mirror it reflects the trees and the sky, which also is of a misty greenish hue. In my last picture (*The Beacon*) I painted the sky a silvery yellow which was like a revelation, and other colors and combinations which I didn't know before are dawning on me. I am looking forward to comparing the works of this summer with old ones when we are back in Zehlendorf; it will be very interesting. Oh my darling, my head is full of projects for new works, and the heart is all loving and longing. Always remember that it is the surface only which makes me appear cold—within, wonders are teeming.

In a few weeks it will be October; there is so much that I want to accomplish. The time seems short. How shall I manage? And yet, once in a while, one has to run wild to sweat the accumulated poison out of one's system. I sit in the room too much. If tomorrow the weather is enticing, I'll be out all day. Yesterday after dinner, I sneaked out and let the others sit and talk. I went to my room and played on the harmonium for a long while; it gave me peace of mind; it was a great comfort. . . .

[August 26, 1913]

. . . Thank you for the flowers and for the lovely letter . . . both bringing me greetings from a foreign and unfamiliar world. As eight years ago, in the fall, when you had gone to England, which I didn't know, again I experience this sort of separation in which I am not able to visualize you. It makes me quite melancholy.

I am working well now. I am painting the *Bathers at the Beach* with the black water which I started at Zehlendorf. I have now found conscious expression for what one and a half years ago was only an intimation of things to come. It will be a strange picture, remote in character but, I think, very beautiful. You shall see. This summer has been decisive in many respects. It looks as if my endeavors were leading out in a straight direction so that work is no longer an obsession, and to some degree an *idée fixe*. For once I am through with theorizing. I am in a period of intuitive creative work. The technical means are of secondary importance, no more a worry to me at present. Soon we shall have contact with many who are striving as we are for new solutions in art; that will be stimulating; we shall meet interesting people. . . .

## A Member of the Sturm Circle (September 13, 1913–September 2, 1917)

<div align="right">

Weimar
September 13, 1913

</div>

. . . Yesterday the weather was incredibly lovely. So I went in the early afternoon to Vollersroda, and on the country road to the left, behind the church where you and Dodi* the other day were collecting petrified rocks while I was drawing, on to Öttern. It was new land to me. I walked along the ridge of the hill. The view was opening out, becoming more grandiose toward the higher mountains. In the direction of Buchfahrt the road runs down so steeply once more that no vehicle could make it. At the foot of the cliff our little Ilm is turbulently roaring along on its way to Öttern. There are three quarries with high-water marks, but the village lies drowsily tucked away in the bottom. After sketching the funny little Baroque church, I went out at the other end and saw a signpost: to Kiliansroda, 1:20 kilometers. Kiliansroda! Kiliansroda—a beautiful name, where did I hear that before? Since it wasn't late, a quarter to five only, I thought I'd quickly go up and have a look. Well—up! Never in my life have I walked a steeper road, like the slant of a gable roof. Every step took me eight to ten inches higher. Looking backward I saw the landscape spread out for miles and miles. Through openings between the opposite hills were vistas of villages, one behind the other, in the golden light of the afternoon sun. Then the place itself, a real little mountain village. Century-old houses higgledy-piggledy side by side and above each other, and finally the church. If I didn't see the legendary Schellroda, afraid of being disappointed, Kiliansroda in the last rays of the sun of a dying September day made up for it; it caught my heart and love. I don't know whether I shall ever paint a picture after what I have seen here, but I was deeply inspired, this is my own country outright. I stayed and made one sketch after the other, until 6, then home in a hurry.

Now a gladdening piece of news: today I got a letter from the Sturm. The well-known art collector Bernhard Köhler wants to buy my picture *High Houses in Paris*. He has made an offer of 600 German marks. Mr. Walden writes:

"Mr Köhler was a great help in getting the Herbstsalon† started. I think it would be in the interest of each of the represented artists to

---

* The nickname of Feininger's youngest son, T. Lux Feininger.
† An exhibition of avant-garde European art organized by Herwarth Walden, director of the art gallery Der Sturm and editor and publisher from 1910 of the periodical also known as *Der Sturm*.

Lyonel Feininger

oblige Mr. Köhler, who, unlike many others who buy art, is a collector of taste and whose fine collection is famous. The Sturm, under the circumstances, would, as a matter of course, refrain from taking percentages. It would also make a good impression if at the opening one of your canvases could be marked as sold."

I think I should accept; besides I would much rather sell to a real collector for less money than to any man who has the dough but knows less about art. You would hardly guess how this offer encouraged me. The constant feeling of my uselessness had brought my self-esteem to a rather low level, stupid though I know this reflection to be. . . .

---

Weimar
7 P.M., September 15, 1913

. . . This morning two letters from you arrived at the same time. It was good reading that you were so pleased; I am very curious about all that may come our way from now on. So far the people from Der Sturm have been a set of strangers and maybe a little too "stormy" for us. But intercourse with them might bring some stimulation. One thing I know for certain: it will not change anything in my life in connection with my work. Of course I am most eager to have your reaction about the show, also if you could buy some of the newspapers the day of the preview it might be interesting. Do you think another sale likely? I myself hardly expect it. The picture which has been sold was the most captivating, though the *Church of Teltow* is stronger and the *Jesuits* is brought to greater perfection. But I hardly now remember the things, it seems so long ago that I painted them. It is time to break off and turn another page. I am fidgety, caught in perplexities. I have to compare my old works with the new ones. God bless you. Your courage and confidence were very comforting. . . .

---

September 25, 1913

Sweetheart mine,

Thank you for your letter, the package with the catalogues enclosed, and for the wire. Thank God that you seem to be feeling better at last. The catalogue interests me very much. I have been waiting for days without making a noise about it. Since the reproductions are only black and white, it is impossible to get a conclusive impression. According to

what I see—for color may change a lot—tension seems to be predominant. Delaunay and his wife are almost scientific, an optical corporation. The reproduction of my picture is printed sideways; the effect was, of course, bewildering. When I got it right it struck me as if it contained something of that which I had intended to impart: a closed chord. I am afraid, though, that even into this company I won't fit. The point of relationship between them and me is that most of them are striving for a determinate formal expression also—only they more or less pluck to pieces, whereas I am bent on monumentality. At least it seems to me so from what I can make out after the reproductions, of which some are very fine, but they don't excite me. I am aware of having estimated pretty definitely the scope of my powers to strive for structural build-up. If, one day, I should be able to express the inner content, my form, I hope, will not seem trite but be able to carry my vision. . . .

Weimar
Easter Sunday, April 13, 1914

. . . Two and a half hours this morning in the park. On sunny paths between the Börkenhäuschen and the library I walked along the Ilm drinking in the air of spring, listening to the birds. All of Weimar, of course, out in their Easter finery. Now at home it is quiet in an uncanny way—even the mailman won't ring and bring something. I read Stahl's review of the Freie Secession.* It didn't comfort me, yet at least it is honest stupidity. It is the absence of old-fashioned illustrative pictures that he is lamenting; he is happy that [Hans] Purrman has sworn off following Matisse and is painting objective facts instead of "color only"—Wow! He doesn't utter a word about us, which I think is a decency on his part. Of course, he is unable to see anything in a painting if he cannot compare it with nature. Even if I don't often say it, I have you in my mind constantly, and I am thinking of what this separation implies. I am not perfectly happy or gay because I am alone and can devote myself entirely to my work. This work, that is, working at art, involves great perseverance, and there are many dark hours one has to fight one's way through until the goal is in sight, not to say reached. The enemy is one's own inadequacy. How dependent we are on "grace"—if what we have been striving for is to be attained finally. Not always does grace reveal itself. Struggle is only preparatory; achievement is the victory of intuition. Yet we don't know the moment when achievement is arrived at. How easy it would be then. Oh dear,

* Exhibition in Berlin in the summer of 1913. Feininger had two paintings in the show.

Lyonel Feininger

there is so much I could say, but which you and I know, and need not tell each other. . . .

<div align="right">
With fondest love,<br>
Your L.
</div>

P.S. I myself have been thinking frequently of the relationship between drawing and handwriting of the artist. It is difficult to formulate, as one does not draw as one writes, at least I don't; or rather one has to distinguish between spontaneous sketching and deliberate composing. My handwriting compared to former times, when it had a more decorative character, has become almost careless, whereas my draftsmanship today is exact and precise.

<div align="right">
Weimar<br>
April 14, 1914
</div>

Little sweetheart mine,

How good of you to send me Easter candies, thank you so much. But that was not the beginning of the day, to receive the package. At seven I had already finished breakfast, done my dish-washing, and was working at the *Yellow Painting*. Yesterday and the day before I had been toiling at it, once even washed it off, which is always effective, bringing the colors into coherence. But today I placed it face to the wall in order not to botch it. I took up something new, starting with the charcoal drawing on a canvas for a formally very strong, yet abstract painting (*Beacon II*). It even surpassed the first sketch I made of the subject some time ago. I shall commence with color tomorrow. I have time for new work and for wandering about the country and all is harmony within me. No more fretting and brooding, gone is my nervousness, I am master of my day; I am not cheated. I can't say how lovely it is around here; I'm just simply happy. Work, the quintessence of life and love combined. The inner compulsion to work being so strong that everything in life depends on it. It is no force from without but from within, impelling to deeds and to creation. An ecstasy such as only love in youth can give, but an ecstasy which survives youth, takes its place, and prevails to the end of life. No words can express the gratitude I feel for your love and understanding, for your good, courageous letters. My dear, I have not sent you anything for Easter. I have nothing to give but my entire heart, and tender thanks for your help in my regeneration. . . .

Weimar
April 14, 1914

. . . Your father has sent the *Vossische Zeitung,* with the article by [Karl] Scheffler. This gentleman, of course, is ignoring us. He has desperate tenacity in recognizing nothing except Impressionism, or "talent," laying stress on, and throwing into relief, one or the other of the "skillful." By hook or crook he wants to avoid taking a stand with regard to us. And with it all this pitiful perplexity, trying to discover a reason why exhibitions have become more and more boring. If you ask me, I don't see any difference from previous ones. However, some person or other may dimly be struck by the fact that we are around; that our paintings disclose that subject matter, in the illustrative sense, is not the only thing to provoke attention in painting. . . .

April 30, 1914

After having taken the Heckels* to the station, I am now sitting in the Kaiser Café waiting for the rain to stop. It is oppressively sultry. The Heckels and I had met before 9 A.M. We went to the park; it was most beautiful. At the tennis courts, though, we had to seek shelter from a downpour under one of the big chestnut trees. When it was over, all was hazy as in a Corot painting. We talked of all there is in relation to art; we helped to set art up on her legs again. I think they like it here, and it did me good to talk to somebody after three and a half weeks of taciturnity. But day after tomorrow I shall meet a brown little girl at the station, yes? With love and greetings. . . .

Weimar
May 7, 1914

Never let us forget the perfect days we have had here together. An interruption of my solitude was the best of all things to happen to me now. I have gained new elasticity. I got your postcard, was much pleased about the presents for the boys: 2 turtles—weren't the little chaps delighted?

Today I really felt blessed. At half past eight I went on foot to Vollersroda, where I did a lot of observing and sketching. There is no denying that for me it is the only way to advance, to renew my powers through contact with nature.

* Erich Heckel (1883–1970), German painter, member of the Brücke group, and his wife.

Lyonel Feininger

there is so much I could say, but which you and I know, and need not tell each other. . . .

<div align="right">

With fondest love,
Your L.

</div>

P.S. I myself have been thinking frequently of the relationship between drawing and handwriting of the artist. It is difficult to formulate, as one does not draw as one writes, at least I don't; or rather one has to distinguish between spontaneous sketching and deliberate composing. My handwriting compared to former times, when it had a more decorative character, has become almost careless, whereas my draftsmanship today is exact and precise.

<div align="right">

Weimar
April 14, 1914

</div>

Little sweetheart mine,

How good of you to send me Easter candies, thank you so much. But that was not the beginning of the day, to receive the package. At seven I had already finished breakfast, done my dish-washing, and was working at the *Yellow Painting*. Yesterday and the day before I had been toiling at it, once even washed it off, which is always effective, bringing the colors into coherence. But today I placed it face to the wall in order not to botch it. I took up something new, starting with the charcoal drawing on a canvas for a formally very strong, yet abstract painting (*Beacon II*). It even surpassed the first sketch I made of the subject some time ago. I shall commence with color tomorrow. I have time for new work and for wandering about the country and all is harmony within me. No more fretting and brooding, gone is my nervousness, I am master of my day; I am not cheated. I can't say how lovely it is around here; I'm just simply happy. Work, the quintessence of life and love combined. The inner compulsion to work being so strong that everything in life depends on it. It is no force from without but from within, impelling to deeds and to creation. An ecstasy such as only love in youth can give, but an ecstasy which survives youth, takes its place, and prevails to the end of life. No words can express the gratitude I feel for your love and understanding, for your good, courageous letters. My dear, I have not sent you anything for Easter. I have nothing to give but my entire heart, and tender thanks for your help in my regeneration. . . .

Weimar
April 14, 1914

. . . Your father has sent the *Vossische Zeitung,* with the article by [Karl] Scheffler. This gentleman, of course, is ignoring us. He has desperate tenacity in recognizing nothing except Impressionism, or "talent," laying stress on, and throwing into relief, one or the other of the "skillful." By hook or crook he wants to avoid taking a stand with regard to us. And with it all this pitiful perplexity, trying to discover a reason why exhibitions have become more and more boring. If you ask me, I don't see any difference from previous ones. However, some person or other may dimly be struck by the fact that we are around; that our paintings disclose that subject matter, in the illustrative sense, is not the only thing to provoke attention in painting. . . .

April 30, 1914

After having taken the Heckels* to the station, I am now sitting in the Kaiser Café waiting for the rain to stop. It is oppressively sultry. The Heckels and I had met before 9 A.M. We went to the park; it was most beautiful. At the tennis courts, though, we had to seek shelter from a downpour under one of the big chestnut trees. When it was over, all was hazy as in a Corot painting. We talked of all there is in relation to art; we helped to set art up on her legs again. I think they like it here, and it did me good to talk to somebody after three and a half weeks of taciturnity. But day after tomorrow I shall meet a brown little girl at the station, yes? With love and greetings. . . .

Weimar
May 7, 1914

Never let us forget the perfect days we have had here together. An interruption of my solitude was the best of all things to happen to me now. I have gained new elasticity. I got your postcard, was much pleased about the presents for the boys: 2 turtles—weren't the little chaps delighted?

Today I really felt blessed. At half past eight I went on foot to Vollersroda, where I did a lot of observing and sketching. There is no denying that for me it is the only way to advance, to renew my powers through contact with nature.

* Erich Heckel (1883–1970), German painter, member of the Brücke group, and his wife.

In the forenoon a southwester was driving huge masses of clouds over the sky, the sun peeping through for moments only. On top of the hill I could hardly breast the wind, I was almost blown over, but it was jolly and bracing; it called for resistance, which did me good. After dinner, hardly home again, the wind veered to the northwest, preparatory to the weather clearing up. But naturally by this the atmospheric balance was upset, and it rained a lot; there were even thunderstorms. Now it is quiet and the heavens high—so I'm going out.

Yesterday evening I made a very strong composition, very Plutonian. That will be a picture, for the first time in a long while a strong piece of work. This evening I shall work again at composing. The unrest has left me, I know how to proceed, and this anxious seeking has stopped. There can be nothing stronger or more firmly fundamental for me than what I am now attempting. I can't be captivated by the merely charming in art, if it is nothing but pleasantly attractive. I am unable to content myself with it. . . .

6 P.M., May 27, 1914

. . . You were right not to relent until you succeeded in dragging me out of this sort of numbness. I feel like myself again; no more, as in these weeks past, the automatically reacting machine. I was just too much cut off from human companionship. I almost lost the gift of speech, hardly talking to a soul. I know that I am a stranger, "the American of Weimar," but they made me feel it. Yet there is not enough Americanism in me to easily overcome my embarrassment at being stared at wherever I walk. Introvert that I am, this oversensitiveness to my nonconforming made me feel, at times, like being hunted. Only successful work liberates me from such feelings of constraint. And, oh, how I miss music; it would have been my salvation. Sunday in the park the grand ducal band played a small piece of Mozart, variations I had not known before. They played exceptionally well. I had to withdraw from the crowd, for I was so overwhelmed by the sounds that I could hardly suppress my tears. . . .

June 8, 1914

. . . The time of hardest struggle lies 3 to 4 years back, before we went to Paris, when I was fighting against Impressionism, when I was seeking a way of my own, and it was difficult for even you to follow me into uncertainty. Now for some time, but definitely since last year, I see my

road clear. I am assured of your understanding and support. For these, and for several other reasons, I am happy and in good spirits. This morning I got your letter with the address in Butzel's* handwriting; thank you with all my heart. I also had one from [Otto] Löwenstein containing the glad tidings of being provided with models to work on for weeks.† Last but not least, I have been out on foot in the open for several hours, which always sets things right with me; thus my world is resurging once more.

Weimar
June 9, 1914

I hardly dare to speak of it, but I am painting—the houses of Nieder-Grunstedt, which you know from the charcoal composition, a monumental conception in diagonals. I had the drawing on canvas for some time, never had the courage to start painting, but now feel myself renascent. These last days after a long pause I got again into close contact with the universe. I was entirely exhilarated by the experience of the great forms and rhythms in nature—as otherwise I am transported only by Bach's music. Now once more I feel impulses. There is for me no such thing as a merely good-natured contentment in work. Through my open window my pets, the little birds, are flying in and out, they are my company. It seems as though I had not really lived these last weeks —but now at last a heavy burden fell from my spirit. Never before did I feel such love as now fills me, surpassing all that went before. Can such ecstasy endure? I believe not, for it carries one to the very borders of existence. It comes too close to fulfillment. But I shall never forget this happiness. The weather is warm without sun, a brooding haze fraught with evil, squalls from all directions, earthquaky, sinister. But effects of light and shade, a luminous splendor, beyond all description. Only here and now have I realized the unity of this earth and its skies— once felt, it is inescapable. . . .

June 13, 1914

. . . Thank you for your good letter which acted on my fuel-filled spiritual center like a tinder box. It may well be that my pictures are less

* Nickname of Andreas, the Feiningers' eldest son.
† For Feininger's designs of toy trains for mass production, see T. Lux Feininger, *Lyonel Feininger: City at the Edge of the World,* photographs by Andreas Feininger (New York: Praeger, 1965), pp. 26–33.

Lyonel Feininger

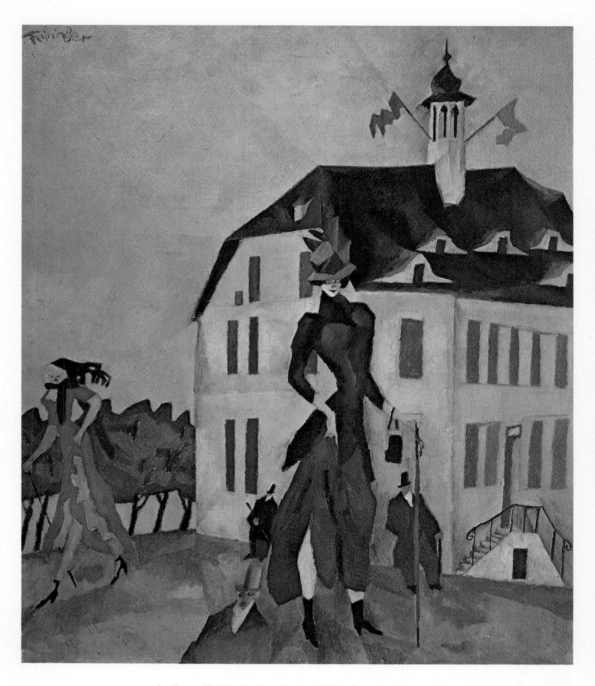

I. *Town Hall in Swinemünde.* 1912. Oil on canvas, 27½″ x 23½″. Collection of Martin S. Ackerman. Photograph courtesy of the Marlborough Gallery, New York.

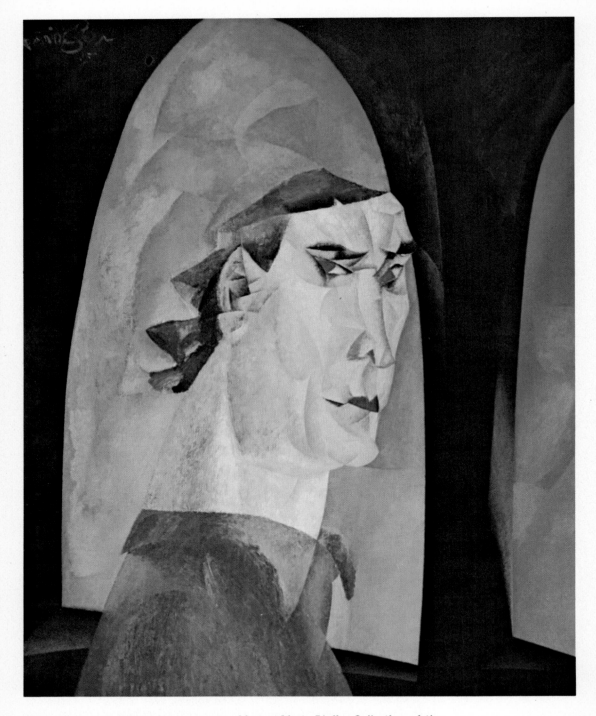

II. *Self Portrait*. 1915. Oil on canvas, 39½″ x 31½″. Blaffer Collection of the University of Houston.

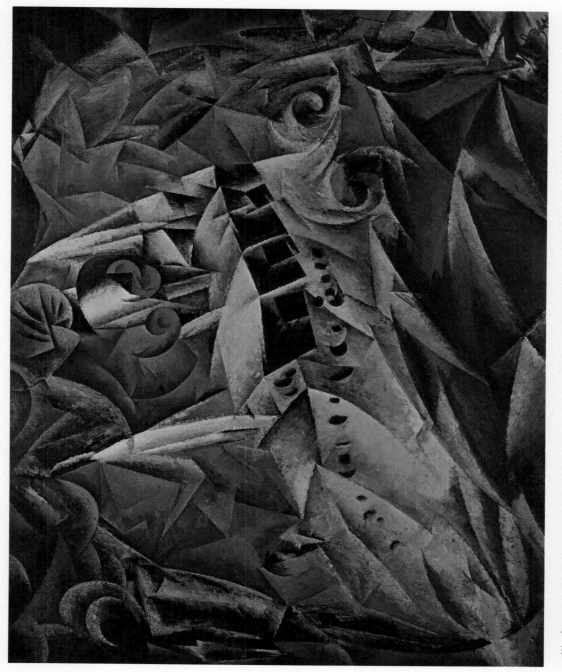

III. Steamer "Odin" (Leviathan). 1917. Oil on canvas, 29¼" x 32". Courtesy of the Marlborough Gallery, New York.

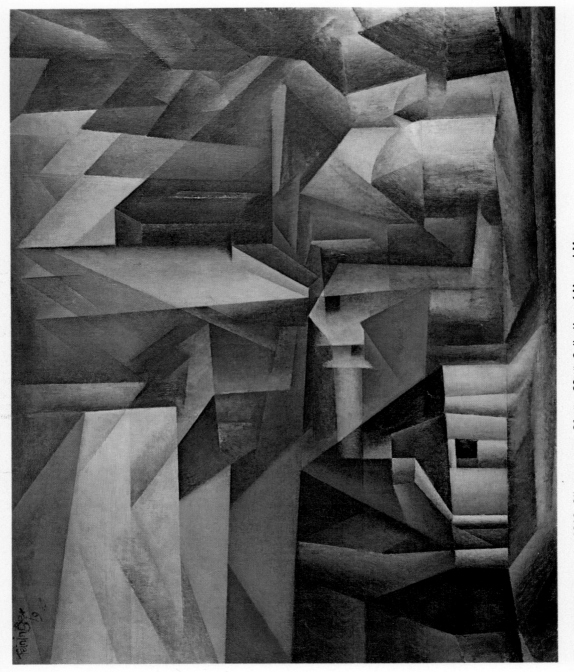

IV. *Village Neppermin.* 1919. Oil on canvas, 31½" x 39½". Collection of Mr. and Mrs.
T. Lux Feininger. Photograph courtesy of the Marlborough Gallery, New York.

complex, more elementary than those of others; I am not concerned with the ultimate judgment of the world. No such reflections enter my mind; I have no connections, and I don't seek any, with the world of the painters. With all the longing that my soul is capable of I want and try to hold the vision of my world.

All over the world one can find harmony between nature, architecture, and human beings; beauty is permitted to live, is felt, unconsciously perhaps at times, as a necessity. Only in Germany is there this disjunction: wherever beauty could have a chance, arrogance and snobbery or dullness pure and simple pervert its charm into a parody, not to speak of police regulations and restrictions. It hasn't always been so in this hapless country; but who can deny that it is so today? What good is the Werkbund show,* a product of diligence, industry, and drawing table? How long will it be until Germany regains her primeval spirituality?

_____

Sunday, June 14, 1914

. . . From early morning until 7 P.M. I have worked at the picture with infinite devotion—only to see it become drier, poorer with every brushstroke, absolutely no good at all. What a lesson! How little art does the clever brain alone accomplish. But I wouldn't have the courage to write about it now if I hadn't gotten into a rage, despair even, developed some sort of disgust against it an hour ago, and just simply slammed it together. Now it stands up, I shall get it, or possibly have gotten it already. Sometimes one can't help it, there has to be a sacrifice. Ordinarily I have an aversion to pegging away, but sometimes it is unavoidable. Lately I have been talking a lot; I've had a pretty big mouth. I am sure I wouldn't have been so voluble had I not been so utterly overstrained and exhausted. It is the dark side of the artist's temperament and probably a sign of impotence—either one is able to create, or one talks to oneself. Lately I have been talking to myself. . . .

_____

Saturday A.M. (not yet 9:30), July 16, 1916

. . . I have been working with inspiration, and in a very happy mood, as has not often happened for quite some time. The light in the room, the size and texture of the canvas, the subject, in short, all this combined

* The Deutscher Werkbund was organized in Germany in 1907 to raise standards of design and public taste. Its members included artists, architects, business men, educators, and critics.

made me very well content. A load is lifted from my mind, the brain is acting freely, and painting is a very great joy. . . . By the way there is a short ad in the *Tageblatt* today which reads thus: *Der Sturm* announces the opening of an art school on September 1st. Students will be trained until fully perfect in Expressionistic art! What a ghastly proposition; it gives one the shudders to think of the results of such art instruction. For the only way to keep Expressionism alive would seem to be to teach each single student to search within himself for the "expression." . . .

———————

July 31, 1916

. . . For days now I have been living in a sort of bliss. What eight years ago I felt in a naïve way but wasn't able to realize I have captured, and I can do something with it. I am through those last three or four years of difficulties. I have overcome that mountain of form problems and theories of construction at last—now I am no longer mastered by them but am able to make them serve me, to use them according to my needs. To follow one's own conviction and truth in whatever work one does—devotion is the presupposition; all else matters little. The work will stand the test if achieved with one's utmost intensity. At the moment I am feeling, working, and talking like one redeemed. I am full of self-confidence; I believe in my powers to find the expression of all I have to convey. You see from now on it won't be hard for me to be communicative, to take part in everyday life, to be more companionable; no more so often withdrawn within myself; a happier period for all of us will arise.

The weather is ideal for work, westerly winds, warm, gray. But what may it involve for you high up on that jagged star rock of yours? You are at least 1,500 to 1,800 feet higher than we here in the plain, and easily might poke through the clouds which, here, are still high above our heads. On one of our evening strolls we walked down the Königsweg to the second grade-crossing. The harvested fields, the rows of acacias and birches bordering this lovely road, a last glow in the west; in the east the delicate violet of approaching night, a clear sky—it reminded me of that evening in Graal, when you and I tried to view the world upside down, and only the laughter of Abeking, who met us just at the right moment, prevented us from standing on our heads. It is like yesterday to me, yet, on the other hand, as if it were a hundred years ago that we walked here together last spring. Everything is so precious in one's recollection, and all of a sudden one is struck by the realization of how happy one has been. The older I get the more I am

concerned with the problem of awareness and nostalgia. It seems obvious that the artist must strive to answer these questions for himself, for longing is the impulse and mainspring of creative achievement. Another consideration suddenly intrigued me: that children paint and create uninhibitedly until they are taught something. The young people of today do not work uninfluenced; most of them are following certain prototypes, making the most of what technical knowledge they have ingeniously acquired and may have adopted. Really unconcerned are, again, those few who have matured and fought their way through to a certain philosophy. . . .

Zehlendorf-Mitte
5:10 P.M., August 7, 1917

. . . I am sitting at your desk. At last I managed to get the preparations for my show into some sort of working order. I selected drawings and made a list of them with dates; I counted the available frames, and I even worked on a painting: *Zirchow II,* a delicate thing in gray tones, where, at the left, the blue-gray sky seemed somewhat empty, I have improved it. Together with a few others from the same period, they will be worth showing. Tomorrow I am going to work on another one. I shall take up one after the other, either to give a finishing touch or correct where it is needed. I am doing all this in a quiet and deliberate mood. Now I am really pleased. I won't start painting new things; it is not good to have too many irons in the fire. . . .

Zehlendorf-Mitte
August 8, 1917

. . . I had so much wanted to start a letter to you early in the morning and have it interweaving all through the day. It was not possible, and now in the evening I am very tired. I have been hard at work, painting, ordering, packing pictures, and after dinner I brought two paintings to Walden, besides the drawings which are to appear in the September issue of *Der Sturm.* Now at a quarter to seven I am back in the studio, and the light, still good, is stimulating for painting. I may get another old worry off my chest; it is the *Hollow Lane.* It will be a good picture once I have given it more precision and put accents into it.

In Berlin, last week, fruits and vegetables were on the market in great quantities, prices accordingly dropped, and immediately, of course,

nothing was to be seen any longer of all the abundance, all is held back. Damn it! This double dealing! On the one side a well-meaning but excessively stupid government which does not learn a thing from whatever experiences it has been through, on the other the black market and rapacity, which brings forth the "efficient" German merchant.

You are so very right; there is so much trimming in our lives that we have almost lost the capacity of getting close to nature. During these last three years of war I have, at times, been driven almost mad by the limitation of my freedom.* Not being permitted [to go] whenever and wherever I wanted, having to resign the inborn yearning for out-of-door life, a condition of utmost importance for me to work successfully; this combined with many other impediments has stunted my powers. Nonetheless one may call me names if I haven't at times, even under these obstacles, achieved some things. Then these last weeks in the mountains made evident my resilience, proved how easily I am restored as soon as my work is furthered by my own way of living, which involves this irrepressible desire to be left to myself at times, which you, poor child, had to suffer from lately. Yet, my darling, has it really been so very bad? I can hardly now remember that we were completely unhappy while I was with you all. Of course I suffered from seeing you so low, not being able to do what would have helped you. I cannot change in this respect. I get carried away by the generally unsuspected impetuosity of my nature. There is nothing I can do about it. I am tortured by my conscience at the thought of neglecting my dearest, but I am beyond improvement. I cannot resist the temptation to wander away.

Today Walden and I have decided upon the drawings for publication in *Der Sturm*—altogether five pictures: the *Trumpeters,* the pen-and-ink composition of *Markwippach,* the rather cubistic drawing of Klein-Schwabhausen, the *Street in Paris* drawings, and, as title page, either the *Mill* or one of the *Neppermin* motifs. . . .

Wednesday evening, August 11, 1917

. . . Just back from town where I had to buy paper for the mountings for the drawings and watercolors. I selected white, lemon yellow, and a grayish blue; some I shall put on black, and the very delicate drawing *Nieder-Grunstedt,* which I gave you last year for your birthday, will be on Japanese silver, with a narrow silver frame (of course, not for sale). Again I took two oils to Walden. He wants my portrait to appear on a postcard—I dread it and won't comply. For the one reason: I am

* Feininger as an American citizen was restricted in his movements during World War I.

Lyonel Feininger

"moulting," looking neither like the Prussian Lieutenant (whom I had in mind when trying to grow a mustache), nor like the painter Lyonel Feininger. But I have nothing against his intention of reproducing one or two of my paintings. I still have to finish the index of the catalogue. *Hollow Lane* pleases me immensely now. My days are chock-full of work, and for that reason only I write such poor and meager letters, not from negligence. I would love to tell more; often I am itching from the desire to talk—sheer communicativeness—but I simply don't manage. . . .

Zehlendorf-Mitte
August 14, 1917

. . . When I take up a painting these days I keep close to the original composition; I never try to make a new picture out of these old ones, I only strive to perfect them. The underlying discipline of former times wouldn't allow any changes—but brought them to completion as they had been intended; they will be of importance as samples from the period 1913–14. However, it also shows that, since then, I have covered some ground. To work on old canvases is very instructive and furnishes means of comparison. I realize how much less sentimental I have become in my work. Pictorial components now are conceived as pure form, whereas before I was more or less dependent on story-telling. My conception is clearer and more my own. There is more invention and abstraction now in my work besides the deeper feeling and psychic need to paint. Three years ago I was still concerned with picturesque qualities which now I have succeeded in overcoming. The earlier paintings did not have much spatial depth; I had modeled the surface only. Just let me get to entirely new works in September and you will see.

Vivid and lovely in my mind are the days we had together in Wildpark last year. Only I get the shudders when I remember that then we were in the midst of the war. I simply don't want to think of it, I have to look forward, I have to keep up hope and faith—or else I succumb. . . .

Zehlendorf-Mitte
August 15, 1917

. . . How sad is the tenor of your last letter. I shall feel better if I start writing now, in the morning, to keep in touch with you throughout the day. I thought I could detect in your letter at least this much of a

comfort—that you were not utterly miserable any more and annoyed about Braunlage. It is entirely up to you to decide how long you want to stay. But you shouldn't lose courage thinking of what you call our social "decline." There are reasons to expect exactly the opposite. It has only been due to my reluctance to appear in the open that there is no external sign of success. For the first time now I will come out before the public with a large number of paintings and drawings. The show will be exceptionally many-sided and interesting; also the publicity given me in the September number of *Der Sturm* will arouse attention in those circles where modern art is appreciated. It is hardly to be expected in these terrible times that the show will open a mine of wealth for us, but if I were lucky enough to have a sale or two it would change our social position and also our footing with your father. I didn't often mention it these last years but I am longing for the time which will bring independence for me. I always have tried to control my impatience, to accept his help without protest, since it is readily given, and as a matter of course, a feeling of obligation paralyzed me. All is on a grand scale with your father, and he never tried to interfere in questions of art. During these last ten years of work I have laid a foundation as unshakable as a rock; one cannot very well overlook me any more or take no notice of me. This gives me the hope of seeing your suffering come to an end. Too well I understand that I cannot go on like this. We Feiningers are an obstinate lot, pursuing the road marked out for us *bon gré, mal gré*. About my grandparents I know very little. My father's as well as my own first marriage was wrecked. A feeling of extreme compassion in sound egoists like my father and myself seems to me an indication of weakness, or immaturity. In my mind I go over the road of my development: a talented but strangely fragile child, muddled and neglected; the block I was as an adolescent, a complexity of passions and stress. And then, to think how I was able to evolve within these last ten years what under ordinary conditions would have taken a generation to achieve. At last the essence of my being has struck bottom, has reached a depth which gives a support to build on. The bane of my childhood, the conditions in my parental home—in spite of music—has for many years been a weight on my spirit. If I hadn't as a child lived those six or seven years in the country in the home of farmer friends where I was free to expand, and to follow my inclinations without so-called culture, I really can't determine what influenced my turning to art as a vocation. Anyhow, I was not influenced by any of my relatives. I know myself never to have been practical, but I am logically inclined, trying to discover the why and wherefore of things and happenings. Neither in my work at art nor in my life would I think of mentioning a blossom. I was too old to produce one worth speaking of. The fruit that ripened late was bitter. I had to work hard and with

Lyonel Feininger

determination to get that far, it wasn't just thrown into my lap. Yet there is a flower in my life, but that flower is you. The actual existence of myself commenced when we first met, the first day of laying eyes on each other. There had been a curse on me to be a hack, a beast of burden, and I would still be nothing else—a commercial worker at illustrated periodicals—without ever finding a way out, but for you! You recognized the spiritual potencies within me; you believed in, you trusted me. My art didn't grow freely within me, didn't have its roots in the virgin contemplations and perceptions of youth, but had to fight to free itself from the well-trained routine I had acquired as an illustrator. I would never have got to creative work but for you, who gave me heart and soul. I am not like the others. I am a marked being with my frustrations, my unavailing attempts at revealing my deepest and most precious emotions. This is one of the reasons of making your life with me a torture at times. Your believing in me must suffice to make you happy, you poor child. Art simply devours my entire existence. You can't help noticing for yourself that there is a dismal, poignant quality in my endeavors, you know with what anguish I am at work, how tormented I am at times. This is the burden we have to carry together. . . .

Zehlendorf-Mitte
Early morning, August 22, 1917

. . . Why do we write so much about the weather? Is it because it is a compelling influence on our nerves and mood, conducive to relaxation, to forgetting the world, that is to say, temporal happenings? For the moment one gives in to laziness and passivity, and also resignation and sentimentality, all that which is unconsciously probably restful for the moment yet hardly reconcilable with spiritual activity and resolute planning—ah well! . . . All my 60 or more drawings are matted now. For the first time in days I am sitting at a nicely cleaned table, in an orderly room. It is important for me. I am always unhappy in disorder.

From [Adolf] Knoblauch I had one of his good and stimulating letters; he also sent me a copy of his new poem, "Die Ruhe," which, I think, is a strong piece of work. He hopes for a furlough in October which would be well deserved. He would like to start something for the Insel Verlag [publishing firm]. What an energy! To be up to one's neck in perdition and yet have the strength to spare for spiritual work. Maybe, though, it would be the same with me; one has simply to do it for the sake of self-preservation. . . .

Zehlendorf-Mitte
Evening, August 23, 1917

. . . It has been a day of hard work but now at the end I can say, a good one. This morning I was very depressed and in a state of uncertainty, the prey of sad thoughts. This is nothing new to me after I have been at Walden's; it always knocks me over. In the midst of such beautiful and outstanding works of art I become too conscious of being entirely out of contact with the art of others; I feel my inferiority, that I am on a side track. But after a while I pick up courage and fight it out myself. There were there, besides myself, the Waldens, Bauer, both the Schrimfs, Mrs. Knoblauch, and a rather pretty young lady whose name I have promptly forgotten. The Waldens really are doing a lot of good for their young artists. We had tea in the marvelous Chagall room. For an hour we talked about travel, food and food prices, and all the misery of war—until I had enough of it. I asked Walden: What of art? When will there be price control for works of art? That made them laugh, and we predicted that from that moment on all pictures, etc., would disappear from the market—and some more of such witticisms. . . . I had a talk with Walden on a few subjects in relation to the show, but definitely tomorrow we shall make the selection of pictures to be photographed for the picture postcards and talk over last questions concerning the manuscript.* Walden said that he would require a drawing in order to have me represented in his graphic collection. Whether or not he will buy an oil will be decided when the show is hung.

Today you write what I also have been thinking, that I am surrendering my pictures, casting them adrift, and it is as if never again I could look upon them as belonging to us. And yet it was high time to get them out of the studio; they have often given me almost intolerable pain; there is hardly one which I can think of with real pleasure. Up to the last I have always been troubled (and still am) as to whether or not to leave them as they are, until I am simply at the end of endurance. And you know to what a degree they block my way to get to new work. So your letter today arrived at just the right moment to cheer me. I have read it in the train, for again I had to take pictures to Walden. When back in the studio I felt ever so much better, no longer oppressed and cast down. Getting in motion does one good anyhow—but the "moral" help came from you. . . .

---

* The exchange of open letters between Feininger and Knoblauch in the September, 1917, issue of *Der Sturm*. See pp. 28–33.

Lyonel Feininger

. . . It was lucky that I came rushing in over half an hour earlier than usual, to get dressed for the Sturm party—or we would have missed each other at the telephone. I could hear and understand very well. Again it was a nice evening at the Waldens, a small circle: Blumner, the poet Ring (in his field uniform), two elderly painters, Schnebel, and the inevitable Bauer. Walden played two of his own compositions for piano. I can't divulge details now. It is all dynamics and sensual appeal to the nerves, delivered with great power and passion; dissonances to call one back from oblivion, the shrieking of a sawmill in full go, Expressionism at its peak, oriental in sound and rhythm, a sword dance, razor blades, ecstasy, and cruelty of the tiger, and what distortions in agony. I was constantly in fear of Walden's having a stroke.

Tomorrow I have to be at the gallery early to attend to the framing of drawings and oils. A man from Heidkamp will be coming to help. Three loads of pictures have to be taken to town. Blumner said to me yesterday that my paintings have already caused a sensation. Well, I am looking at the walls of my almost empty studio and feel a great relief at the thought of being rid of the pictures. As long as I had them around they kept my thoughts in fetters and didn't leave me free for new works. It occurs to me that now, for a change, *they* can work *for* me; they are getting around in the world; they make my name known and will be the carriers of my reputation among the public in the art world. Tomorrow when you get this letter the show will have opened. . . .

---

Zehlendorf-Mitte
Midnight, Sunday, September 1, 1917

. . . This morning and tonight a letter from you! I see you also are living with all your thoughts whirling around the show—which will be the turning point in our lives. It starts promisingly. Walden bought the *Marine* last evening when we were hanging the show; the label marked "sold" is already affixed. The day was a regular junket. At 9 A.M. I was already at the gallery with my load of three paintings, and punctually the man from Heidkamp arrived to put into frames the more than 60 drawings. This good fellow really did his best; he worked from morning till after 11 at night with hardly an interruption. Then we took the night train home together. I myself put 40 oils into frames. A good many of the stretchers had been keyed too far apart. I had to unmount

7 canvases in order to make them fit the frames, a tiring task in itself, in addition to which, it had to be done in the narrow space of the cellar in bad light. Yet I didn't mind. I even enjoyed it, it was all so jolly. I went home for dinner and in the P.M. to town again carrying the—now really—last load of paintings. At 5, Walden started taking down the Kluxen collection, with the help of Bauer, Blumner, and two of the young girl secretaries. This created quite a commotion—down into the cellar, up with as many of my paintings as they could carry. I myself in the meantime, merrily hammering on, fell to my sandwiches at 6 (we are having five meatless days a week now), and toward 7 I had so far finished with the framing that I could go upstairs into the gallery. All the paintings were placed along the walls on the floor, and then Walden commenced the grouping. . . . Soon the first of the walls was arranged, and it was excellent right from the beginning. Five pictures, in the center the *Marine,* all of them frame close to frame, correlative in superb rhythm, were hung in the following order: beginning at the left *Zirchow II,* then *Am Palais* [*At the Palace*] (vertical); at the right end, *Bathers I.* The total effect of the paintings was richly glowing in deepest color, most impressive. Walden with an unerring instinct arranged the other walls in accord with the same principle. Thus, with the work going on he grew quite excited, became more and more enthusiastic, humming and singing, giving commands, running hither and thither to select a painting or discard another, and all the time expressing his delight in words not to be misunderstood. All the participants were as happy as children at play. The very long wall in the back gallery is especially effective. There are nine paintings, all framed in black, placed as in the front room without interspacing. Here the center is emphasized by three verticals, the largest *The Barns* in the middle, to its left the *Beacon,* at right the *Hollow Lane.* Those three are the most dusky of my canvases, and what there is of somber glow in them creates the most mysterious effect. Adjoining, to the left and right, are horizontals, and each end again is accented by a vertical—at the far right the *Trumpeters* (which had to be got from Cassirer), and at the left the *Church of Gelmeroda* with the yellow sky and the fir tree. This wall is absolutely exciting in its organization. Walden is dead sure that with this show I would come through at once; he himself told me so this evening. I can't repeat half of what he said, but he thinks I am good. And now about the drawings. In the entrance room are 7 or 8 vertical columns of framed watercolors and drawings—always 4, one above the other—forming a large square. They are disposed according to colors, technique, and frame. They are given support by a painting at right and left, all of it blending together in a most unusual way, comparable to mounted butterfly wings in a case. This describes one wall only; the graphics on other walls are arranged in a similar way. You will be

Lyonel Feininger

astonished at the effect Walden has produced with the material of my work at his disposal. Mrs. Walden was also busy among us; she had made tea and served it to us with cookies; all was so jolly, and we were all so stimulated. They really have done nobly, the show promises well.

With this I have, at least, given you a preliminary report; I shall try and get some sleep now, though I am rather excited and very happy. I am hoping for the best. All our expenses covered by the sale, and I can make the trip to you. So I shall not send the empty suitcase but bring it when I come. Now good night and God bless you. . . .

In the studio
Early Sunday morning, September 2, 1917

. . . A sparkling morning, warm sun and a cool wind, the sky a lovely blue, in the east a straight line of luminous windblown clouds, brighter than the sky, the house roofs all in a glitter. On the blue cloth of my table a square of sunlight—and it is "my" day which commences so lovely. If we could only be together!

There is free space in the studio at last. Yesterday already I had cleaned up nicely; nothing remains of the disorder of the last weeks. The feeling for order becomes more and more imperative with me. Is it to be wondered at? There is great order in the universe. With the capability of realizing this, man yet permits his energies to be frustrated until he manages to get control over disorder, at least up to a certain point.

I am glad for your father that this day will, in a way, compensate him for all the sacrifices which he made for me uncomplainingly and with so much affection. He will be pleased when he sees the results of my labors so well presented, and a public taking notice of it. The sale already, as Helen told me over the phone, gave him much pleasure. After dinner: I have sneaked off into the studio. I have to give you a first account if in an ever so sketchy way of all I have learned from Hedda about the opening. Only tomorrow, after having seen and talked to Walden, can I let you have the real news. When I came in for dinner I was met at the door by your father beaming at me: "Now, my boy, you may well laugh." These words nicely illustrated his feelings. The decorous and obviously very interested public milling around, the numbers of works on the walls made a big impression on him. Hedda brought me greetings from Walden, who wants me to know that Professor D. has a very high opinion of my work. Hedda herself was enthusiastic. Among other things she told me that everybody was full of curiosity to have a look at the *Self-Portrait*. Approaching the corner where it is hung they

were met with these glowering features. This gave me pleasure, though as a rule I do not incline toward malice. But it would make me laugh if I were to be confronted by a beautiful idealized self-portrait of the artist. Which of the two is preferable? I think, self-ironizing by far, the incognito to protect oneself against mass curiosity, as was the custom 200 years ago when Europe still had a fine culture. . . .

## The Bauhaus Years in Weimar (May 19, 1919–March 17, 1926)

*In 1918, Feininger met the architect Walter Gropius. Both were members of the Novembergruppe, an association of artists, architects, composers, and writers who believed in the necessity of a major social and spiritual change. The association wanted to unify the arts, reorganize art education, and clarify the relationship of art to the state.*

*In April, 1919, the Bauhaus was founded in Weimar with Walter Gropius as director. For the next fourteen years the existence of the school "was threatened by a shortage of funds, hostile [government] officials, and internal feuds. . . . The school set out, in a resurgence of optimism and idealism after the first World War, to train a generation of architects and designers to accept and anticipate the demands of the twentieth century . . . to create an environment that would satisfy man's spiritual as well as his material needs.*

*". . . Gropius enlisted the help of* avant-garde *artists such as Feininger, Klee, Kandinsky, and Moholy-Nagy; it was their function to create and stimulate the creative process; and their attitudes to shape, color, space, and form had a profound influence on the work of the Bauhaus."\**

Weimar, Elephant Hotel
May 19, 1919

How shall I begin? Is it possible to experience so much in twelve short hours? It seems like weeks to me. The most beautiful of all is my studio—in the top story of the building facing west-northwest, a huge window almost the whole width of the room, and a skylight with curtains as big as a giant mainsail of a full-rigged ship, adjustable in every

\* Gillian Naylor, *The Bauhaus* (London: Studio Vista, 1968. New York: E. P. Dutton, 1968), p. 7.

direction to regulate the light. And the view! Over the gardens, over the roofs of the town out to the Ettersberg, just beautiful. Besides there is an anteroom three to four times as big as my hole in Zehlendorf, which in itself would be a wonderful studio. I tell you here I will be happy. This space I shall fill with my works. Dear good Gropius allotted this place to me right away. I have been all over the school with him; I have also seen the printing shop—marvelous; from now on we shall be in a painter's heaven. In Secretary Kammer's room we met [Richard] Engelmann and, later, Director [Bernhard] Köhler. Students saw us; they will, by now, know who we are but they will have to get accustomed to us. Between you and me, it seems as if they had been living in a Sleeping Beauty's tower up to now as far as art is concerned. And yet the reactionaries are getting busy. A pamphlet, "Bolsheviks in Art," has been published by politicians in the Landtag [the provincial assembly]. Gropius is mad, ready to burst. We had a pleasant trip. We arrived at noon. Tonight I shall sleep well, I am very tired but in high spirits. If you could see the studio, you would be happy with me. It is absolutely palatial. God bless you, little one. . . .

---

10 A.M., Wednesday, May 21, 1919

. . . Mrs. Gropius* sent a message asking me to have tea with them. From then on I was swamped. Besides both the Gropiuses, Köhler, director of the museum, was there. We had very important talks about the intrigue of our opponents, which is beginning already, how best to counteract it, and how to deal with them in what seems to be a wasp's nest of a little town. I had wanted to write to you and I felt as if I were sitting on hot coals. This morning I got up at 7, and later sneaked away from the Bauhaus in the early afternoon, hoping to escape the threat of habitual usurpation by our director's lady. She is a very intelligent, vivacious and spoiled cosmopolitan who won't be able to endure Weimar for a length of time, it seems to me. Even without this I am constantly rushed. What a frenzied sort of life I am leading. You'd hardly imagine that with such teachers as Klemm and Engelmann† there is already an "Expressionistic Genius" infecting Weimar. Compared to *his* fly-leaf and wallpaper patterns, my work appears as that of an old reactionary, not to say obsolete academician.

The other day I made the acquaintance of several writers, etc., in the café—so far I seem to be the queer fish here. But if more of such

---

* At this time, Gropius was married to Alma Mahler, his first wife.
† Walther Klemm and Richard Engelmann were conservative teachers whom Gropius had been obliged to carry over from the Weimar Academy of Art.

wild stuff should turn up when we know more of the student's work, I can feel at ease. Nobody need worry about the possibility of my influence corrupting youth and endangering their artistic development. I think it would be important to have the show of my works here as soon as possible. It would clear the air. We should not wait until January but put it on right after Dresden, then Frankfurt and Hanover later.

As I wrote you I have seen a house which we could possibly rent. It is very difficult to get apartments. There are dozens if not hundreds of people who have been on the waiting lists for months. I have been told about another one in Belvedere Allee. How much better if we could be searching together, if you could manage to come here before the return of the damned National Assembly.* These people have done incredible damage to Weimar, besides corrupting the whole neighborhood. In all the villages around they have—among other things—bought up eggs by the hundred thousands and shipped them to Berlin. No peasant now will sell an egg for less than 1.20 to 1.40 German marks apiece, and the same inflation holds for meat, etc. I have this from the headwaiter at the Elephant, who told me so today, complaining bitterly about the situation. Life is terribly expensive here. I am horrified at what I have to spend for the little food I need. At present the hotel is almost empty and will be until the damned National Assembly turns up again. I can get permission for you to enter Weimar the moment you send a telegram that you will come. I can hardly wait for the time when we'll all be together here, leading an orderly existence. Your letters mean happiness to me. Be cheerful and keep up courage. . . .

———————

Weimar Art School
6 P.M., May 21, 1919

. . . Again I have been on an apartment hunt; no success so far. Whatever is empty has been seized, but I have an address in Oberweimar which I shall inspect.

There is no end of intrigue and chicanery here. It is perfectly grotesque how the "old ones" and the people from the Kunstverein [Art Union] plot to do dirt to Gropius in order to drive him out already. Now, I, all of a sudden, am the scapegoat—it has transpired that I am supposed to be a Cubist. I have been asked to pay visits to the Thedy, Frohlich, Rasch trio, who seem to resent that I haven't yet been to see them. I shall try my best to make a good impression. Klemm and Engelmann are nice and friendly, only too timid and easily alarmed. I am sure they mean well.

* In 1919, Weimar was the seat of the Republican National Constitutional Assembly.

Lyonel Feininger

Monday evening in the Kaiser Café there was the whole group [of people against Gropius], I obviously figuring as Gropius's lion tamer. I am to use my influence to make him do this or that. Gracious! With all my heart I long to do something other than constantly being committed to playing a part in this camarilla. Oh, my dear little girl, it would be so good to have you near me. You could talk to the people ever so much better than I, who am so absolutely unsuspicious and guileless. But I shall try hard to keep some sort of association, for with me they are all friendly. I might be of help in mediation. Gropius wants to publish some of the reviews I have had lately in connection with my shows, to let the public have some information about me. Could you, please, collect what you can find and send it here immediately? It could all be so good, and I am quite confident that it will be so. The public just has to get to know us and me in order to find out for themselves that I am no revolutionary out to corrupt their youngsters. The students I have seen up to now look very self-conscious. Almost all have been in the war. It is a new type, a new generation. They are not as timid and harmless as the old professors here imagine them to be. As I see it, I think they are after something new, a new way of expressing themselves in art.

It is a lovely day, bright sun with an easterly wind. A report about economic conditions—all sorts of vegetables, even lemons are on the market. The bread is very good, and one can buy the most wonderful cake—but my, it is expensive! I was at the tailor's. A suit costs 600 to 800 German marks. In case you should come, you must bring at least 1000. I haven't touched my salary yet. God bless you, darling. Love to the boys. . . .

Weimar Art School
May 22, 1919

. . . It may be that our housing problem is solved. I have seen (though from the outside only) the place at the Belvedere Allee in Oberweimar. A lovely situation, in a garden, sun from all sides, seems big enough for us. I would think at least six to eight rooms. As soon as the owner is back from his travels I shall examine the house closely and, if possible, come to terms with him. The house would be free for us to move into immediately.

I have paid my inaugural visit to old Professor [Max] Thedy. He was very nice, talked about Gropius and his radical way of proceeding. He said something like this: that the program was good, only too Utopian, Gropius too aggressive; that it would suffice if he were just the nominal director and were to appoint as teachers people like me(!!), etc;

that this would have an unavoidable effect, etc., etc.—the innocent mummy! The students, he said, were completely out of control. Since the war every bit of discipline has disappeared. "There are even hotheads among them who follow the new expressionistic trends." Obviously the old gentlemen here lack the capacity to deal with this. So the staff of teachers has to be renewed (very simple). But for something new to come about as a necessity in the evolution of art—to build it up, not just paste on the surface of it, takes patience and time. If only more people were conscious of this. I cannot very well judge Gropius's deeper relationship to the spiritual meaning of art in our time as we understand it. Sometimes I find myself wondering whether he would not willingly subjugate plastic art to make it serve architecture, and then would agree to the fantastic and decorative side of it only.

I have my first student, a young girl from Munich, a painter. She has seen my show at Goltz. . . .

Weimar Art School
6 P.M., May 23, 1919

. . . So much has to be attended to in a day, so much to be talked over with Gropius, the works of the students to be inspected—by the way, I have another pupil. At my studio door now my name testifies to my presence. When I got in this morning, there were about a dozen young people goggling at my card. Funny conditions prevail. The school is crowded with male and female students who are all doing more or less as they please. An undercurrent of individualism is strongly evident. The intrigue against Gropius is becoming very pointed and naturally also against myself. The city government is thrown into a ferment. It would almost seem as if they were willing to make an end of us by refusing us subsidies. This evening there will be a meeting of our antagonists, and they have announced a fight at daggers drawn. These now are the "protectors of the Fatherland," the Pan-Germans! And although our affair concerns art only, they are dragging party politics into it. The mere fact of having changed the name of the art school to "Bauhaus" has been enough to enrage them. The guilds are also afraid of us, of impending rivalry in their field of crafts, and are moving in closed ranks against Gropius. The director of the museum in Erfurt, on the other hand, is on the side of Gropius and myself. He is expected to talk this evening at the meeting, to tell them some things plainly, and stand up for *Sturm* expressionism in his speech.

Yesterday in the Kaiser Café we couldn't help overhearing the con-

Lyonel Feininger

versation of three young students at a neighboring table. They talked about painting, about the recent exhibitions, about Kandinsky, and finally one of them said, "and this man Feininger who is supposed to come here." Obviously they didn't know me or my work, but seemed to have heard people talk about me in a nice way. They were wondering whether I wouldn't be more of an adviser, to be consulted in case of need, instead of a teacher in the old-fashioned way. How often it now strikes me that these youngsters are babies no longer, that they do not accept without scrutinizing mercilessly. Expressionism for them is the conception of their own generation, and their longing. Also they said, and this I thought rather good, that what counts in art nowadays is not so much the how but the prompting spirit and absorption. Of course, they also talked of Gropius, but he seems to be still a puzzle to them. Finally they sized him up as a man of "universal talents" with a capacity for organization. Now, what should one think of such youngsters? This afternoon I started to paint. I have no furniture yet but hope to get a table soon. For the present, it is more like housing in the desert, in the midst of the vastness of the Sahara, in an oasis represented by my easel, two boxes, a decrepit chair, and a solid ashtray. . . .

<hr>

In the studio
Noon, Sunday, May 25, 1919

Yesterday I had a bad day, a sudden cold. Today all has disappeared as if by magic. I can smell and I am smoking again, no more blowing, etc. After dinner, I lay down for a little while and at 4 I was called down to the lobby. There I met Dr. [Edwin] Redslob, the director of the Erfurt Museum. He is a charming, very blond young man with a funny salient upper lip in a waggish face. We had a good talk for quite some time. He has been in Berlin, where he saw my show. He is a convinced advocate of the new trends in art. In his museum he has woodcuts of mine, among others *Gelmeroda III* and *VII*. Weimar is his home town; he was brought up here. I was very much pleased when he told me that my rendering of the Gelmeroda church had struck him as being the perfect realization of his own earliest vision of this amazing building.

Yesterday I got Andreas's letter and also the newspaper clippings, which Gropius pounced upon. Early in June there will be a party in honor of Gropius. He wants me to put up a collection of my drawings and graphic works in the big skylight hall in the school building where a concert will be given on the occasion of the festivity. This as a prelude, then later in October, the paintings will be shown.

P.M. This Sunday afternoon I am all alone in the building. I had asked the janitor to let me have the keys, for he also went for a walk in the lovely weather. I am working at *Neppermin,* happy beyond words in the wonderful studio, and the heavenly peace and stillness around me today. On Monday registration of new students will commence, also a *Meisterrats* [staff] meeting is scheduled. . . .

I had a request to send in two paintings from Dresden, from the Secession Group of 1919. I think an old one and one of the newest would be good. A letter from Segall made me see the importance of joining the group. I've seen reproductions of Segall's paintings and I was quite struck by them. Now I want you to do something for me. Please, my dear, put *Zottelstedt* into the frame of *Nieder-Grunstedt* and have the bulky gold frame fitted around the *Green Bridge.* It is pretty urgent, for they have to get their catalogue ready. *Green Bridge,* 2,000 German marks, *Zottelstedt* 3,500 German marks. It is of importance to show my work in Saxony now. They know absolutely nothing about me, but if they get to see some of my paintings and hear that museums are fighting for my works—which obviously made a great impression, Gropius told me—it will be of help to all of us. Gropius also said that things are shaping up and that difficulties are diminishing. The people have been dumbfounded by the vastness of his program; also his aggressive attitude and Prussian personality may have gone against their grain, as the good man now admits. . . .

In the studio
Early Monday, May 28, 1919

I am writing in a hurry with regard to the drawings I asked you to send. I have just seen Director Köhler in the [Weimar] museum and we have talked over and agreed to have a preliminary show of my graphic works at the beginning of June. The students seem to be scared stiff. It is extremely funny to be looked upon as an ogre, ready to pounce upon the youngsters. Goodness, if they only realize what a gentle creature I am *au fond*. As a whole, the *Künstlerkammer* [members of the board] did not appear to be aggressive, but rather in doubt, when at a meeting on Friday they discussed not only Gropius (who, by some, is called "Grobian") but also my poor self. Engelmann and Köhler, as well as Redslob, are said to have given excellent speeches on our behalf. Much curiosity is aroused. It is time to let them see things. So please select very good works. Take them out of the frames—watercolors, pen-and-ink drawings, and charcoal compositions. About the

Lyonel Feininger

woodcuts I have written before. They and the etchings are to be included. Send it all as soon as possible, please.

Gropius is away for a few days. Thank God there will be no *Meisterrats* meeting. . . .

---

Early Friday, May 30, 1919

Yesterday I couldn't write. I was rather nervous due perhaps to the uncertainty regarding our housing problems. I did not want to depress you. If what they say is true, that the damned National Assembly is not to return here, conditions would change for the better at once. All around Weimar the villages are stuffed full of soldiers who eat up whatever there is to be had. If the entire military occupation could be withdrawn, the confiscation of houses that has gone on for months would stop at once. It would be a blessing for all of us if this piece of news really were true.

Yesterday at a big tea party at the Klemm's, the entire Weimar intelligentsia was assembled, actresses, opera singers, writers, etc., and also, of course, our director and his lady. I don't want to be very explicit on this theme now, but I think a lot about it. These two in this small-town atmosphere. In him and in her one has two completely free, sincere, exceptionally broadminded human beings who don't acknowledge evasion—characteristics of great rarity in this country. Naturally people react against them and regard them as exceedingly obtrusive. The relationship between them and myself has always been perfect. They have never interfered, and they have left me to make my own decisions. But I am sure that I couldn't stand it any other way. You know me to be no less fanatical than Gropius, but he values crafts and the technical aspect. I am concerned with the spiritual side of art—at least at the present—more than he is. But he will never ask me to make concessions, and I, for my part, want to help him and give him all the support in my power. He is a man loyal and frank, full of idealism, and without any selfishness. His creativity, in the sense that we understand it, doesn't count as much as his personality as an outspoken human being, and she is in a class all by herself. They are both very wonderful to me.

I do the best I can to find again my own singleness of purpose, but it is a Herculean task. To think of all the letters I have to write and to answer. I manage to get to painting a few hours a day, but—oh my God! it should be much more. . . .

---

. . . I spend the forenoon at my desk. I have to answer five or six letters every day, overtures from galleries, even commercial correspondence, etc. That is why you and the boys are neglected.

We have had our first *Meisterrats* meeting. I was received and admitted with ceremony, and then for more than two hours we discussed internal affairs, among them some ticklish programmatic questions. On the whole it was very *gemütlich*. I had expected something more senatorial, with robe and ruffles—a council of the masters sounds so grand. Well, a lovely afternoon melted away. I would have much preferred to spend it in Gelmeroda.

Sunday all the masters are invited for tea at Mrs. Gropius's. She is to leave Weimar the day after and not to return until October. Good Gropius then may perhaps have a quieter time. He is harassed almost to death. I think that he has not had a restful minute since we have been here. Yet it would almost seem as if this sort of life suits him, to be in contact with people constantly, to be important in the weaving of destinies. But it keeps him from doing work of his own.

They have reinstalled old Wieland on his pedestal in the Wieland Platz. Last year they took him down to have him melted into shell cases, but fortunately it didn't come to that. Now all the Weimarians are happy to have him back. The empty platform had a rather melancholy effect upon them.

My new student has one leg only. So I now have a deaf-mute and a one-legged student. (No comment.) But I am greeted in a more friendly way every day. I have to stop. I want to paint for a short while before going to dinner, on *Neppermin,* which is slowly growing into a unit.

[June 2, 1919]

. . . The afternoon is very hot, a strong east wind puffing out the curtains of my windows. By clever handling I have adjusted them so that the light I get from above is concentrated on the easel and the painting. The picture needs merciless treatment before it will stand up. In a half hour I have to go to Mrs. Gropius's, though the party has been called off, since Itten* arrived from Vienna today. I am curious to meet him. It seems as though he has made up his mind to join the staff here. That would relieve me, the only one who conducts classes. I had hardly

* Johannes Itten taught the preliminary course at the Bauhaus from 1919 until 1923. He was succeeded by László Moholy-Nagy.

written the sentence above when there was a knock on my door and Gropius came to see me to introduce Itten, who made a good impression on me and seems to be clever. They are now looking around the building and at 5 we shall meet at the hotel.  . . .

June 5, 1919

. . . My *Neppermin* slowly approaches completion. I think it is well painted. However, I have nothing to compare it to, but I believe that it will really be good. Yesterday Klemm and I printed some of my etchings. Of course, I left all my new plates somewhere in Zehlendorf, but it doesn't matter much. Of *Tetlow* we got some good prints. Gropius is very attached to me. We eat dinner together in the Elephant. He often visits me in the studio to tell me of happenings. He asks my advice, or rather my *opinion,* on matters which need consideration, for he really does not need advice (and probably wouldn't follow it). Mr. Leutert is wonderfully attentive. In my room the other day I found on a silver platter a half-pound of butter surrounded by twelve absolutely gigantic eggs, a rare sight nowadays. Everybody is very good to me. . . .

June 20, 1919

. . . At the moment all of us here in Weimar are living in anguish and in a state of horror-laden expectation. It is almost impossible not to succumb to its influence. Many alarming questions are cropping up, and even the future of the school seems in jeopardy. Nothing is definite yet, for all depends on whether or not the peace treaty will be ratified. In either case, the consequences are unpredictable. Disturbances, even riots, must be expected. The communists intend to isolate Weimar; we have had no communication with Jena for days. Erfurt is a hotbed for all sorts of putsches. Nobody knows how long the railroads will function. Perhaps it won't last long or be dangerous, but one has to be prepared for weeks of trouble. Here everybody is convinced that the treaty will not be signed. Then what? Personally I do not believe one tenth of all that people here make the Allies responsible for. I foresee trouble through German discord, German blundering, Germans hating brother Germans.

Late afternoon: just got your letter of yesterday morning. It did me good, for you appeared a little more cheerful (in all your trouble).

Too easily we distinguish the sad note only in reports of the other's misery, forgetting that light will break through all darkness before long. This morning there was talk that the treaty was not to be signed, and in the meantime the cabinet has resigned. Those who were against signing left. The others remained. In case they manage to form a new cabinet, there is great probability that the treaty will be signed after all.

———————

June 22, 1919

. . . At 4 P.M. the *Meisterrat* assembled to examine the show of students' works, to decide on federal stipends, awards, etc. It was for the first time that I saw an assemblage of student works. In the beginning I had great trouble in adjusting myself. Some works simply dumbfounded me and made me feel quite humble at my inadequacy. I felt like a loiterer left behind on the wayside. But, there was also a confusing mass of industrious studies without any signs of talent. But after a while I was able to discern more clearly. Gropius had told me privately that he intended to deal harshly and attack certain elements uncompromisingly—and so he did. I have to admit that he was perfectly right. He has very precise judgment, and what a man like myself might have cherished out of tradition, he is apt to overthrow. This seems hard, but it clears the road and is stimulating. That is what we are here for, to fight sterility in the arts. The Thedy class fared the worst. They showed nothing but works of the driest academic character. Thedy was beside himself, uncomprehending, and it was quite pathetic when he claimed the vote to be unjust. At good works of other classes he shook his head and declared them execrable.

Perusing your letter I saw the passage: "the National Gallery has acquired *Vollersroda III*." I couldn't help it. I blurted out this piece of news, and it acted like a bombshell. Then I was quite ashamed of myself, for truly it is not glory which I see in this success, rather a piece of good luck, a price paid in advance for work to come in the future which I have to guarantee to do. And I ask myself whether my capacities will allow me to take upon myself a pledge of that magnitude. I have only my longing, my desire for the realization of my visions—and intensity while at work. I know myself to be less talented than most of the students here at the Bauhaus. For me it is a struggle for life and death. When I am working on a picture, the energies I have to employ are very different from those the out-and-out painter can make use of. I lack the quality of being "picturesque" in the accepted sense. For me only totality counts, and the painting is but a component of a larger entity. On my easel I have a perfect beast of a picture. I had to give it

Lyonel Feininger

the works. It was so deceptive and captivating, so infamously insipid and full of "delightful" details. I pounced upon it with the savagery of a panther, mercilessly enforcing law and order, and now I will get it. . . .

———————

<div align="right">

Bauhaus
8 A.M., June 27, 1919
</div>

. . . I could not write a line to you for two days. One of the reasons: too much work with putting up the show and then interruptions always at the most critical moments. But now the things are on the walls, and the whole looks quite presentable. For three days, from 8 A.M. to 9 P.M. I was busy. First with taking prints and photographs out of big frames that decorate the walls of the corridors of the building. Then preparing backgrounds for my works to suit me: I had not only to cut yards and yards of paper, but often also to glue together several sheets, which was not at all amusing and very taxing. After having selected from among several hundred sketches, drawings, watercolors, and small wood-block prints, I had to group the different items on the sheets and put these into the frames, finally nail the backs tight, and all this without anybody to help me. Of course, by far the most difficult task has been sorting out suitable material from my thousands of sketches, and deciding upon the right combination. Into ten big frames I have placed sketches after nature from Quiberville and Paris, of 1906 to 1909—works carefully observed, some of them meticulously executed, some more impressionistic —and from Heringsdorf and the Baltic, more colorful and decorative items. The latest (about 1913 to 1917) show the freedom with which I finally went to work, and some from Braunlage indicate a more or less cubistic solution. Thus, I think that I have shown formal as well as sentimental (romantic) observations. The main idea is to show that I work with utmost economy, with the simplest of means in these recordings. Obviously it was a good plan. The necessity of the way makes itself evident. The students can see clearly how without working in a classroom one is also able to study, how I have gone to work to maintain the tension between nature and the work of art. To round out the impact I also showed about 20 good photos of oil paintings. For the hanging I had the most willing and enthusiastic assistance of three young men, two of them my students. When Gropius came to see the show, he was quite delighted. Impulsively he pressed my hand with great feeling.

Our housing problem may not be solved before October. At the moment Weimar is empty. You will easily get a room in the Elephant Hotel. The National Assembly has scattered in all directions, Scheide-

mann* had to flee, for the soldiers were after his head. He managed to escape by automobile to Ossmanstedt. . . .

These days the Bauhaus resembles a madhouse. There is a flaring or brooding rebellion all around. The reason? The prize awards. In the heat of passion a good many of the students expressed their indignation by simply quitting, but there is a dark camarilla that intends to apply to the government, demanding nothing less than Gropius's dismissal right away. So yesterday evening Gropius called in the rebels to talk things over with them, and he listened to everybody's complaints. That eased their minds and helped to clear the situation. These youngsters are, on a small scale, what Germany is in the aggregate: easily upset, full of resentment, insecure in judgment, or else ready to believe every tale of horror. What made the students most irate was that Gropius had said that he would always defend the most extreme in art as a manifestation of the times we live in. I, for my part, think that Gropius is wrong in this respect. One cannot demand that 150 young people in a school produce, at the outset, extreme art. That would rob them of the possibility of normal development (which requires years of growth) and push them into mere imitation of certain leaders of extreme art. I am going to talk to Gropius about this. Truly these days are full of "inner" and "outer" history.

June 28, 1919

. . . The peace treaty will be signed today. Though I doubt human justice, I believe in a logical one, and this, I am afraid, points in the direction of future wars and misery for mankind, and no end to it. . . .

I wish you could see my little show. I got the best possible effect by placing bigger ones among frames containing smaller works. For example, together with charcoal compositions, I put one or two water-colors and a pen drawing and so on, a variety of combinations which makes it very jolly. The frames containing sketches after nature are especially instructive. Talking with the students, I was pleased to notice that they agree with me, that is, with my claim that works of art ought to have the study of nature as a foundation to build on. Though this by no means has to be confined to the drudgery of drawing after plaster casts in the classroom. They were all aroused by my way of proceeding, stressing the importance of constant observation with eager eyes and an open mind.

* Philipp Scheidemann was the first Prime Minister of the Weimar Republic.

Lyonel Feininger

. . . I am so pleased that you got my letters early in the day and that so far this fatal railway strike has not cut off our communications. From tomorrow on, Weimar will be overcrowded once more. The damned National Assembly has assaulted the place already in overwhelming masses and will keep on showing off until the end of July. Prices have gone up enormously, and we are again on starvation rations. . . .

Yesterday I visited one of my students. He showed me his works and I talked to him like an uncle. Now, these consultations are among the affairs uppermost in my mind. I have always pondered on the ideal way of communicating with pupils. I think I shall be able to follow it now, leading and helping them along, talking to them freely, exchanging thoughts and ideas with them. I feel strong and rich and convinced of contributing to their development without forcing them into something not inherent in their nature. The trust they place in me is very wonderful. Among the students there are so-called finished artists who will remain "finished" forever, completely stuck in a rut on the threshold of creativeness. Others again are in despair because they feel in a dim way potentialities they are unable to realize. There has been no one so far to draw their attention to laws intrinsic to all art. Good little Klemm could teach them no more than a few mannerisms which now lie thick on their work as superficial and meaningless touches.

Yesterday Gropius delivered an important speech before an audience of well-known critics, school men, and representatives of the guilds and crafts. Leipzig, Jena, Erfurt, and other towns sent delegates. After the lecture there were discussions. . . .

9 A.M., June 30, 1919

. . . I knew that you would be without news for days, and I was in despair, not only for that reason. What a week! So many meetings, constantly sidetracked by all these misunderstandings between the old and the young ones—so much commotion—my time was reduced to a fragment. Yet you won't believe that in other places, Munich, for instance, they look upon "free" little Weimar with jealousy and longing. I am convinced that our Bauhaus could, and that it *will,* develop into something very wonderful. Soon Weimar will have a reputation in Europe and, before long, all over the world.

Evening—I just wanted to tell you that I drew the outlines on a wood block for the strongest cut that I ever conceived. I shall start cutting

now. Despite all the moaning and groaning in the beginning of this letter, if I am honest with myself, I must admit that I am fully responsive to all that is happening—alive to it, recovering after these last five years of dull brooding, which has been almost killing, shut up in my innermost self. I see a way out. It is overwhelming, this wonderfully deep feeling of vitality. . . .

In the studio
After 7 P.M., Tuesday, July 8, 1919

. . . Again we had a meeting of the masters this afternoon to determine which of the students are to be admitted. That is such a difficult question, and all sorts of reflections occur to me. In my mind's eye I see these young people vividly over whose fate we hold decision so. If the outcome is negative, God knows what hopes may be destroyed. It is a strange thing that the most gifted of our students simply goes ahead unheeding. In a way this one remains unmolested, but others whose talents are less conspicuous on the surface, who have to take pains to overcome the antiquated methods of the previous system—should they have no chance? I very decidedly take sides with those who work hard and want to achieve something. The development of art is a thing of slow growth. It requires time and plenty of it. It cannot be forced. What would have become of me with insufficient time to struggle through my problems, to overcome my stumbling blocks? I am no genius, that much I know. I have managed to save one or two. They got a break. I found Gropius open to discussion. Only he wants to see quick results. For him, "It lasts too long. It lasts too long.". . .

Saturday morning, September 11, 1920

. . . I am wrapped up in the work on *Sussenborn,* a new painting after an old composition. I am at work on two pictures after former compositions, the second one, *Bourg-la-Reine,* but something new is erupting in my system—I feel it welling up in me. I have to get back to formal solutions again after this period of peaceful, rather insignificant painting. My pictures came back from the [Erfurt] museum. I don't know where to place the lot. We shall have to open a gallery at home when you are back.

There is much in your letter that stirred and interested me, the comparison between Marées and Böcklin.* What is a big reputation an art-

* Hans von Marées and Arnold Böcklin were artists renowned in Germany at the end of the nineteenth century.

ist has acquired in his lifetime worth if, after only one generation, the glory peels sadly off because the work, built on insufficient foundations, revealed its shortcomings, did not withstand the test. Passion and sensitivity are not enough. It is essential to *know* what it is all about in order to make it *be*. Bach knew, and Dürer and Grünewald. The multitude of those who didn't take the trouble to know, in spite of emotion and effort, are petering away, are cast aside. I am desirous to achieve that which I know—not to do my work by halves, and to be conscious of what I am feeling. But be aware of being deceived by the heart, of being a good fellow, or else one goes down gushing. . . .

September 25, 1919

. . . Yesterday I had a letter from Dresden. The show will be closed. No sales worth mentioning up to now, but Richter writes that the interest awakened in art circles has been exceptionally strong, and [the show] must be called a great success. He also sent me reviews from *Dresdener Nachrichten, Dresdener Anzeiger,* and *Dresdener Neuste Nachrichten.* They are very good, quite exhaustive and detailed. One of the articles stresses one point in my work, another something else, and for the first time attention is paid to my woodcuts. You will be pleased to read them when you are back.

Yesterday and today I worked with intensity at *Nieder-Grunstedt.* Yet in the end it struck me as clumsy and ignoble. Therefore, with my well-known determination to get to bedrock I washed off the entire thing and reconstructed it completely. Still not satisfied today, I had to repeat the whole procedure, thus preparing a very good surface to paint on. I shall be on my guard, building up forms according to the original conception and paint carefully, "with air" to keep it soft. I have composed a piece flooded with light, so to speak, not dissected or harsh any more. It is growing naturally now, and I hope that it will be good when I have it finished. On the *Windmill* I have also made some corrections, though very cautiously, for what is there already I want to retain. Both these works will be carried through to their ultimate form.

Monday, November 14, 1921

. . . I have had a terrific lot of work to do with the portfolio—mostly lettering—so that for days I have not been able to think of anything else. I have been entrusted with this work—the *Portfolio of the Bauhaus*

*Masters*—and, since I carry the responsibility for the completion of the project, I have to see it through. In fact, it is a work, as are many others, in honor of our joint endeavors. Yesterday I had a visit from Van Doesburg.* We had a long talk together. He at least is very real and of healthy flesh and blood. He was rather explicit on Monsieur Itten. It seems this champion of Theosophy at times does not act up to the role. He is said to have ripped down my work and to have left hardly a shred of my person, which is gratifying. Anyhow he did it publicly—he should come to grips with me and we might get even. . . .

<center>═══════════════</center>

<center>12:30 P.M., Thursday, November 17, 1921</center>

. . . There is restfulness and peace around me working at the long table in the living–music room—and while I write this the spell is broken by the eager cries of the boys coming home from school. Yesterday I had a bad headache from early morning on. It got worse in the afternoon—yet I had to keep on working because everything was most urgent. The front cover of the portfolio is turning out very beautifully. Hirschfeld† is printing my woodcut, as he did the small samples, with the roller right on paper. You will have to see this dark surface, with a few bright spots growing out of the mysterious structure, to get an idea of the strong effect it makes.

I haven't seen Gropi for days. I hope he is not angry with me for refusing to participate in the competition for the Bauhaus seal. I am not made to invent symbols, and besides there should be something that is not done by me.

The time of my periodical craze for making toys for Christmas is approaching. Every year I get the urge to saw wood into bits and to paint them in bright colors. The boys take it for granted that I shall make manikins for them.

Tomorrow we are going to have another of those horrid—I mean "wonderful"—mass gatherings of representatives of the art departments of all the German states [*Bundesstaaten*]. The alarm is given to all the workshops, and in the skylit hall a show of the works from the *Vorkurs* [preliminary course] as well as products from the workshops is put up. For decency's sake I shall have to be present. I cannot get around it. But I will not let them enter my studio. I shall refuse. Once was enough

---

* Theo Van Doesburg, Dutch founder (with Piet Mondrian) of the magazine *De Stijl*, and head of a group of artists of the same name. Van Doesburg resided at the time in the immediate neighborhood of the Bauhaus and attracted many of the Bauhaus students to his lectures.

† Ludwig Hirschfeld, a journeyman in the Bauhaus graphic workshop.

for all time. My domain is the print shop. There they may goggle to their heart's delight, and I'll answer questions to please Gropi, but all else, *no!* . . .

───────────────

Early Saturday, November 19, 1921

. . . Yesterday I had no letter from you, and I miss it badly. But all day long I have been at work on something dedicated to you, intended to give you pleasure. In between I was at the Bauhaus, where I had to submit with good grace to the avalanche of representatives of the art of all the states. As a whole it was not as bad as I expected, and after a quarter of an hour, anyhow, I withdrew. In his field-gray military cloak, Gropi looked grim and fierce and unapproachable, shut up like a clam. He whispered in my ear that they were a loathsome, insolent crowd and that he would like to throw them out. This, in fact, encouraged me to take French leave. The exhibition of the workshops is very good; the productions of pottery, the weaving, bookbinding, and wood and metal works show remarkable progress beyond former things, and I was very glad and interested to see them. Itten was the speaker—and here his verbosity was warranted. Well, now it is over and done with, for some time at least. I enclose a letter from Kaesbach.* I have agreed to his proposition with regard to *Scheunenstrasse* and *Country Road,* for I think we can oblige a friend for the sake of his museum. And we shall, by this arrangement, be placed on the safe side for a while. . . .

───────────────

February 11, 1922

. . . Yesterday at noon your telegram arrived, together with a letter of February 3, and this morning I got your letter written yesterday. But two are definitely missing. They may be among the mountains of un-delivered mail and turn up some day. During strikes, the malevolence and collective ill will of mankind declares itself much more cruelly in a big place like Berlin and makes itself abominable. Here in little Weimar we have had no strike whatsoever. Coke and coal have been seized by the government, but only because supplies didn't come in, and without this precaution we would have had no gas or light. But now everything is functioning normally again.

* Dr. Walter Kaesbach, in charge of the modern section of the National Gallery in the Kronprinzen-Palais, Berlin.

I am quite thrilled about your meeting with Kandinsky. He is to come to Weimar in the near future, Gropius told me. I suppose my show will be closed by now? Yesterday I sent sketches to Schardt* in a hurry for the issue of the *Kunstblatt* with his article on me. I'm sure they will arrive too late.

. . . Yet what I consider of utmost importance is to simplify means of expression. Again and again I realize this when I come to Bach. His art is incomparably terse, and that is one of the reasons it is so mighty and eternally alive. My poor overladen bars! If I were to compose music again, I should commence in a different way. I could go on and on writing. I would get no further without this determination. I must avoid becoming entangled and fettered in complexities. I am feeling at rest for a while. Things now have to grow quietly within me beyond the notch I have cut. I am studying intensely the three-part fugue which is unbelievably beautiful, and so simple and clear in construction. . . .

━━━━━━━━━━
━━━━━━━━━━

Lüneberg
August 12, 1922

. . . Yesterday I really was so upset that I longed to get away, to be somewhere else. I can hardly stand it any more. I think I shall never want to be here again. After the first spell is broken, a frightful emptiness makes itself felt from which there is no escape. And one could hardly believe, hardly think it possible how expensive everything is, how the people watch the course of the dollar and raise prices accordingly. We noticed it while you were here, but it is getting constantly worse. The money is melting away. It scares me terribly. Yesterday the dollar was 897, soon it will be 1,000. Yesterday I felt haunted, which I know was only due to my state of mind, but it is not a good condition. It is some sort of persecution mania. Let's try to find another place where we can go when you're back. It could be Timmendorf, where we could be at the water and see ships. Well, though I have no taste for it, I shall go out now and try to get warmed by the sun if it is willing to break through the rain clouds. Yesterday there were banners all over the town, and the crowds were awful. One thing I've not been able to find out is whether the children go to school here. The streets are teeming with them, and the small creatures are swarming all over the place. . . .

━━━━━━━━━━
━━━━━━━━━━

* Alois J. Schardt, art historian and director of the Moritzburg Museum at Halle.

Lyonel Feininger

for all time. My domain is the print shop. There they may goggle to their heart's delight, and I'll answer questions to please Gropi, but all else, *no!* . . .

━━━━━━━━━━━━━━━━━━━

Early Saturday, November 19, 1921

. . . Yesterday I had no letter from you, and I miss it badly. But all day long I have been at work on something dedicated to you, intended to give you pleasure. In between I was at the Bauhaus, where I had to submit with good grace to the avalanche of representatives of the art of all the states. As a whole it was not as bad as I expected, and after a quarter of an hour, anyhow, I withdrew. In his field-gray military cloak, Gropi looked grim and fierce and unapproachable, shut up like a clam. He whispered in my ear that they were a loathsome, insolent crowd and that he would like to throw them out. This, in fact, encouraged me to take French leave. The exhibition of the workshops is very good; the productions of pottery, the weaving, bookbinding, and wood and metal works show remarkable progress beyond former things, and I was very glad and interested to see them. Itten was the speaker—and here his verbosity was warranted. Well, now it is over and done with, for some time at least. I enclose a letter from Kaesbach.* I have agreed to his proposition with regard to *Scheunenstrasse* and *Country Road,* for I think we can oblige a friend for the sake of his museum. And we shall, by this arrangement, be placed on the safe side for a while. . . .

━━━━━━━━━━━━━━━━━━━

February 11, 1922

. . . Yesterday at noon your telegram arrived, together with a letter of February 3, and this morning I got your letter written yesterday. But two are definitely missing. They may be among the mountains of undelivered mail and turn up some day. During strikes, the malevolence and collective ill will of mankind declares itself much more cruelly in a big place like Berlin and makes itself abominable. Here in little Weimar we have had no strike whatsoever. Coke and coal have been seized by the government, but only because supplies didn't come in, and without this precaution we would have had no gas or light. But now everything is functioning normally again.

* Dr. Walter Kaesbach, in charge of the modern section of the National Gallery in the Kronprinzen-Palais, Berlin.

I am quite thrilled about your meeting with Kandinsky. He is to come to Weimar in the near future, Gropius told me. I suppose my show will be closed by now? Yesterday I sent sketches to Schardt* in a hurry for the issue of the *Kunstblatt* with his article on me. I'm sure they will arrive too late.

. . . Yet what I consider of utmost importance is to simplify means of expression. Again and again I realize this when I come to Bach. His art is incomparably terse, and that is one of the reasons it is so mighty and eternally alive. My poor overladen bars! If I were to compose music again, I should commence in a different way. I could go on and on writing. I would get no further without this determination. I must avoid becoming entangled and fettered in complexities. I am feeling at rest for a while. Things now have to grow quietly within me beyond the notch I have cut. I am studying intensely the three-part fugue which is unbelievably beautiful, and so simple and clear in construction. . . .

Lüneberg
August 12, 1922

. . . Yesterday I really was so upset that I longed to get away, to be somewhere else. I can hardly stand it any more. I think I shall never want to be here again. After the first spell is broken, a frightful emptiness makes itself felt from which there is no escape. And one could hardly believe, hardly think it possible how expensive everything is, how the people watch the course of the dollar and raise prices accordingly. We noticed it while you were here, but it is getting constantly worse. The money is melting away. It scares me terribly. Yesterday the dollar was 897, soon it will be 1,000. Yesterday I felt haunted, which I know was only due to my state of mind, but it is not a good condition. It is some sort of persecution mania. Let's try to find another place where we can go when you're back. It could be Timmendorf, where we could be at the water and see ships. Well, though I have no taste for it, I shall go out now and try to get warmed by the sun if it is willing to break through the rain clouds. Yesterday there were banners all over the town, and the crowds were awful. One thing I've not been able to find out is whether the children go to school here. The streets are teeming with them, and the small creatures are swarming all over the place. . . .

* Alois J. Schardt, art historian and director of the Moritzburg Museum at Halle.

. . . I had no trouble with the ticket. Gropi was waiting for me at the gate. We didn't have much time since the motorboat for Timmendorf was to leave at six—but we went to meet the others on the terrace of the casino (six German marks entrance fee, as a guarantee that good society would remain exclusive). The Kandinskys, Gropi and I ate very good cake, and I had a glass of iced chocolate, and the delightful view of the harbor and the opposite shore of the Trave. I also enjoyed the elegant public, prettily dressed, and the jolly, many colored sweaters. In the ballroom a Hungarian band, correctly dressed in white, was playing with unctuous sentiment, while outdoors the bourgeois orchestra was performing serious music in a very boring way. For most of the time at our disposal we remained on the terrace, as was fitting and proper—the needs of the body first and foremost, the spiritual later— and then we hurried through the beautiful grounds with magnificent trees, along the harbor toward the inner town and the church. Alas! We didn't get that far, for the siren of our motorboat way out at the other end of the pier was howling furiously. We had to rush and just reached it in time. So we didn't see the old gabled houses or the church —but I didn't mind. I was even glad, for I'd rather get my first impression in a peaceful mood alone and not in such haste. Nevertheless, we did see many fine things, many yachts, a few really large schooners, and exquisitely shaped motorboats. But one small cutter, a keel yacht, especially delighted me. The little craft rode the water like a toy, high-sided and extremely narrow, built of beautiful brownish red mahogany, with its cabin hidden below deck. She was snug and clean in her lines, built so that a man could sail her singlehandedly, and naturally seaworthy, capable of crossing the Channel as is to be expected of an English vessel. For that she was, carrying a tiny English flag at her masthead. I shall long remember the lovely little thing, which was like the embodiment of a dream of my young days. We had a good voyage, quiet, yet with considerable swell. I was sitting high up on the roof of the cabin where I had the best view. The sun was setting in a fantastic welter of thunderclouds, rising from the west. We passed the spot on the beach where you and I two days before had climbed up. Had we proceeded for ten more minutes, we would have reached the last promontory and could have seen the masts of the harbor from afar. We reached home about 7:30. After dinner Gropi gave the glad tidings of a special-delivery letter from Meyer,* who urged him to make use of the fine weather to stay until Monday, which he intends to do. This was greeted

* Adolf Meyer, Gropius's associate in his architectural firm and also a member of the Bauhaus staff.

with cheers and shouts of hurrah, and at 9 an improvised celebration took place in the garden at the border of the woods, with candles in colored flower glasses, Chinese lanterns, and coffee and cake. The arrangement was charming. We all stayed until 11. It was warm and sultry, yet we were animated and had good talks. Later in the night we finally got the thunderstorm which you had predicted, and it was a pretty big one. There were terrific crashes; several times we thought that the tall poplar had been struck; and rain fell in torrents. . . .

Timmendorfer Strand
September 2, 1922

. . . Fog and rain have been blown away and we can take up beach life proper. Without sun and warm air one often asks why one puts up with so many inconveniences only to freeze, but no, it is always good to be here to walk at the water's edge even under an umbrella in the rain. There is so much to be seen and observed, and I go through inner experiences as never inland. It is 3 P.M. The Kandinskys and I just returned from the Rotkappchen. On the way home we bought some food for breakfast and supper, for we have to provide for ourselves from now on to keep body and soul together. But we shall keep on eating dinner at the Rotkappchen, for the cooking is excellent and the portions so big that our friends could hardly believe their eyes. All that for 120 German marks, with good coffee thrown in.

Yesterday evening we had a farewell party for Manon. It was a great success. First we all sat together in the drawing room, which was lit and nicely warmed by the flames of the big log fire in the fireplace, until the cry for "amusement" arose. So Gropi gathered his liege men of both sexes, and a game of really witty charades ensued. Goodness! Wasn't it funny! So much ingenuity and talent came to light. It was such a lucky hit that finally each of us acted out a picture of himself, and we almost died with laughter. Now today is Gropi's last day. I am sure something or other will be on this evening. . . .

Timmendorfer Strand
Monday evening, September 4, 1922

. . . An incomparably beautiful day with a heavy storm. It started with clouds and fog, the east wind blowing directly on the beach, the sea wildly agitated, and not a single sail to be seen—but the barometer ris-

Lyonel Feininger

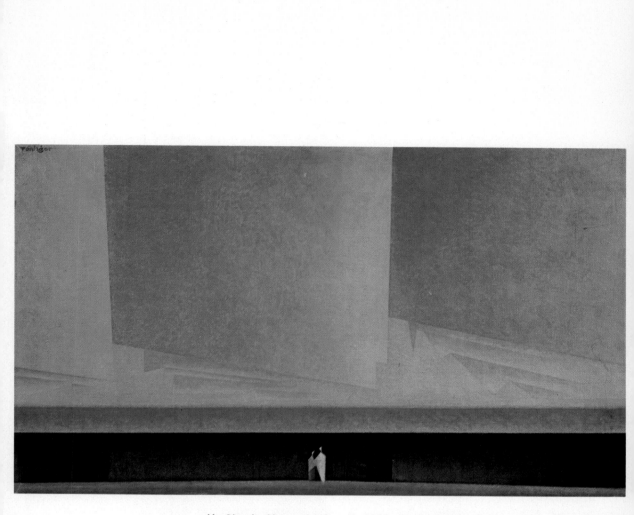

**V.** *Clouds Above the Sea II*. 1923. Oil on canvas, 14¼″ x 24″. Altonaer Museum, Hamburg. Photograph courtesy of the Marlborough Gallery, New York.

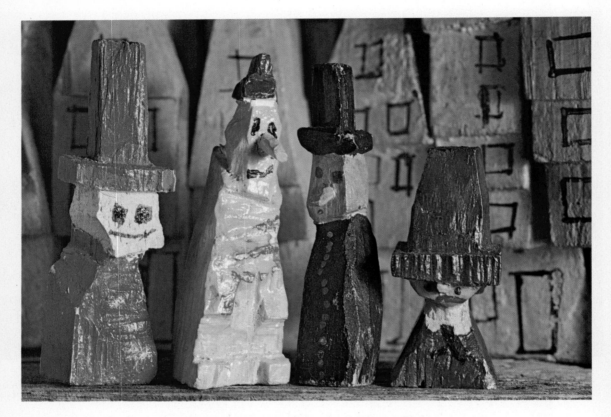

VI. Toy figures and houses carved in wood and painted by Feininger. Photo-
graph by Andreas Feininger.

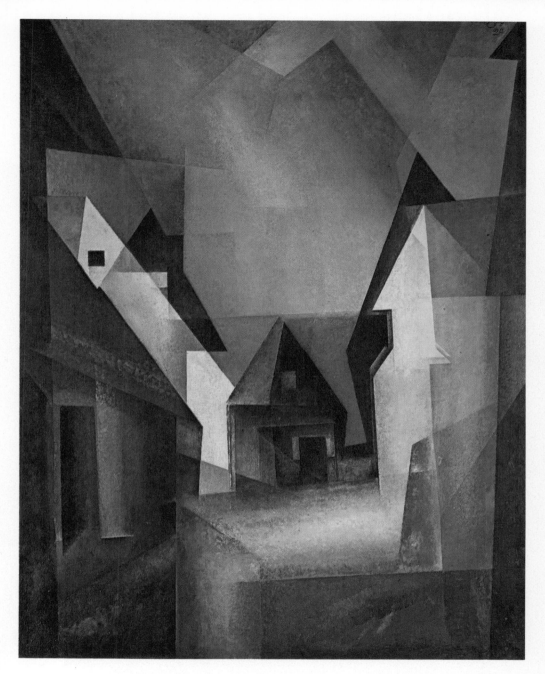

VII. *Gaberndorf II*. 1924. Oil on canvas, 39⅛" x 30½". Nelson Gallery–Atkins Museum, Kansas City, Missouri. Gift of the Friends of Art.

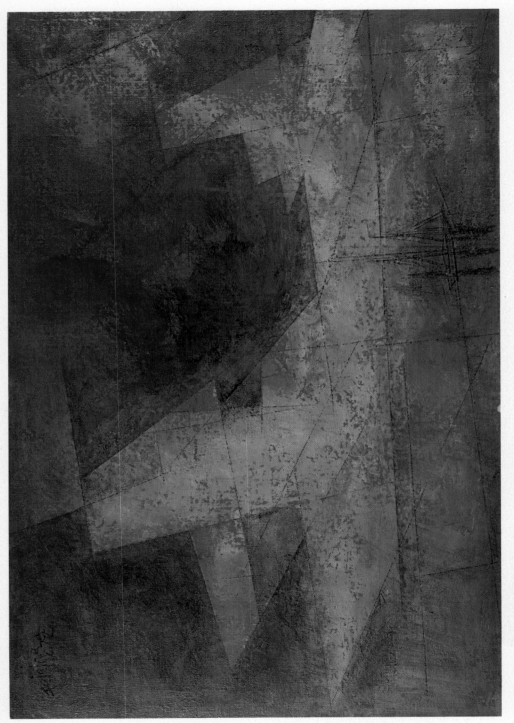

VIII. *Sunset Fires*. 1953. Oil on canvas, 24″ x 36″. Collection of Andreas Feininger. Photograph courtesy of the Marlborough Gallery, New York.

ing, one point per hour. At 12 noon I decided to go bathing, though the air was cold and no sun. I told the Kandinskys that I thought the forenoon was the best time for it. I went down first, undressed in the cabin in less than two minutes but—lo and behold, my bathing suit had disappeared! So I put shoes on my toes and my naked trunk into the purple bathrobe, clambered up to the house, searching everywhere, but no suit turned up. Within the two or three minutes between the time that I dropped it and returned to search, somebody had found and had cabbaged it. Well, resolutely I took your suit and squeezed into it (you won't believe how tight it was for me), and I tell you I've never had a bath as exhilarating. Over and over again the huge rollers broke over me; I couldn't get enough and I stayed in the water longer than ever before. In the meantime Kandinsky had come down, but with his overcoat over his suit he emerged from the cabin alone. "Losing bathing suits seems contagious," he said, for his wife had also lost hers. Only they were luckier, when he went back he found hers lying in the garden. . . .

After dinner I played the piano for a while. While we had tea, at 4, we decided to go to the beach to pull the *Manon* higher up on the shore, for the storm had very much intensified. The breakers along the bay were tremendous. The foam cast up looked like a single sheet of white luminosity. Later we all went to the quay. Many took the risk of going out to the end of the pier, and we also went, including Mrs. Gropius, who is as courageous as any. The sight out there was incredibly beautiful, the crests of the incoming sea rising several meters above the edge of the breakwaters before crashing over. To watch the people was very funny—their jumping and hopping—a wildly gesticulating crowd. A photographer, of course, was on the spot. All of a sudden he and his assistant came rushing out to the end of the pier, crying, "Hold it, shoot," and we were all in for it. Now comes my own ridiculous little story. I don't remember what had prompted me to wear an overcoat and, carrying my Zeiss, to put on my straw hat, but there I was. It flashed through my mind to have some fun of my own, and I decided to be in the picture. With one big leap I jumped over to the empty space at the flagpole where not a soul was standing. Seeing the camera fiend turning his machine my way to shoot a solo of yours truly—well. In the eyes of all mankind, with the wind howling around me and tearing at my trouser legs, for a second still holding on to the brim of the daisy, I let it go, and like a shot it flew off into the thick of the crowd, I dashing after it wildly, and all the time the reel was humming. I said to myself, "You wanted to be filmed. Now you've got it." I had to take the consequences, which were, in the words of the operator, that the film would be shown tomorrow afternoon in the casino.

But wait, I'm not through with the tale of this jolly afternoon. After

my heroic antics, we started going home, Kandinsky in the lead. He was down on the lower stretch of the pier when a gigantic wave double the height of a man came racing over the planks. Instead of standing still and waiting to let the monster pass over him, my dear colleague commenced running and really managed to keep at exactly the same speed as the waters the entire length of the pier. Drenched to the skin, sopping wet, are not adequate expressions for what he was. We were completely dumbfounded, yet couldn't help laughing while we followed his progress and saw how he got the shower bath with mathematical exactitude from beginning to end. We wiped his face and hands with handkerchiefs, but more we couldn't do. A wringer could hardly have gotten him dry. . . .

Timmendorfer Strand
Wednesday evening, September 6, 1922

. . . I often would like to be left more to myself. I get up around 7 and have finished breakfast two hours before the others turn up. In the evening after dinner they generally play halma; then I go out. That is my best time. I wander along the beach to the harbor, all alone. New themes for fugues keep cropping up in my head. Some I note down to make use of later. I am determined, however, not to start anything that has to do with composing music now, fully aware of the inherent dangers. I see clearly that I have to get back to painting. The most important period of my painting life seems to be just ahead of me if I manage to concentrate all my powers in that direction. Therefore I trust that even these weeks of doing nothing have been good as a time of preparation to make me conscious of it. . . .

Timmendorf
Between 2:30 and 4 P.M., September 7, 1922

. . . Your letter showed only that you are already too much caught up in the grip of your everyday life. But wait, before long the small yellow room upstairs won't be empty any more. Somebody will stand before an easel painting, and you will have a place of refuge.

What you write about Zachmann is not unknown to me. Yesterday while we had supper together Kandinsky and I had a talk about this. He thinks Van Doesburg will leave soon to go to Berlin, Weimar being too small for his activities. We were wondering how many (or rather how few) of the students are really conscious of what they want to achieve and strong enough to follow their course painstakingly. For

most of them the unsentimental and perfectly unyielding Van Doesburg seems to supply something definite, a dogma, something ready made to cling to—contrary to our explorational endeavors, which in the long run would lead them much further. Why is there this voluntary submission to the tyranny of a Van Doesburg, and this mulish noncompliance with all requests or even suggestions put forth by the Bauhaus? The Bauhaus places them under obligation, while to follow Van Doesburg implies nothing of the sort. He leaves them free to take it or leave it, to come and go as they please. Of course it is crass sabotage against everything that the Bauhaus is aiming at. God knows what can be done about it. Either the ideology of the Bauhaus will prove itself vital enough to overcome all the opposition from within and without or it will break down because there are so few nowadays who straightforwardly and with conscious judgment are willing to adhere to the cause. Maybe such experiences are necessary before an equilibrium can be reached. We also were reflecting upon the possibility of having Van Doesburg among the staff, whether it might not be so bad, but rather of help, in counterbalancing a certain high-flown romanticism which crops up at intervals. But we were pretty certain that he would not be content to remain within the boundaries but assume to hold command of the whole, as Itten had tried before. Taken as an individual, Doesburg is disappointing. He is claptrap, vain, and ambitious.

Timmendorf
September 9, 1922

. . . An endless succession of pictures is turning up in my fantasy. I long for a realization of these visions. There is Paris and those typical Parisian figures, old architecture and the streets with colorful, bustling people, the Luxembourg Gardens where we pushed Andreas in his pram, the Boulevard Montparnasse where we bought our *petite suisse* for supper at home in our little chalet. The more I become a painter, the deeper grows my love for these pictures and experiences, which are all inseparable from our life. Not since the war have I felt this well bubbling up within me. There are certain hours which seem predestined to be incorporated in our consciousness as most precious memories. I felt it strongly this morning when, after breakfast (consisting of a glass of milk, a roll, and some marmalade), I stepped out into the cool air. I had started at random but put into my pocket the pad I am writing on now. Arriving at a spot which offered a wide view over the sea, where a bench most providentially had been placed, I sat down in the soothing warmth of the sun, which we had missed for so many days. I lit my

morning cigar and immediately a special mood arose. I was inseparably connected to this very minute in the course of the universe. I commenced drawing, somewhat absentmindedly at first, but by a lucky chance the clouds above the sea turned into more and more beautiful combinations, and I felt inspired. So I made five or more sketches of the beach and the clouds which will be a source of joy for me in years to come. There was a feeling of perfect happiness within me. I know that this half hour will remain as a memory and a longing. I am now capable of concentrating my powers on painting, and even my attempts at composing music won't fritter away my energies any longer. If I could only be reassured and believe it, that this liberation I am feeling now will not be paralyzed again by everything connected with the Bauhaus. . . .

September 10, 1922

. . . For days I've made sketches only of clouds. At no other time am I as wide awake. The most beautiful landscape cannot hold my fascinated attention as nature by the seaside and all that is connected with the water. Now the sun is low over the treetops. In a few minutes the shadows will have swallowed "fisher and skiff," in my case, me and my chair. The air is cooling rapidly. I wonder whether we'll have a moon as strange as last night. I had gone out to the beach for a breath of air before going to bed. I was startled by what I thought to be a searchlight way out over the water, enigmatic and exciting. Then I perceived that it was the moon hanging low over the horizon, shining behind a fantastically shaped cloud in the sky—which was brilliant with stars all over. Kandinsky, from his window, had also noticed it and said today that he had never before seen anything so startling. . . .

September 11, 1922

. . . Gropi's mother told us today that she had had a letter from him from Berlin in which he tells about terrible conditions. He is perfectly aghast. He had to pay 500 German marks for a night at a hotel. A suit at a small tailor's costs 28,000. The hatred and greediness of the people he describes is disgusting. I almost begin to worry how our life will shape. In these times it is reassuring to have America in the background. . . .

Lyonel Feininger

. . . It was good to see Klee, Kandinsky, and good old Marcks* again. When I left Timmendorf, the Kandinskys were worried about me, thinking me short of cash, and wanted me to accept money from them. Two days later, when they were traveling themselves, they arrived in Berlin with only 400 German marks and the second-class carriage to Reichskanzlerplatz cost 600, so they had to run into debt in order to pay for the one-horsepower conveyance running on oats.

I hardly get to work, we are having one meeting after the other. . . .

October 5, 1922

. . . Two meetings again today and tomorrow. We are forced into a compromise, to come out now with the big exhibition we had been planning. We are all reluctant to agree to such art politics. I cannot and do not want to go into details here. The fact is that we have to show to outsiders how we perform (and what we are able to produce) in order to win over the industrialists. It is a question of do or die for the Bauhaus. We have to steer toward profitable tasks and mass production. That goes decidedly against our grain, and we are aware of forestalling the process of evolution. But we won't consider it a sacrifice if it saves the cause. This evening we shall have a meeting with the students to discuss the subject. We have to convince them of the necessity of taking this step. As time is short for preparations, the workshops will be open from now on in the afternoons. You can imagine how charged the atmosphere is. Gropi appears in a new light. He has a clear perception of these realities; only he is on the side of the purely mechanical approach. Thank God that Kandinsky, Itten, and Muche preserve the pedagogic balance very well. Kandinsky and myself are as comradely as ever. Saturday I shall be with Klee. Wednesday, after the session, Marcks went home with me and we prepared supper as best we could. They are such fine fellows—also Muche, Schlemmer, and my other colleagues.† I recognize an accumulation of power emerging from this group, devolving from the intensity of their humanity. Gropius, without a doubt, has the best of intentions, but he can be uncharitable and

* Gerhard Marcks, Paul Klee, and Wassily Kandinsky were all members of the Bauhaus staff: Marcks from 1919 to 1925, Klee from 1920 to 1931, and Kandinsky from 1922 to 1933.

† Georg Muche was a member of the Bauhaus staff from 1920 to 1927, Oskar Schlemmer from 1920 to 1929.

harsh at times, only to become conscious of it soon after and sorry of the lapse. In times of stress like these he thinks that personal importance has to stand far behind the requirement of the moment. "Whosoever is not ready to demonstrate his mettle at once had better quit entirely," he said the other day in a meeting.

---

Weimar
October 7, 1922

. . . No meeting in the offing for the next days, but I have to be in the print shop almost constantly. I am hard pressed to get the Bauhaus portfolio finished. The title pages, the index, etc., have to go to the lithographer, and material for the bookbinders has to be selected.

Through the Möller Gallery I received an invitation to exhibit in America. I have to think carefully about which pictures to send. I have to be represented with good and strong works. . . .

---

Weimar
July 28, 1923

. . . The picture is almost finished. I could have done much more without this eye trouble. I have loosened up my way of painting. This new "cloud" is as spacious as the first one but the vision is larger, not so caged in with hard modeling. . . . Yesterday I met Hirschfeld. He wants to come to me on Sunday to have a talk and ease his heart. He says that he has to get work of his own now, and wants to leave the Bauhaus in the fall, as others intend to do, after the show is over. It might be the end of the print shop if Hirschfeld leaves, for we have nobody to substitute for him.

"Art and Technique, a New Unity" is the slogan on our Bauhaus poster at the railroad station. Oh dear, will there really be no more in art than the technique necessary to become profitable from now on? Since times are bad, art has to give in, and authority is granted it by associating it with usable things—a hateful conception. But I may say, God bless us, we are not at that point yet.

. . . Sunday morning, it looks as if it might rain. The news from Berlin in yesterday's evening papers was very depressing. Today will be a critical one for the nation.* It is the weight of these fateful years

* In 1923, the Social Democrats declared the need for a national coalition because of rampant inflation. Shortly after this letter was written, President Friedrich Ebert called upon Gustav Stresemann to form a new cabinet.

Lyonel Feininger

lying upon us all that disheartens us and makes us despondent. Every single person, each for himself and from his own personality, has to fight for and win the power to stand up against it. Perhaps you sometimes think that I am inconsiderate when I try to forget about it all and long for gaiety, but it is for one reason: to be able to continue my work. Joy, gladness as an end in itself, we hardly know any more.

At last I have the written guarantee from Weidler to go ahead with the portfolio for the Bauhaus. But these three to four weeks of time lost will make a difference in price of many millions. According to book dealers, my own small portfolio, which formerly would not have cost even 50 German marks, today costs seven million.

Weimar
Early Wednesday morning, August 1, 1923

. . . Alas, when I start thinking of all that is happening in the world and, looking around me, am aware of so much that is distressing, I realize how we have been favored. We have to keep in mind what it means for the life of the boys, and for us, to live in a small town. Seen from afar, Berlin may appear stimulating and exciting—but only with the advantage of our existence in Weimar and its lovely landscape as a secure background. More often than not, I am inclined to extract the good from present conditions even though I may not always succeed (but that is generally my own inadequacy). How often I tell myself that for no other reasons than those evolving out of my nature I am unable to work here consistently. Yesterday I met Gropi in the street. He came toward me and took my arm affectionately, wanted to have a chat with me. So I went with him to the Bauhaus. He is working through the nights until early morning, hardly ever getting enough sleep, yet he never complains or becomes embittered. If he looks at you kindly, his eyes shine as no one else's ever do. He has to face continual difficulties to make ends meet. The costs for the Bauhaus alone are rising into the billions. His example is indeed inspiring. Often enough I find myself in disagreement with him and unhappy with the tendency that seems to me to be a decline, but where would we be without the dynamic energy of the man? I am certain that not Gropi alone but the drift of the times and the human material at hand are to be blamed if things should get out of control. Personally I am entirely, as well you know, against the slogan "Art and Technique, a New Unity." It is a misconception, but it may be symptomatic of the era we live in. A true technician won't allow any interference and would avoid everything that hints at artistic appearance—on the other hand, even the most perfect of technical achievements can never take over the mission or substitute for the spark

of art. There can be no merging of art and technique. Their distinction is fundamental. . . .

━━━━━━━━━━━━

Weimar,
Sunday afternoon, December 9, 1923

Yesterday everything turned out differently from what I had expected. Instead of coming upon preparations for the show of the students' work in the skylight hall, I barged into a session of the masters with Gropi, preliminary to the important discussion concerning economic affairs, which later took place in a classroom with all the students present—and I couldn't escape. According to Gropi's explanations the outlook for the Bauhaus is not at all promising. It was a long meeting and not too pleasant. On my way home at 2:30 I met the two soldiers whom I had seen in the morning around our house in Gutenbergstrasse. They accosted me and asked if I were "Professor Feininger." "Yes." Well, they were looking for quarters, and since they had been told that we had a free room, etc., etc., what could I do? The one we are to billet looks clean and intelligent. He scraped his shoes very thoroughly on the doormat before entering the house. He'll be out all day, being on duty from 7 A.M. until the evening. Since he has an orderly who will bring his stuff, I imagine him to be a lieutenant or something of the sort. In case we should need the room at Christmas, he would be willing to find some other place.

In the evening I went to the movies with Andreas and saw an American film very well done, with pictures so clear and precise as one hardly sees here, although Germany's reputation in the field of photography is outstanding.

This morning we were all up rather late. I was terribly tired. It was a quiet forenoon. Laurence went to the museum with Orlo. Andreas stayed home working at something you never would guess—he is making designs for a dining-room table and chairs.

Yesterday at the meeting there was much talk about the problems of those among the students who are doing creative work on their own. The difficulty of keeping themselves above water arises if, during such a period, they don't actively work for the shop and then get paid. This gave me the idea of suggesting to Andreas that he show what he is capable of, and I promised to pay for it. He immediately agreed and started making sketches. Tomorrow he will discuss the technical details with Weidensee.*. . .

━━━━━━━━━━━━

* Reinhold Weidensee, the master craftsman of the cabinetmaking workshop.

Thursday, December 13, 1923

. . . Yesterday I tore up another short letter which I had written in a hurry. It sounded as cheerless as the first one. Yet I am not feeling too bad. Only my lack of productivity is depressing, and the days are so dark and short. These days I get up at 7 when it is still pitch-dark, the world wet in a dripping fog. I feel very virtuous, but I also have to get my boys going.

At 8:30 this morning I was already in the studio printing. I have demands from many galleries (today from Würzburg) for wood-block prints, and we have very few left. I printed *Fishing Boats* and *Lehnstedt*. Tomorrow I shall get to the ships with the curlicue reflection in the water which everybody likes. I did a lot besides—letter writing, coloring toy houses, busying myself with portfolios, seeing visitors.

Yesterday I painted some at the *Church of the Minorites,* hoping for better light tomorrow to get on with it. There is not much else to report. We got our salary, 31 gold German marks (which is supposed to last for 10 or 14 days???). . . .

---

Weimar
December 15, 1923

. . . According to Gropi's explanations the outlook for the Bauhaus is not at all too promising. The government proceeds against us with determination, in preference, of course, to the old art school. While the contracts for the Bauhaus will be extended until 1925—and for this Gropi had to put up a fight, since they wanted to limit them to 1924— the government will endorse the art school until 1927. And they may enlarge the staff of teachers, whereas we are not even allowed to fill our vacancies. The auspices are really very bad. We shall have to be cautious again and begin saving after the holidays, since we are on half pay as government officials. . . .

---

Sunday, January 20, 1924

. . . The weather: thawing with mud knee deep. Other items of news: yesterday I wrote a long letter to Churchill on behalf of Emmy Scheyer.* She will probably come to Weimar by the end of January to

* Alfred Vance Churchill and Feininger met in Berlin in 1888–89, when they were both students at the Academy. In 1906 Churchill was appointed Professor of the History and Interpretation of Art at Smith College. Later he became di-

talk over and settle everything with regard to her going to America. The Kandinskys left for Berlin only today. The good man will have more trouble in court on account of the Walden affair.*

I had a letter from Dr. Engel† which made me laugh, yet I was pleased to think that they remember me kindly. I was so young and full of pep at the time; the years I was harnessed to their concern were important for me. I can see it now. Having had development so different from other painters, I know that what those years of hard work and even compulsion did to me is just what I feel to be missing in the education of our Bauhaus students.

I received an article from the Deutscher Werkbund which deals with the Bauhaus and its aims at great length in a moderate and seemly way. They point to the fact that emphasis is placed on form *à tout prix* whether or not it is logical or usable. They illustrate their criticism with pertinent examples. The author of the article claims that a really ripe and original form can develop only after the student has acquired full mastery of a chosen craft, and not by being filled with all sorts of prototypes and theories. Now young people are almost all beginners. You see what I am aiming at in connection with my reflections on Dr. Engel's letter.

There is not much to tell about my doings at present. I am simply unable to produce for commercial enterprise or sale. If my work of free creation answers this demand, all to the good. . . .

---

Wednesday, January 23, 1924

. . . I was very pleased with Andreas. He has decided to build a set of kitchen furniture, trying to avoid the mistakes and shortcomings often found in Bauhaus designs. Yesterday he showed me his sketches, very good and simple and nicely executed. He really succeeded in keeping clear of the mannerism in fashion.

Yesterday we went to the movies again, and the film we saw was the most beautiful I have ever been to, at least for my American heart. A

---

rector of Smith's Museum of Art. Galka Emmy Scheyer organized the Blaue Vier, a group made up of the artists Feininger, Klee, Kandinsky, and Alexej von Jawlensky for the purpose of exhibiting their work.

* Kandinsky had left about 150 works of art in Herwarth Walden's Sturm Gallery. When he returned to Berlin, he received only a small amount of money from Walden, and only two canvases were returned. The rapid decline in the value of the mark was one of the causes of the discrepancy between what Kandinsky expected to receive in the way of payment and the money Walden paid him.

† Dr. Engel was probably a member of the staff of *Ulk,* the publication for which Feininger drew humorous cartoons early in his career.

marvelous railway story in the Rockies, perfectly authentic in detail, wonderful pictures of American express trains, so exciting and full of variety. I was quite transported. My American childhood recaptured me, and I became acutely conscious of the poisonous atmosphere in which we live. I realized that I, too, am a free American and the country across the sea is still my own land—not a strange world for me at which I gape, but truly my world—our world my dearest, yours and mine and our boys'.

Everything that occurs in the story—the racing trains, the high roads, the houses, and above all the people, the same human beings I loved as a child—all this is part of myself, not born out of my fantasy on European soil, in Paris or wherever. There are not so many different types among us in America. For that reason I think one feels more readily at home in America, even among strangers. *Au fond* they are all alike, good harmless folks, easy to know, no intellectuals (who are in a class by themselves). In the German version, the title of the film is *Das Rote Signal,* but the original that appeared on the screen was *The Westbound Limited,* which is much better. I was perfectly carried away by the beautiful pictures. There was one of a young horsewoman racing along on the tracks; the horse stumbled and fell and she desperately tried to free herself from under the beautiful white animal. At that moment in the distance the train appeared at top speed. It was a second of breathtaking suspense to watch the train come so close that we onlookers seemed to be under the cowcatcher before it was brought to a standstill. Another episode just as exciting: at night two express trains on a one-track line are rushing through a narrow valley in the mountains toward each other. A tremendous thunderstorm is going on. One sees the reflection of lightning on the wet steel of the cars. We are shown first one train then the other at different points on the line; watch the expression of each engine driver, first of one train then of the other during the run (as if from the outside—how this is done is a complete puzzle to me), the alarm in their eyes when all of a sudden they become aware of what is going to happen. The monsters are brought to a stop in the nick of time, but it is indescribable how horrible the growing tension is until one is really sure that the calamity will be averted.

Indeed, yesterday in the movies I felt free and easy, not at all like a dejected European any more but conscious of my American liberty, as if a new life had been given to me.

These last days I haven't had much energy. I was tired and lonely, but now I feel clear and unburdened. I feel as if I had overcome Weimar at last. I am as I was 20 years ago, before the war started, when my mind became afflicted. You can hardly know how much you help me if you are glad and happy. . . .

. . . A terrific thunderstorm was raging over Treptow. We were sitting in a compartment of the narrow-gauge railway which was to take us to Deep, and the hail was rattling on the roof of the cars. When we reached Deep, the storm had blown over, and we walked to our destination, the house of Fraulein Fritzner. Over a narrow bridge one crosses the river Rega to the opposite shore, and on through woods, which were still wet and steaming from rain, the air sultry and oppressive.

The sea is beautiful, only it looks so completely abandoned, such an expanse of water as I have never seen. It is as if never a vessel would pass by this stretch of coast—their course may be far beyond the horizon, so that nothing but a stream of smoke can be seen.

The woods in back of the dunes are a delight, and the path leading from the house over the dunes to the sea is very pleasant, thickly covered with pine needles. Yesterday after supper we took a short walk down to the beach. The western sky after the thunderstorm was a greenish yellow splendor, glowing through the twisted and distorted stems of the low pine trees. When we crossed the dunes we saw the sea spread out at our feet like a sheet of fabulous coppery gold. Another storm was approaching, and the peacock-blue shadowed side of an immense cloud stood out against the luminosity of the dunes. . . .

West-Deep
Monday before breakfast, August 18, 1924

. . . Yesterday we saw the most spectacular sight when we went down to the beach shortly before sunset. An immense double rainbow, sharp and clear, was spanning the sky over the dunes from a point in the east to where our path comes down. Since the sun had all but touched the horizon, the semicircle was nearly complete, a well-nigh soaring apparition. The intensity of the colors can hardly be described, the entire universe steeped in an uncanny copper glow at the sunset hour. In the east around the arc, all was a deep purple-violet. Layers of ghostlike clouds scuttling over the gloom indicated the approach of an enormous thunderstorm. Higher up above, the cloud bank bellied out, changing from purple to copper, fading into lemon yellow—though duller than the spectral yellow in the rainbow. The pageant lasted until the sun had completely disappeared; at the end only the foot of the arc in the east was visible against an almost midnight-black sky. Try to imagine with

Lyonel Feininger

this the warm brown of the dunes, much lighter than the sky—weird but awe-inspiring. At the same time, in the west, a sunset just as fantastic—out of zig-zagging clouds a blazing ray of light like a sword stretching over half the sky. . . .

West-Deep
Early Tuesday morning, August 19, 1924

. . . The news from Weimar is absolutely shocking. The chauvinists and the National Socialists, with Ludendorff presiding, have been fraternizing in an incredibly repulsive way. Hitler and his gang have been celebrated as heroes; resolutions have been decided upon which make one doubt the sanity of these people. I believe no good time lies ahead for free-thinking men. What are the auspices for the Bauhaus under this regime? I wonder whether Gropi has been around. Where there is danger, one always finds him on the spot and ready. For me it is quite soothing to be out of touch with Weimar for the time being. . . .

Weimar
November 12, 1924

. . . I saw Kandinsky to inquire about the Bauhaus affair. Friday they fought a big battle in the Landtag. Gropius told about the funds he had collected, and one of the rightists shouted, "Ah! The usual swindle." But that served him ill, for then it was agreed upon to summon Alfred Hess and another man from Erfurt, who are among the contributors, and the meeting was adjourned. Now Hess is said to have delivered an excellent speech yesterday. I didn't learn any of the details, but we know how well he can talk. His explanations created a sensation, and the assembly realized that the Bauhaus question could not be solved as simply as it had been hoped. Once more, therefore, the decision was postponed. Gropius has rounded up the sum of 100,000 German marks, an almost unbelievable thing, as it is extremely difficult these days to raise money. The Prime Minister is said to have been deeply impressed. Kandinsky hadn't talked to Gropius personally but has learned from Muche that prognosis for the Bauhaus is good now. . . .

. . . Perhaps now the sky will really brighten, and the clouds hanging over the Bauhaus and all of us will lift. Muche told me that the government had given us the buildings and the sum of 50,000 German marks per annum. A joint stock company has been founded with a provisory capital of 100,000 German marks to keep up production in the workshops. Thus, our independence is guaranteed, and the government will leave us unmolested to work as we think best for the development of the school. I feel as if elements of evil were withdrawing and as if I were capable of breathing freely once more. More than ever I have realized my inadequacy these last days. I have become terribly touchy, almost helpless against inner shocks or influences from the world around. Knowing that there existed an institution by the grace of the government called the Bauhaus, with claims on my time and energies, was enough to tinge my thinking and put my efforts at naught. I simply cannot bear to live under the tyranny of a suggestion of any kind. Yesterday I suddenly became conscious of the loss of the cheerfulness that was such a help during our first period here, at the beginning. For years now we have had to fight and bear up against hostility; we have been humiliated and degraded. No wonder our former high spirits have been sobered. But perhaps now things will change and clear up. We *do* need laughter and light impulses to make us feel alive and productive, or else, too easily, a mood of resignation creeps over us, and looking backward, we feel almost like giving up. Yet, in order not to lose the confidence of the young people, we had at least to avoid the appearance of being discouraged. . . .

9 P.M., Saturday, November 15, 1924

. . . I went to the movies to be alone among strangers, to have my thoughts pulled away from myself into the fidgety world on the screen. I saw *Soll und Haben*. It was a good performance. I was reminded of the first days after my arrival in Germany. This must have been the first book read to me in German by good old "Aunt" Prealle in the winter of 1887. Many dear recollections came to my mind, of youth eternally lost, when I was the age of my big boy now, when every single thing and experience was new, and Germany full of mystery of the "old world" for the American youngster.

In the *Kunstblatt,* notice is given of the publication of the new almanac *Europa,* with the title page by Léger. My name appears together with [Erik] Satie's, and a fugue by Feininger is announced. We two are

the only ones mentioned in the category of music. Satie is the outstanding French composer. He belongs to the group of painters and musicians in Paris, the Section d'Or. I had read about the foundation of this group; it was quite exciting at the time. Now, in a spiritual way I am getting in touch with them through my musical experiments. I wonder how the facsimile of the manuscript, though reduced in size, will turn out, and whether there will be any repercussions. These last days I have only been able to sit at the piano, longing for music; I had neither the inclination nor the strength for anything else.

---

Weimar
November 18, 1924

. . . Today I got to painting. It went well and was not as insufferable as it has been lately; nobody disturbed me. In the morning I met Kandinsky. Together we went to the Bauhaus. Gropi is in Cologne delivering a very important speech for the big industrialists. At present, we masters have not too clear a conception of the future—how the Bauhaus can be kept functioning, how to change it into a producing concern, yet at the same time to have it continue as an educational institution. It is a complicated problem. If only we had room for more students so that the number of those working in shops and earning could be augmented. That would leave us free to train newcomers and beginners in accordance with our principles and future needs, before we have to "fleece" them. This threat of a joint stock company hanging over our heads still may be the undoing of the wonderful idea of the Bauhaus as a school. We have to wait and see how things develop. . . .

---

Weimar
Wednesday, February 11, 1925

. . . The Kandinskys won't arrive in Dresden before Friday. So much has happened with regard to the proposals from Dessau that he has to meet the two gentlemen—the curator of the museum and the mayor—for an important talk on Thursday. It seems like a a very serious overture, and since it would be on short notice—to begin on the first of April—we have to examine it carefully and consider every possibility. It sounds ever so much better than the offer from Mannheim because it would mean that work in the Bauhaus could go on without months of interruption. The yearly budget would amount to 130,000 German

marks; no carrying over of former instructors, adequate space for the workshops and studios, and architectural commissions guaranteed. They want us immediately and in toto—and Gropi, the good man, not here, and nowhere to be reached. This we didn't dream of when we sent him out on his four-week vacation with our blessings.

Today there were three conferences, at twelve tomorrow the gentlemen from Dessau are expected. The spirit of that city is said to be quite democratic, on the whole not politically interested in the Bauhaus. We all agree that nowhere else would the soil be so well adapted to the ideology of the Bauhaus and to its ideas as in this little independent state. Though we are unanimous in our opinion that we ought to stay together and accept the offer, certain difficulties arise. With us Feiningers it is the question of the future education of the boys. Klee feels himself ready to go to Frankfurt, but Wichert* said to Muche the other day, "If you get an offer from some other place, don't hesitate to accept," and the same holds good for Klee. But, of course, we all think this is Klee's private affair; we shall not try to influence him. Only if he does go to Frankfurt, he might meet with great disappointment. We all know Wichert to be an extremely timid creature who looks upon his people as functionaries working to the tune of Prussian cultural tendencies. ·

Now the foremen of our workshops have as good as accepted the offer of the Weimar government to remain here—what a ludicrous situation. It will come to the point where Weimar with "its" Bauhaus is going to fight Dessau with Gropius and "our" Bauhaus. Instead of being dead the Bauhaus had doubled, "calved," so to speak. An investigation is of the utmost necessity and importance. It also will be interesting to see the town and the surrounding landscape. The country is flat, the Elbe not far, the Mulde flowing into that river a few miles to the south, and Dessau is the seat of the Junker's airplane factories. If I were absolutely without obligations, free to work on my own, I would be very much in favor of it. To remain here without our friends would just be hopelessly lonesome anyhow. . . .

================

Weimar
6:15 P.M., Thursday, February 12, 1925

. . . In the studio—a few words in a hurry to let you know about the conference with the mayor and the curator of Dessau. From 1 P.M. to 5:30 they have been with the masters, first inspecting the workshops,

---

* Dr. Fritz Wichert was director of the Frankfurt Art School.

Lyonel Feininger

later in Gropius's room for talks. I had gone to the studio to work at *Gaberndorf;* at 5 I went down to meet the party and to make the acquaintance of the delegates. This morning we met in Klee's studio to note down all the points and items we want to be taken into consideration—including the one bearing upon my desire of being free from teaching, which, in the afternoon, was willingly granted. Well, it was a powwow conducted in the most pleasant, liberal spirit. Their policy of building up industrially as well as economically, and now trying to get the Bauhaus in order to develop as a cultural center, speaks very much in their favor. All this gives a background, and if we can manage to stay together we shall be a group that may count not only at home but also abroad. The salary will be better than in Weimar, for we would be in the 10th rank, instead of 7th as we are here.

On Thursday the 19th, Kandinsky and Muche will go to Dessau to study and investigate conditions, to get a clear picture on the spot.

I had news from Mr. Erfurt. The pictures have arrived. He also writes that Arno is going to play several of my fugues at the opening of the Bauhaus show. You know how deeply that affects me. . . .

February 13, 1925

. . . As for Dessau, or a second edition of the fight for the Bauhaus—I am certain that not one of us goes into it lightheartedly. The possibility of working as freelancers hovers before our eyes like an enchanting vision. Klee, the dear man, said to me the other day and his voice had a pathetic ring, "Well, yes, now I begin to understand you, your desire for being free." He is wishing for a good "long pause." But to remain together is compelling for us all, and the most important and comforting thought.

Saturday afternoon: since 9 o'clock I have been in the studio, drawing in charcoal on my canvases with great care and precision. The cut-up *Gaberndorf* was the worst thing of that sort that I ever did. The longer I look at it the more content I am at having cut it up. In the end there was no truth or life in it any more, just handicraft. As a picture it was dead. Paying too much attention to manual skill may become dangerous, and I wonder if this is not particularly easy for a painter-professor at an institution? Often I am haunted by the idea of being driven into a rut, of having no escape left if employed at a school. It is like being caught in a nightmare, losing one's susceptibility, getting stingy with one's powers, until one day one sees clearly that it is too late and one cannot pull oneself together any more to fight for a way out. Isn't this

horrible-hor-ri-ble? And when an opportunity to free oneself occurs—one agrees to go to Dessau, thinking it may work out well. But they have assured and guaranteed me freedom from teaching—they only want me to remain attached to the common cause. . . .

<div style="text-align:center">═══════════</div>

Wednesday, February 18, 1925

Gropius has sent a wire giving his vote for Dessau and authorized us to go ahead with negotiations. I just met Moholy, eager to catch Muche, who is leaving for Dessau, to give him Gropius's message. Personally I had mail from France—Galerie Vavin-Raspail in Paris wants pictures and graphic work for a show—from the U.S., Point Loma, California, printed matter from a Theosophical Society (a-hem!)—and a postcard from Gropi with greetings from Naples. Half an hour ago I produced a letter full of groaning and moaning, which then I hadn't the courage to send off. You might as well read it here when you'll be back, and it won't poison your days in Hellerau. But I simply *had* to write it to be able to breathe freely, to get the load off my chest. Now I can go on under full sail. . . .

<div style="text-align:center">═══════════</div>

Friday, February 20, 1925

. . . We masters met today at noon to hear Kandinsky and Muche report on Dessau. The visit there marvelously successful, men and women equally satisfied. Mrs. Kandinsky and Mrs. Muche had been appointed to investigate the town. At first not overwhelmed, but later beyond the industrial section, a good impression, mounting to enthusiasm. Houses with studios for the masters to be built in a beautiful park, according to personal needs, to be ready by October. Water all around the town, the Mulde flowing into the Elbe, water sports, sailing, motorboating, angling. Wired Dessau "conditional acceptance of proposal, letter to follow." Now the masters' wives have to get together to consider the plan—but *my* mistress is missing. Of course it would be good to discuss our needs with Andreas as soon as possible.

Marcks without fail goes to Halle. Klee bides his time, waits to hear what Wichert is doing (does nothing! says yours truly). Schlemmer undecided. Otherwise all unanimous for Dessau. Do we take Gropi along (question of the editor)? . . .

<div style="text-align:center">═══════════</div>

Saturday, February 21, 1925

A thin layer of snow is lying on the roofs. It is damp and cold, nasty. Since the day before yesterday I have not had news from you; it really is not a long time. All the same, I am eager to hear what you have to say with regard to Dessau. We have been out of step with our letters.

I told Andreas about the plans for building our own house. He was enthusiastic. Muche spoke very nicely about the mayor in Dessau. He called him a generous man. They import the Bauhaus because they want to include fine arts in their program of cultural development. There is no stubborn tradition to fight, as here in Weimar, where the culture of a century ago, long dead, still has those living here now (as they see it) in its grip. When he was in Weimar visiting our mayor, the Dessau mayor expressed his surprise that Weimar will let the Bauhaus go. Whereupon Herr von Müller (or whatever his name is) pulled a long face, and, in the course of conversation, it emerged that he had never seen the inside of the Bauhaus. The one thing troubling us is Klee's attitude, his conscientiousness in taking Frankfurt's offer so seriously, believing it an obstacle to remaining with us. If he goes to Frankfurt, he will be very isolated, and I wonder whether Wichert has sufficient understanding of him to back him up. That is something I cannot quite penetrate. Or could it be that Klee also is afraid of being too much influenced by the Bauhaus ideology (that would be a reason I could understand)?

March 2, 1925

. . . What I am at right now I had better not say, but I am working with great intensity and am getting ahead. Gropius is expected back in Weimar on Wednesday. From then on we shall have no end of sessions and talk. I'm not very certain that he will be pleased or even agree to having one of his masters on the staff without obligations. This will have to be clearly settled. I had a letter from Appelbaum. On March 18 he is giving a concert in Leipzig and he is going to play my ninth fugue.

So finally the President died.* In Weimar the flags were at half mast, but oh, what a wonderful sight! Those gorgeous flags—gold and red—they didn't look at all like mourning in the bright sun. The feeling of spring in the air, the blue sky overhead, the ocher-yellow of the old houses, all this together created a mood of gaiety. These glowing colors, turning and twisting in the wind, golden yellow and vermilion and black against the blue sky. . . .

* Friedrich Ebert, President of the Weimar Republic, died on February 28, 1925.

We still do not try to prompt Klee; but we would be very sorry if he really were to leave us. On the whole, the way the troubled atmosphere of Weimar is brightening, and the curse that has been on us all these years seems to be lifted, is a miracle. Once more we are hopefully looking ahead, confident that no longer will we have to waste our powers in fighting constriction and stupidity. . . .

Weimar
March 2, 1925

. . . With patience and skill I have mended the three slashes in *Gaberndorf,* using the same sort of canvas the picture is painted on for sealing the back. It will be an easy job to paint over the traces. I don't mind these scars at all. I even think them an improvement. A strange thing happened to me in connection with this. After having worked for several days on a new canvas with the same motif, but in a different spirit, treating the color loosely, I had a pleasant surprise. On turning the cut-up picture around from the wall, it suddenly seemed beautiful to me in its depth and mystery; the colors strong and deeply glowing, almost more than in any other of my paintings. These days have done me much good; my joy in painting does not let up; my memory is improving. I really had been ripe for an asylum, it seems to me now, so unconcentrated have I been. If I can keep on working in this spirit, I won't leave for the seaside before June. By then I may have accumulated 25 good pictures. I am able to carry on as during my best times twelve years ago, and at large canvases, with large brushes and much color, as at the beginning. I have discarded the horrible Weimar white entirely. It was one of the reasons why I felt so utterly helpless technically.

Now I have to stop. It is getting dark. I have to wash all my brushes, and there is no electricity. They say that we shall have the new current soon. Today they put in the new bulbs. At home they took away the light meter. If they haven't put in the new one, we shall be sitting candle-lit again this evening. When I am so deep in work I am not very talkative, but I am thinking of my good little "sprite."

Friday, March 6, 1925

. . . What you tell me about the organist, of course, interests me very much. You can well imagine how I would like to make his acquaintance

Lyonel Feininger

and to have a talk with him about my musical work. Only I see that my music writing has fallen through a trapdoor, and I shall leave it there for the time being. That what I have written proves good enough to stand criticism in the long run is what concerns me, and it would make me very happy. But the one and only thing that really matters now is my painting—this has to stand the test or I am finished. . . . Not without good reason must the artist go through dark times—months, years often. They help in spiritual growth. After such a period, new clarity of purpose is revealed, and hopefully he feels joy return to his heart.

I met Kandinsky and we went home together. He told me that Gropius had talked to him. I won't say anything. I keep my neutrality. It all depends on Gropius. He may think of me as a nuisance on account of my expression of relief last year when things were so precarious and questionable in the Bauhaus. If he will take me along—God knows what his feelings may be—if I could be certain of going on with my work here as I do now, I would be almost afraid of moving. I am quite defenseless when I think of new embarrassments that may crop up in Dessau. . . .

Monday, March 9, 1925

. . . When I was mailing my letter to you on Saturday evening I was surprised to see light in Gropi's studio window. I thought of saying hello to him and went up. I knocked but was rather confused to hear a medley of voices. I was greeted by a crowd whose laughing faces—when I entered—slowly became recognizable. There were there, besides Gropi, all the masters and their wives. They were still together after the tea party in honor of the people from Dessau, which I was supposed to have attended, but had forgotten. The Dessauers had already left. I was completely dumbfounded. Gropi—the way he looked—seemed very angry at me. I begged his forgiveness, but what could have produced a better effect than my stupid face! Words were not necessary. The great day had passed without my assistance. When I saw Kandinsky in the morning, he just told me "tea at 4:30." He himself didn't know more, nor where we were to meet. Later in the afternoon somebody went to fetch him, but not even Kandinsky had the bright idea of getting me. Well—I did not mind too much at having been left out—I had spent some hours working in peace, and was just as happy. . . . Yesterday, Sunday, the Muche show was opened in the skylight hall. I went around noon and met Gropi with his new wife, Ise, and some of the masters. We all sat together on the bench under the side window, talking about the pictures and Dessau, and listening to Gropi, who

talked about Italy. With Naples he was especially delighted, also with the people. He has a wonderful tan, feels fine and restored, which is not surprising, having been bathing in the Mediterranean for weeks and sunbathing for hours every day. He was very reserved with regard to Dessau. The auspices for future development are promising, but at present everything is not as rosy as was thought at first. The housing question especially presents difficulties. Only one-third of the million German marks is to be used for the buildings, and even this partial sum is not willingly granted by the town councillors. They object to spending it on strangers, since they have not been permitted to build for themselves. Today Gropi is giving a lecture in Dessau—probably "Art and Technique," etc. He has to examine things personally and talk to people, of course. I can't write more about possible results. Our aims are becoming more and more clear, and have been expressed very precisely in an article by Moholy. They go against my grain in every respect, distress me terribly. What has been "art" for ages is to be discarded—to be replaced by new ideals. There is talk only about optics, mechanics, and moving pictures. Colored diapositives, mechanically produced, stored like gramophone records and placed into viewers, are the art mankind is to have from now on, within reach at every moment, usable according to mood. Cooperation is no longer requested from the onlooker, no call upon the mind to take in what an artist has tried to express—this Moholy calls "static," not fitting into our fast-moving time. It certainly is a very interesting project, a gadget for the masses, but why call a device like this by the name of art? It is frightening. And to think of this as the one and only art of the present and the future means the end of everything that was once understood to be art. Would this create an atmosphere for Klee or myself or some others of us to grow in? Klee was very depressed yesterday when we talked about Moholy. He called it the "prefabricated spirit of the time."

I am sending you the catalogue of the show in Wiesbaden, which arrived today. You will see that I don't cut too bad a figure in comparison to the others—there are some good works. . . .

Wednesday, March 11, 1925

. . . Today I am sending you the catalogue of the show at Daniel's Gallery in New York staged by Emmy Scheyer.

We [Kandinsky and Feininger] sat in the café and just chatted, and it was only on the way home that we talked about Gropius. Kandinsky made it quite clear that they all want me to come along. Only Gropius said he feels somewhat embarrassed and doesn't quite know what to

Lyonel Feininger

offer me if I won't teach. Kandinsky was entrusted to talk it over with me. Gropius, Kandinsky said, had proposed to let me have the house and studio rent-free, but no salary, which I think is perfectly justified and absolutely fair. I shall be happy with whatever solution if it keeps me free from any obligation. We also talked about the houses. Muche, we thought, is right to recommend centralization of management. One very modern plant for all the houses in common, furnace, laundry, etc., for economical reasons and to simplify the upkeep as well as to save work for each single household by having one caretaker for all together. It would also reduce building costs and leave money free to be spent on more important items, not to be foreseen now. Closets and wardrobes built in, balconies, terraces, porches, all this goes without saying.

March 12, 1925

. . . I got your special-delivery letter yesterday evening. If ever a word from you came at the right time and at a critical moment, it was this one. We must calmly and scrupulously consider what would be the proper thing for us. We have to wait for decisions. Gropius came back from Dessau yesterday evening. They will have a meeting today, at which he will report to the masters. Nobody asked me to join them; therefore I do not know how the land lies at present, and I consider myself not to belong among them. They obviously want to keep me here— Engelmann repeatedly hinted at it—with a salary and no obligations, only to belong to the staff, to be consulted whenever a student wanted to talk to me. Of course, there is no question of remaining, since it seems to be an accepted fact that I am going with them all to Dessau. Besides I would loathe to be here without our friends; my equilibrium depends too much on harmonious relations with my surroundings, on good understanding with those I live with. I suffer if things are doubtful or unfriendly in this respect. Of course, there is Moholy, his ideas and system of opinions. They are considered by Gropi as the most important thing for the development of the technical institution he wants the Bauhaus to become; in fact, Moholy, from this point of view, is *the* man. But we others also count as representing, in the personalities of each single master, the different ways of expressing that which makes our time eminently rich and unlike any one before. Andreas told me that at least 20 students had asked him whether I was to go to Dessau. This should give Gropi something to think over. Yet I would find myself in a very doubtful position if the only reason for taking me along was to spare my feelings. We just have to wait to see how things will develop. Let others break their heads to find a solution to this dilemma.

Now my little sprite, you see how much good your letter did me, and I think that I went into the question correctly. Kandinsky repeatedly said to me that Weimar would be missed by all of us; we all feel the same way. We personally—you and I—formerly loved Weimar above all other towns in Germany. But the hostilities against the Bauhaus, and the gangsters who pecked at us without interruption right from the beginning, cast an evil spell on this little place, and we were drawn into the maelstrom of passions. No, to think of remaining here alone, separated from our friends, would be too much for me.

It is very cold; I am freezing in the studio. The Bauhaus has used up its budget and is not provided with fuel any more. . . .

Early Sunday morning, April 26, 1925

. . . I have worked with great intensity. That helped me get through the day. Wiesbaden has returned the pictures from the show. They are standing in the studio, and I am learning a lot. The two that belong to you, *Nieder-Reissen* and *Blue Marine,* look very good. Comparing these to the small marines I have painted lately, I see that once more I have to free myself from being too much influenced by nature. Every once in a while I make this mistake, only to have to overcome and correct it in those that follow—and not only marines. It would be so much simpler to avoid it from the start but maybe that too wouldn't be the right way. It might become routine. I don't know—I am doomed to suffering in order to achieve a thing.

In the evening my good Lux came to the studio. He said that he thought I might be lonesome. It made me very happy. It showed so much delicacy and warmhearted consideration. He told me about Andreas, who had returned from the examinations very late, having lived on sausage sandwiches during the day. But the happy news is that of the twelve candidates Andreas has come off first. His artisan's test piece was by far the best. Likewise, though it sounds a joke, the Bauhaus examinees, as a whole, did much better than all the others. All of a sudden, credit is given to what they have been fighting against—all that Gropius has propounded that they have held against him. Besides, now it has become the "Weimar Bauhaus."

With regard to the election of the President, Weimar is like a madhouse. At noon a military parade with flying colors, black, white, and red, and the flourish of trumpets and ear-piercing pipes marched along the Marian Strasse, cheering and yelling. Whoever owned the simplest pipe joined in the hullabaloo, the "savior" of the Vaterland inspires them all. The savior who is to lead the country into war again—to trust

humanity, and to build up feelings of brotherhood with other nations would take too long. Besides, the demands of self-abnegation, discipline, and the true Christian spirit would be too great to permit them to achieve peaceful intercourse with the world. Nobody here seems to be aware of the fact that with the candidacy of Hindenburg, all foreign credit has been stopped. Misery and material suffering will soon be worse than ever before—but, "We'll show them." They don't mind at all if those who are not of their opinion are hurt. One could have seen this type of the German race in the streets—a loathsome caricature of mankind. . . .

—————————————

Monday, May 4, 1925

. . . Schlemmer has just left. He wanted to talk to me about the meeting in Dessau. But neither he nor I shall attend. We have to leave it to Kandinsky to be the spokesman for our demands as to the number of rooms, etc., in the houses. I have written repeatedly and made it quite clear what we would have to have. Now I think not much can be done anyhow, since the plans are finished, finally and unalterably. Schlemmer has had a reply about the payment of the subsidy that has been promised to the masters. This, though, only holds good for those who are already in Dessau and have to have rooms there temporarily while they still keep their households running here in Weimar. So it does not concern us. But I am somewhat ruffled by the request that I contribute to the party that has been given in Dessau. Why pay for "coffee, liquor, candles, flowers, etc.," which I didn't see, since I wasn't there? But I guess we have to for the sake of solidarity. . . .

—————————————

May 6, 1925

. . . Just a few lines for a practical reason. I stayed home all day, didn't dare leave the house, waiting for the mailman with the money, but unfortunately he didn't turn up. Are you sure that they sent it on Monday? If they haven't done so, please let me have 50 German marks by wire. We scraped together all our pennies to pay the water bill. Now we are stranded.

I didn't see Kandinsky before he left for Dessau. I am powerless now, can't say or do a thing. We just have to wait and see how Gropius will act. He knows damned well what we want, and if he isn't able to provide for our needs we shall have to see how to come to an understand-

ing, short of a clash. Schlemmer, again, told me of his difficulties. For his scenery at the theater he is to be paid 1,000 German marks. For that money he has to put up I don't know how many scenarios a season. At the Bauhaus he has theater classes, with acting and teaching, and his salary—besides the free studio—will be 600 German marks. That is as good as nothing. It is evident already what advertising value the theater department and the band alone have for the Bauhaus, and almost daily Gropius makes use of these two attractions as means of propaganda. It seems as if Schlemmer were not treated very nicely. I for my part am coming into bloom here, far away from the Bauhaus and all its troubles and confusing excitement—which by all appearances are merrily going on in Dessau. . . .

May 7, 1925

. . . Mrs. Gropius, whom I met the other day, gave me some information about the houses in Dessau. It seems as though the needs of the masters had really been taken into consideration. We are to have seven or eight rooms, she said. But the funds will by no means suffice, and Gropius is trying to put the costs of the studios on a special budget. Mrs. Gropius was very amiable. She talked in terms of high approval of the landscape, but with less of what she called the "stink" from all the factories at the four corners of the town. . . .

West-Deep
June 24, 1925

. . . Thunderclouds of gigantic size filled the sky over the sea. Far away one single flash of lightning zigzagged down. The rolling of thunder came after a long while, and that was all. Behind us the clouds were like mountain ranges, their blackish-violet color—ghastly—intensified against the brightness of the beach and the dunes, which caught the sunlight breaking through in the west. There was so much variety. It was very stimulating walking. A new fugue was running in my mind. I have noted down the motifs on my drawing pad. You wouldn't believe how the aspect of the shore has changed since they have planted beach grass in a methodical way. Almost mathematically straight, the dunes come down to meet the beach; not much left to nature and what there is, utterly inexpressive. But in a strange way it now resembles my painting *Rainbow over the Dunes,* which is also conceived in straight lines and

Lyonel Feininger

as a painting does express the mood of this afternoon. There is not a bulge or a bump left which might serve as a landmark. One walks and walks along this regulated stretch as if into infinity. . . .

. . . I just had a visit from Gropi, who is here on account of a lawsuit, . . . and he is as good as he can be, and that is very good. He looks terribly tired from overwork, but he is full of confidence and very optimistic about the future in Dessau. He asked after you and the boys, then told me about the houses, which, of course, interested me most of all. The scaffolding is finished. The roofs will be on before the cold sets in. If weather conditions remain favorable, the houses will be finished by February. The Bauhaus building, a block of three buildings rather, is under construction; the work on them goes on feverishly. They wish to move in by Easter. There will be a special studio wing for 24 master students. The building for the workshops is a huge construction of glass, and the third part, connecting these two, includes the stage, a mess hall and kitchen on the ground floor, on the bridge above the offices. Baths, etc., are in the basement. The architectural department is already in full swing. Schmidtchen [Joos Schmidt] has been appointed to a position now in Dessau. Gropi would like to have [Erich] Dieckmann also. We talked about Breuer.* I expressed my doubts, wondering whether difficulties would arise, too many disagreements, but our friend was well aware of that. . . .

Weimar
December 2, 1925

We are staying put here while you are darting to and fro. We constantly wonder what may come your way. We are having wonderful weather, very cold, no wind, and the winter sun on the glittering snow, which does not melt it, nevertheless. I have been very well behaved. I've finished cutting the title page [of the portfolio of prints], have made proof prints, and have sent some to the publishers already. But I guess Dr. Rathenau will have to consult with the bookbinder as to the paper best adapted for the cover. Soft paper, which is best for printing, is no good for the cover. It rubs off at the corners too easily. I am thinking of some sort of vellum, spread uninterrupted from front to back on both

* Marcel Breuer, the architect, who joined the Bauhaus staff in Dessau.

sides of the cover of the portfolio. I would hand print the wood-block title, which then can be mounted on the front side of the cover—and I could print it on soft paper. To print on the cover itself seems impracticable. . . .

═══════════

[December 8, 1925]

. . . There is no reason for not writing to you, since I cannot come personally. I am working on six paintings alternately. I want to have them for Dresden, to be substituted for those which have been shown there before and won't go again. Also I am painting *Architecture II* (Lüneburg) as a big and most important one which is marked for Mannheim. Besides, there is so much else, including Christmas approaching, which always interferes with my work. So you see that I have to maintain my ground and renounce the laurel wreath promised to me as a reward in case I were to go to Berlin.

As to Dessau, it will be weeks before they can think of continuing their work on the buildings on account of the cold. The Elbe is frozen to the ground, all navigation stopped. It will be time enough to decide upon colors for the walls in January. What is needed now is saving fare and working at home.

It is miserably cold in the studio. I have to saw wood in between to keep warm enough for painting. I cannot remember that we ever had such low temperatures. I am also working at the large *Barfüsserkirche*. I have, so to speak, redone it. I have effaced the naturalistic figures, painted over much of the surface. I think I have achieved great monumentality. . . .

═══════════

Weimar
St. Patrick's Day, March 17, 1926

. . . I wrote to the Goldschmidt and Wallerstein Gallery asking them to let me know immediately whether they want the painting sent by special delivery after the show closes in Dresden on Monday. Probably it is the same man who wanted the picture last winter, who proposed to pay in bonds. But I think we should, at least, get part of the payment in cash. An invitation arrived from Dessau for the Bauhaus Festival; a card of admission costs 5 German marks if one goes in fancy costume, 10 German marks for ordinary mortals. This took the wind out of Andreas's sails, for he had considered going. Instead he will use the

money to have his bicycle repaired. Nothing else worth reporting. I am in the midst of getting ready for the show in Braunschweig. It will be necessary to order several boxes for the five large oils which have to go. . . . The enclosed card came from Muche. Typically Bauhaus—to remember at the last possible moment that they also should have a show! Of course I answered, "Nothing doing, sirs." I don't rush into such things without preparation. Besides, [Ludwig] Grote has priority with his plan for a graphics show. . . .

## The Bauhaus Years in Dessau and Berlin
## (July 30, 1926–May 18, 1933)

Dessau
July 30, 1926

Today I got your first report about Andreas's condition. If only it continues without complications, how happy we could be. All such reflections, and all thought between you and me circling around the beloved boy, have to be telepathic—it is so difficult to express in writing anything until I am assured of a final turn for the good.

I arrived safely [in Dessau from Weimar] after my journey. Everybody is wonderfully kind. They are all concerned about Andreas. At the Klee's I was received with a cup of excellent coffee, which was most welcome. We sat together for a while, for we had a lot to talk about. At 5 I was expected at the Kandinsky's for tea, greeted by Nina with the words, "We shall spoil Papileo to the utmost," and that's what they all do.

Later in the day, Wilma and I went to our house, but it was locked and Herr Hosgen, the overseer, nowhere to be found. Being terribly tired, I went to bed at 9, and slept quite well. The next morning around 6 I heard the roar of a heavy motor and wondered whether this might possibly be our van. But I remembered that the Klees had had to wait until 2 P.M. for theirs, so I thought I would not hurry and got up at 7. But Lily [Klee] had also heard the noise and came out in her morning gown, the good soul, to prepare breakfast for me.

Soon after someone shouted, "The people from Weimar have arrived!" and from that moment on there was no rest any more. It has been the busiest day of my life.

We had to find Herr Hosgen on account of the keys. Luckily he turned up soon but had forgotten to bring the keys, having left them in town (genius that he is). So he had to bicycle back, and, finally, about

8:30, the unloading got started. Fortunately we were not too much bothered by the rain. Everything went without a hitch, and around 7 P.M. all our things were in place, and the boxes with the china and the wood crates unpacked. But oh, what an ungodly heap of books we have! We are now up to our ears in chaos. Much dirt was brought in, since the garden path is not yet paved and each single piece had to be carried a distance of about 40 meters from the road to the house over the wet soil. Wilma is indefatigable, always cheerful, cleaning up, ordering, directing the workmen. There is a constant coming and going. It is like a beehive—and I have to be all over the place at the same time.

Tonight for the first time we shall sleep in our own house. Gropi is a dear; his wife also is kind and considerate. Manon and Gropi's mother are here on a visit. They all ask after Andreas, wishing him a speedy recovery, and they send loving greetings.

This much I can already tell you today: the house will be delightful. Klee's studio is marvelous, and mine will be fine also, though I do not own such a beauty of a desk. We had dinner together in a restaurant in Ziebigk, for 80 pfennigs a person, very good and plenty. Right now Wilma has made coffee, a large pot full, and it is welcomed as just the right thing at the right moment. I am sitting and drinking it in the dining room. There is absolutely too much to report. Things will have to come out one by one. All my bones are aching from unpacking and running up and down the stairs a hundred times—but we are in very good spirits.

It is raining and the sun is shining by turns every quarter hour. The bicycles are safe in the shed provided for them. Lux can feel at ease in that respect. When he comes tomorrow, he will have to put his room in order, store his books, etc. Also Andreas's and Laurence's things will be taken up to the top floor. Then there will be space in the living room to turn about in, which, at present, is an impossibility. You will be happy here. Your rooms are charming.

Love and greetings to Andreas, all our wishes are with him that he may feel better every new day. . . .

———————————

Burgkuhnauer Allee 3, Dessau
August 4, 1926

. . . It is almost too beautiful here. Something new is met with at every hour of the day, according to the position of the sun. The light effects on the terraces and in the rooms change in a most interesting way. The long balcony of the south room is like the promenade deck of an ocean liner. I have just now been walking on it for ten minutes, to

and fro in the morning sun after breakfast, which I had on the lovely terrace below. We shall never be sorry for having left Gutenberg Strasse, not to mention everything else which has hung around our necks like millstones, wearing us down.

Yesterday, I got up at 5:30. Feeling refreshed and happy, I finished putting the studio in working order. Everything now has its place. I can lay my hand on any item in the dark. With so many shelves built in, the room proper can be left entirely free for work, nothing standing against the walls. It is clear space.

Again and again I have to tell you how much I love the location of the houses. The more one gets to know the details, the more one is pleased. The sun-filtered pine woods, the rhythm of the slender upright stems. To be near friends in the other houses—not too close nor too far away. It makes us all feel good. We all are in a happy frame of mind. . . .

<hr>

Monday, August 6, 1926

. . . My dearest, at last I dug up a pen. I am sitting on the terrace, which is a simply enchanting place. The projection overhead and the short wall at the south . . . which we objected to so vigorously when we saw the blueprints are the absolutely right thing in reality. The light would be too blinding, the sun and midday heat too strong without them. The trees are a blessing. The eye can look into the green without blinking. And how beautiful the treetops are against the sky, free space all around, and the feeling of open air in motion filtered through the pine woods is very wonderful. I would never have believed that our balcony in Weimar could so easily be forgotten. On the contrary, it all is a thousand times more beautiful here.

Our dining room is not too small. Andreas's furniture is so colorful in the warm hues of the wood. It makes the room look handsome and snug. We will be comfortable in it with guests. It is harmonious even without pictures on the walls. The living room will be magnificent. The books have been put in place, but only temporarily. To arrange them in systematic order will be our Mami's task. The sheets of music found their place in our long black former book shelf, so one is saved the bothersome hauling out of drawers. The monster chest-of-drawers for my graphic work is, of course, an eyesore so far. Gropi, whom I consulted about having it put into the studio, said that it would have to be taken apart to be conveyed upstairs. I shall have it done later.

Gropi is, as usual, terribly rushed. All the more to his credit that he lends an ear to our wishes and is always most willing to help. All the

many boxes are stored in the cellar, also the packing material. Thank heaven that is out of sight. The hall and the staircase are my delight. It is so jolly—the red bannister against the blue of the walls. We have to do something to our balcony furniture, the wicker chairs, etc., which don't look nice any more. I am willing to repaint them myself. Would you like to have them a bright vermilion? I think that would look jolly.

Outside, laborers and gardeners are at work clearing away rubbish, leveling the ground, and laying out paths. Schlemmer will be moving in tomorrow. Gropius's house, of course, is miraculous. The furniture and the entire setup are intended as representative. It would take too long now to tell you in detail about all there is in the way of work-saving invention and gadgets. Soon you will see for yourself. But truly and honestly one has to call it an architectural achievement in a new, quite modern style.

Sunday afternoon there was a great reception—all the masters and all the dignitaries of the town. The people in Dessau are terribly curious. Their interest in us is enormous, and in the most naïve way they stare and gape at our houses. Gropi, of course, has caught their fancy most of all, which is natural. The poor man had to put up a high concrete wall in order to protect his grounds from the invasion of masses of too eager citizens. . . .

August 7, 1926

. . . Our hopes of seeing you and Andreas in a few days have been banished by your special-delivery letter this morning. We have been so happy with the progress of his recovery.

I am sure that you both would like to hear how we are getting ahead. The floors in all the rooms are waxed now. Yesterday they did the studio. The dark gray linoleum takes on a soft sheen and looks beautiful. Also the rugs are spread in the different rooms. Only it is too bad that the workmen are coming in constantly, messing up what has just been cleaned. It is good to have a bathroom—and it functions, though the water is still a deep yellow mud, owing to the floods they have had this year.

Yesterday I went to the harbor with Lux, who goes there often. The landscape is very lovely. The embankments are still flooded; out in the middle of the river the current is violent. Along the shores, anglers by the dozens, motorboats coming and going, but the big tow-barges with freight had to be stopped, the water under the bridges being too high for their passage. In the harbor two large Junkers flying boats were at

anchor. One had its wing off, and you could see the inner construction through the hole, the gray struts (probably some light metal), and the hinges which hold the wings of brass.

Yesterday we had the first thunderstorm, far away. Today it is very hot, with south wind, the sky a leaden gray-blue.

We shall have to decide about curtains when you get here. Your two rooms on the south side will have to have some protection against the blazing sun and heat. I'll wait to hang pictures until you come. I am through with painting the wicker furniture, but it has been convict work, I can tell you. Yet I didn't mind, for it has beautified the set immensely. Only here I realized how ugly they had become, weatherworn and gray. Now it is like the growth of some exotic beauty made of coral, or such.

On Thursday afternoon I had a visit from Probst.* The museum in Dresden wants a reduction on *Sloop Maria.* Probst told me that out of the 200,000 German marks at their disposal for acquisitions, they pay enormous sums for the works of foreign artists and "normal" Germans. I have had the impression that some sort of clique is at work at Dresden, and Probst has confirmed it. He said he would not go down on the price for my picture. After the show he thinks that more than one person will want *Sloop Maria,* and he has a client for *Gelmeroda IX.* A date has been made during the first part of September for an exhibition in Hamburg—Klee and I together—oils and watercolors. That suits me.

I know nothing of all the gossip about the Bauhaus. Work on the buildings is going on in full swing. Good Heavens! What are they doing in Weimar worth speaking of? Just ask the philistines and see what their answer is. Mean jealousy is behind all that talk in Weimar. They would love it if elsewhere cultural values were smashed, attempts of others for the reconstruction of Germany frustrated. What welcome food for their jeers! Every single German should damn well care that we here in Dessau are doing good work. . . .

Dessau
August 14, 1926

. . . At 6 sharp every morning the workmen turn up, felling trees, carting sand and soil, spreading gravel. A gardener has been sowing grass, and a few hours later one already sees the brown earth take on a greenish shimmer, which develops into a definite green, and overnight we have a good lawn, dew-besprinkled this morning. The work in the garden will be finished today.

* Rudolf Probst was the director of the Fides Gallery in Dresden.

The rumors of a strike at the Bauhaus, of work stopping in the shops, that are circulating in Weimar as you write, are, of course, mean lies. They should concern themselves with their own mess rather than meddling with other people's affairs that are going well. The Klees will be leaving for Switzerland soon. The Moholys are still in Holland. I am going to have tea with the Muches on Sunday. Frau Schlemmer asked me to lend her a bed. She wants it for herself until her new furniture is finished. Since we don't need it now, of course I gave it to her.

I am looking forward to getting the chairs for the dining room. It was a very good idea to have the material for the seats hand-woven at Fräulein Borner's. The room will be beautiful. We have to thank Andreas for it. It is his work entirely.

Of all the times we have had to live through being separated from each other, these weeks have been the most critical. I here preparing for a new start in our lives—and you with the sick boy. I firmly believe that after this a period of continuous and fruitful work will set in—after we have thrown off the last years in Weimar. Freed from that nightmare, we shall take a new turn, regain our power, revive. . . .

Dessau
February 25, 1927

. . . I have been working with great concentration today at the picture *Incoming Steamer*. I have been able to combine a strong visionary conception with technical skill in a way that has been rare lately. . . . To have freed myself from a more static approach is in itself an achievement after these last 7 years. I am aware of building up a new and very different picture form. It makes me feel happy and confident about future works. How lovely these last days have been. I had the south door leading onto the balcony open all day.

I have a piece of news for you which I forgot to mention over the telephone: We have been registered as American citizens—are you glad? All our friends have expressed their pleasure that Maria Marc will be coming with you to Dessau.* When can we expect you? For dinner? Or later? We will have a series of reunions and festive days. Wishing you both a good time in Dresden—it must be lovely there in this early spring. . . .

* Maria Marc, the widow of Franz Marc.

Lyonel Feininger

West-Deep
Sunday, July 24, 1927

. . . It has almost become a standing habit to go down to the beach toward 7 in the evening to watch the sunset. The shore is wide and beautiful where the ten rows of beams have been rammed in to dam up the sand, although the dunes there are now as straight as a railway embankment. The mole they are building reaches out into the sea for about 150 meters. With derricks and pile drivers still on it, it looks from afar like Stevenson's *Rocket*. They are dredging constantly. Although they want the sand to collect along the stretch of shore in order to widen the beach, they have to keep it out of the channel in the river mouth and not let a sandbar pile up so that the fishermen can get out to sea. But I am still overcome by the loneliness of this part of the sea—no navigation to speak of. At times a single freighter creeps along the horizon far out. Maybe we don't see all there are, for we don't go to the beach as often as at first. We dislike the crowd that has invaded it. There are too many kids and fat, brown mamas and papas. Later in the season, after they have disappeared, we shall go down again.

I am working every day now with great perseverance. I'm beginning to move in a certain direction, although I don't expect results to show immediately. I am seeking for new means of expression. I see the possibility of moving out of the rut of the last three years. A deep love for all things is again enfolding me. Whatever I achieve, it will not have been a vain effort for me.

The other day, out at sea, Lux's *Pearl of Malabar* showed her qualities in calm weather. Though my *Princess* has always been victorious in a good wind, the *Pearl* simply slid away, seemed to take wing. She led the others a dance in that calm. Of course, Lux was happy and I with him. The boy has a gift for building fast boats.

I am reading *Main Street*. All that is so familiar to me. I know the reason for avoiding my compatriots here in Germany. See what has happened to the best of them? One is lonely even among the good Europeans, but there are other aspects of loneliness which are worse. . . .

West-Deep
July 25, 1927

. . . What you wrote about [Alois J.] Schardt's visit sounds good and encouraging. I am working hard, am full of ideas, feeling new power accumulating, and in the fall I shall be rested, ready to put into effect what

is only a promise now. Of course, I think that Schardt's opinion of me is exaggerated, though in one respect, perhaps, my work may be considered of significance, in its passionate quest for strict delineation of space without any compromise—never for picturesque effects. Hausenstein called me a maniac—but he meant it as a reproach. If I have to be a martyr for spatial cubism, O.K. with me. The others seem to me to be just playing with form and arranging it in a pretty and tasteful way that is pleasing to the bourgeois. Now Schardt—the fanatic that he is himself—understands the fanatic in Feininger. . . .

West-Deep
August 2, 1927

. . . I don't paint a picture for the purpose of creating an aesthetic achievement, and I never think of pictures in the traditional sense. From deep within me arises an almost painful urge for realization of inner experiences, an overwhelming longing, an unearthly nostalgia overcomes me at times to bring them to light out of a long lost past. Does this seem wrong? In the "present" I am only concerned with the *process* of work. The "past" provides the incentive. Here in Deep I am detached. . . .

September 16, 1927

. . . I have started a new series of pictures, 2 *Gelmeroda*s and some other motifs, all 80 by 100 cm. I cannot work now as I did last spring. Quite consciously I organize in terms of color. In a quick and energetic way I apply my colors, covering the entire surface, intent on keeping the pigment fresh and vivid to the finish. I want to avoid the sort of correct timidity which lately has been a pain in the neck to me. I am trying to recapture a more vigorous modulation of form. There has been too much nature in my paintings these last years. For that reason people became more and more delighted with my work. For them naturalism, as they see it, means progress, as they understand it. . . .

Dessau
September 19, 1927

The opening [of the art exhibit of Bauhaus masters in the Dessau Museum] on Saturday was a very official affair. Only men invited, and

there must have been a terrific crowd milling around. Kandinsky came home half dead. He told me all about it. It seems that I have three paintings hanging, obviously well placed in the big room, opposite Moholy. Klee and Kandinsky are in one of the small rooms together. I am enclosing a review, which is well meant and optimistic. The museum will be of importance in the future. Köhler, Kunze, and several other museum directors were present. Köhler was the only one to stay over-night. Sunday morning he came for a short visit at 9:30. It was very nice to see him again, but he had to be at the Bauhaus at 10 with a conducted party, and at 11 he had to catch a train. He sends cordial greetings.

I have prepared four large stretchers and made one new charcoal composition. I want to make the most, take advantage of my feeling for form as long as it lasts and is as strong as now. . . .

September 24, 1927

. . . I have been painting with the utmost concentration from morning until now—5 P.M. A strange consideration: my charcoal compositions certainly stand up as works in their own right, but could be no more than suggestions for paintings, which are governed by quite dissimilar laws. It would not do merely to transpose these studies into color. I had to free myself completely from being influenced by them while at work today. . . .

Dessau
September 28, 1927

. . . On my easel I have a picture which promises to become a painting built up really in terms of color. What I was able to realize for the first time this summer with utmost concentration—graphically, in pen-and-ink and in charcoal drawings—I am now trying to attain in color. The picture is designed after a charcoal drawing, not imitatively, in tone values, but in color spaces which contain none of the gradation of the drawing. It seems to me to be leading into new lands, away from the roads I had hitherto followed. Only yesterday it dawned on me to try this approach, and today I have already advanced so far that I can speak of painting, combining form and space determined by color. It would be wrong to write more explicitly about it now, I want to go on quietly, but I am full of confidence. This last summer's hard work, from

which nothing could distract me, has furthered my work immensely. I was justified in not producing watercolors, for I did not want to *sprudeln* [bubble], to use an expression of Thomas Mann's. I have come through now in my painting all the more vigorously for it. . . .

Late afternoon, Sunday, October 2, 1927

. . . What is going on here is beyond belief and almost beyond endurance. Crowds of idlers slowly amble along Burgkuhnauer Allee, from morning to night, goggling at our houses, not to speak of trespassing in our gardens to stare in the windows. From every vehicle, horsedrawn or automobile, heads pop out, people crook their necks to get a good eyeful. Sightseeing tours through the Bauhaus take place every day, architects, craftsmen, trade unions, women's clubs, and God knows what other associations. Today Moholy was leading a gang in turned-down collars. They stood in front of our house until all were assembled. Out on the road there was one creature who was absolutely objectionable, whiskered, long-haired, and unkempt. When he saw him, Andreas cried out, "The missing link!" It is awful to be subjected helplessly to such invasions. Friends coming to visit are always welcome, and some sort of give-and-take generally comes off to make it interesting, but this sort of publicity is hateful. I am developing claustrophobia. It is demoralizing. . . .

Dessau
October 5, 1927

Yesterday I didn't get to write until evening, and for that reason I was plagued by distressing dreams at night. These last evenings after supper I have played the piano, studying the *Art of the Fugue* with great intensity. Also yesterday I made a new charcoal-and-pen drawing—and just yesterday I had been so happy with your letter and had wanted to write immediately. I had in mind to tell you that I feel as you do with regard to our old haunts, Magdeburger Platz, Lutzow Platz, and Schill Strasse. To think of the youth I was then with life still ahead of me. Full of longing, one looks around for what may be left, only to admit reluctantly that, *au fond,* all is changed. To remember the peaceful tranquillity of those years when we were both young. Goodness, walking along the Lutzow Ufer on a sunny summer morning and turning into Bendler Strasse, you would see one lonely hack jogging close to the

sidewalk, and in Lutzow Strasse the small, short, horse-drawn tramcar would just have passed. Today there is acceleration, noise, and stink.

The youngsters of this generation will never know the atmosphere of peace, which, as I see now, formed the background of our lives and development. They only know instability. With rapid strides they are pushing on. They have a restlessness which prevents intense concentration. One can choose between living in the midst of turmoil, traveling about our planet, getting to know things—or withdrawing from today's hyperactivity, carrying within one's mind and heart the picture of this world according to one's conscience—and not even have a feeling of missing much. Our recollections are sanctuaries to which we can turn in later years, there to seek comfort, to forget about the day's grievances and disappointments. Though we also may get accustomed to that, hardly expecting anything else, one nose-length ahead, hope is always beckoning and leading us on. We don't think of a "too late" until one day dawns when there is no more.

I want to say a little more about our former neighborhood in Berlin. There may still be old houses where life holds memories, hardly changed. Only one should not dig too deeply into these relics. Nettelbeck Strasse and the section Am Park are full of personal experiences and magic. The glamour and pomp of the Tauentzien Strasse and Kurfurstendamm I would not willingly miss. There one even accepts the noise and traffic. . . .

———————

Dessau
November 27, 1927

. . . At last the election is over. I am curious about the results. It is unbelievable to what extent the party opposed to the Bauhaus has gone in its blind hatred, no doubt against the interests of the town. I trust, though, that emotions will calm down and reasonable thinking bring about an acceptable solution. One may ask how much really is left nowadays to depend upon. It seems as if all the people in the world were equally crazy. Individuals don't count. Admonition is of no avail, and the next war will bring about the end of everything. One can almost see logic in all this, and think it is right as it is.

Apart from the abovementioned, I'm very interested in my pictures. Resolutely I am obliterating and building up anew, and I should say that without this succession of alternating efforts, my painting would remain timid and unsatisfactory. So far the result has been on the positive side. For too long I haven't wrestled with my work. I hate half measures. Too readily at times one loves the process of development.

Growth has to suffer many transformations before life is breathed, or beaten, into it. . . .

───────

Dessau
December 2, 1927

. . . I am using LeFranc white again. Weimar white is no good, not pure enough, and gray, and the color one mixes with it is deadened. I had given up LeFranc because it was so expensive, but, though Weimar white is cheaper, it does not pay in the long run.

Did you see the sale show of the private collection at Goldschmidt and Wallerstein's? I got the catalogue today with prices. One of my paintings of 1920 is in it, *Norman Village*. It does not say whether it is *I* or *II*. I painted it twice. Both were sold immediately, owner unknown. In the catalogue the price is put at 2,000 German marks—an oil of 80 by 100 cm. That is much lower than my prices now. I would be glad to buy it back so cheaply. . . .

───────

Noon, Tuesday, December 6, 1927

. . . This morning I spent almost two hours with two charming young American academics (Harvard men). They have been in Berlin and in Dresden at the Fides.* They brought a letter of recommendation from Frau von Allesch to me. All day yesterday they wandered about Dessau. They saw the Bauhaus and went to a church concert in the evening, and they were enthusiastic about everything. One is a professor—but like a boy, though 25 years old—and is intensely interested in my work. He saw it at the Blaue Vier show in California. He is going to write about German art, of which nothing at all has been written in England or in America. He wants to know *all* of my work. The professor, whose name is Alfred Hamilton Barr, Jr., bought a watercolor of mine at the Fides —*Sommerwolken,* for 400 German marks. I received the letter from Probst this morning before the Americans came. Probst writes that the *Aquarell* [watercolor show] goes to America. This evening I shall make a good selection of watercolors, drawings, and some graphic work through the years, and also older oils, in which Mr. Barr is interested as the starting point of my development. He detests Liebermann. It gave me much pleasure to tell him about the possibility of a one-man show of my works in the Kronprinzen Palais.

* A Dresden art gallery where Feininger's works were on exhibit.

The other one, Mr. Abbot, was interested in my music. He saw the twelfth fugue lying on the piano. We played it together. They were both delighted. We may try some of the others tomorrow for they will be coming for dinner at 1:30, so that we shall have a good long time together. How I wished you might have been here to meet these two. They are perhaps staying for a few more days. Tomorrow I shall take them to Klee, whom they want to meet. They have been at Moholy's and are now at Schlemmer's. Kandinsky is not well enough to receive them. You can imagine how much we had to talk about. . . .

---

April 3, 1928

. . . We received an invitation for a tea party from somebody I don't remember. *Please, you* write and decline. I can't possibly go alone. Today I have washed off my large painting. I am now trying to build it up again. But since I absolutely hate the motif, I doubt that I shall be able to make anything of it.

Sunday Kandinsky had asked me to tea. It would have been unfriendly not to accept, so I went for an hour, and on Wednesday, that is tomorrow, I have to go to the theater. Without talking much about it—keeping it a secret, so to speak—Kandinsky has designed the scenario for an opera by Moussorgsky. Here again I couldn't hesitate, but had to agree to go.

I am absolutely preoccupied with this unfortunate picture of mine. All of my thoughts are circling around it. Still I hope to get it. . . .

---

April 4, 1928

. . . Oh my, yesterday was bad. The sky came crashing down over my attempts, and the painting had to be obliterated. I didn't even go to the movies in the afternoon. Instead, dejectedly, I walked in the park, following the same path you and I had taken the other day. Though at the time we didn't think it exciting, it became momentous for me now. Remembering that we had been together, I slowly was able to overcome my difficulties. Back home I felt better and so, once more, took up work on the picture, then let it stand. This morning, however, I was shocked to see that I had produced, instead of an edifying creation of space, as I had intended, a wretched caricature. Now I have begun it again and, out of the penumbra, am trying to resurrect it to its first shape, which still held mystery.

Before 8 I went out for a short walk; the air was sweet and clean. I could cast off the remnants of yesterday's perplexities.

Tomorrow will be our Laurence's nineteenth birthday. I shudder to think of that date in my own life. It was the most disastrous day I ever went through. I was judged and condemned by my father for having pawned my watch for 3 German marks. Until I was finally deported to Liège on the 2nd of September, my father didn't speak one good word to me, in fact didn't speak to me any more. And I never saw him again as long as I lived. Is it to be wondered at if I, with my own boys, am disposed to go to the other extreme?

At times the feeling of a curse weighing on my soul takes me by the throat. I shall never lose this impression entirely. Though maybe improvident and careless as a youngster, I was tender-hearted and sensitive, the soul longing for love and understanding, and trusting in a father's wisdom. As I see it now, I should say that the blame was on my parents' side when I ran wild. Though 19, I was still almost a child, with no experience, taking life subjectively. My friends were all and everything to me. I went with them through fire and water. To them I felt my life was bound more than to my parents. It was the most natural thing in the world to pawn a watch if one of these beloved beings was in a strait and one could help him by doing so. It never occurred to us that by doing so, one lost one's honor. To lose one's honor is not quite as easy as it is for somebody else to doubt its existence. Why does it make me so sad often, to think back to my childhood? As a whole it was gay and lovely. But I have always been most happy when living with strangers, that is, our farmer friends. At home there was no inner contact with my parents; besides filial love there was also fear. Lonesomeness and, in a way, neglect—later the separation and divorce of my parents. Only now am I aware of what I missed in my childhood. More than formerly I can see what caused my life to take that fateful course before you and I met, and also why I am inclined toward melancholy so often. Oh my dear, you and I must be glad of heart; we need joyfulness in order to go on living.

---

Thursday, April 5, 1928

. . . A line only to send you a greeting for Good Friday as well as thanks for your dearest letter and the comforting telephone call and talk. Today I look at life from a decidedly more optimistic angle. So much, right now, depends on my finding a satisfactory solution for this painting.

Lyonel Feininger

Laurence's birthday! He is also one of those who never says die but valiantly goes to the end. And I should give in?

. . . I did not get to the theater yesterday. I missed it because the bus was 25 minutes late at our corner. After finally lumbering into sight from Ziebigk, it was so crowded that there was room for only one more person, and I let a woman enter before me, and then no more passengers were taken. So after waiting a half an hour in the pouring rain, I lost courage and went home again. On Wednesday next the thing will be performed again and then you and I shall go together.

It is said to be very good, new in the extreme: pictures by Kandinsky on the stage built as accompaniment to music by Moussorgsky—circles, squares, and triangles—unheard of, especially in Dessau. All the seats were sold. Kandinsky was called to the curtain three times. I met him and Nina in the garden today. They regretted that I had not seen it. He told of the work that he has had with it: never-ending rehearsals— on Tuesday on the stage until 2 in the morning—until finally everything went off without a hitch. . . .

<hr>

West-Deep
June 29, 1928

. . . Today I received your fat letter with all the enclosures: from Paris, from Barr now in Holland. It really is a disappointment to miss the two nice Americans, but at least you have had the stimulus of a friendly visit.

I'm awfully sorry that you've had all the bother and trouble of looking for those identification papers, and in the end for nothing. There is a possibility that they may be in a pocket or a suitcase of yours which you had when you were in Leipzig with Laurence, or, as you think, they may have been left at the consulate. . . .

Day before yesterday it was under no circumstances possible to be on the beach, not even in the shelter of a bath chair. A wind, almost a gale, was blowing the sand along the coast and pitilessly hit one's face like pin points. Eyes, mouth, and ears, shoes and clothes were full of it in no time. If the wind is not coming over from the water, but sideways over the dunes at just the right angle to whip up the loose, dry sand, there is no chance for a human being. One has to quit. Notwithstanding I am profiting from my stay here; I have a clear skin, already nicely tanned; I am full of pep, walking with great elasticity—and finally yesterday something clicked. A brain wave imparted a message, and I feel impulses and resolution arising to start work.

Now Moholy is also leaving. This will affect our community severely, making a gap that will not be filled easily. Muche gone, and Moholy! He was the most enthusiastic interpreter of the Bauhaus aims and, as no other, gifted to evoke and circulate ideas among the students. Besides, we shall miss his amiability and confident vitality, often brought home to us personally when we could not possibly avoid overhearing his resounding voice through the dividing wall insufficiently insulated between our studios. What comings and goings there always were in No. 2, everyone greeted with the same cordiality. . . .

West-Deep
July 4, 1928

It's the fourth, the "glorious" Fourth of July, and, of course, pouring as it always does on this day. It started quite nicely early this morning, just so that all the guests who had arrived yesterday—a huge crowd with mountains of luggage and no end of children—trotted down to the beach, full of expectations and no misgivings, to be driven back by noon, huddled up in their bathrobes, shivering, ghostlike, a pitiful sight.

Do you happen to know whether Gropi is already living in Berlin or having his vacation in Timmendorf?* I should have liked to hear his last speech before he left, after having listened to his talks so often in the eventful years since 1919, though at times with growing resistance. . . .

West-Deep (excursion to coast nearby)
July 13, 1928

. . . The coast is high and steep, beautifully vast in line, but large stretches are crumbling away, for the rains have caused landslides. Far away, at the highest and steepest point, stood something puzzling, a bulky cube which might have been a fort but, in fact, was something quite different. There, on top of the edge of the precipice and, without doubt, doomed to perdition, stood the ruins of a church. I was completely mystified. Using my Zeiss field glasses I studied the thing; I made sketches, and visions of pictures rose in my mind. Successively as we approached, apertures revealed buttresses, and at last, a row of beautifully shaped arched window openings in the Gothic style came into view. It all seemed so magnificent and full of magic. Coming closer, and, when finally quite near, I saw that in sober reality the walls were

* Gropius resigned as director of the Bauhaus on March 31, 1928.

quite low. But I could not be disenchanted. For me they seemed monumental as a big cathedral's. On our return trip we were standing on the outer platform of the car when, all of a sudden, Laurence called out to me, "Turn around!" Doing so, I perceived on the old brown front of the car, sketched in pencil silvery, shimmering on the dark ground, a *Grolpchen* done by Lux, and underneath in his handwriting, "Please do not wipe away." This had been respected, so that it has survived, except for wear and tear of rain and sun, for over a year. . . .

---

West-Deep, in the bath chair
July 14, 1928

. . . I shall give my assent to the sale of *Zirchow V* and send the letter to you, but make it 8,000 German marks, certainly no less than 7,500. This picture, together with *Zirchow VII* and *Viaduct,* belongs in the series of paintings of the past which I shall never again be able to repeat. On the other hand, I think it very fortunate that my really best pictures will stay together in the care of a public institution, to be "saved" for "posterity." If Schardt is still thinking of watercolors and graphic work of mine for a Feininger room in the museum, you must select the very best only, also from your collection, and give them as an extended loan. . . .

---

West-Deep
July 24, 1928

. . . I am working, but badly. Formerly if my work turned out unsuccessfully, at least I was carried on by naïve confidence and zest. Now the entire man Feininger is one big question mark, and full of doubt. I am convinced that this condition will pass. I'm not complaining. I am merely stating a fact.

It's a real comfort to think that I shall find my graphic chest put in order. You are right. We'll have to throw out a lot, everything that is trivia. But we should do it together, for often a thing as yet inadequate, not solved, carries within itself a suggestion, a stimulus for better completion.

Lux and I have been sailing model yachts more often than before during these past years. I am very successful with mine. I have achieved not only boat forms which are speedy but also made improvements in the design of sails, which puts me on a good technical level. I only wish I could say so much of my painting, but it will come.

Your description of Kandinsky's plans gave me quite a jolt—traveling. and seeing things as they intend to do, is also what we need. All else is self-deception. But Paris, of all places, tempts me the least. I have a great mistrust for the aims and ends prevailing in art there now. Barr talked of their "avant-gardism"—such an expression in art is detestable to me. Besides, we would be very lonesome there now. None of our friends of former years are around any more.

---

December 14, 1928

. . . Hans Wittwer came to see me.* He is leaving the Bauhaus on April 1st. He has had an offer from Halle, and he wants my advice. He is in a difficult situation insofar as he is not willing to be director of Arts and Crafts. Now they have asked him to take over the architectural department, but there he does not know the man whose subordinate he is supposed to be. Besides, he wants to have commissions for building, not to be only in the administrative service—I don't know in what way I can be of help to him. Kállai called.† The weaving department has upset his plans. They are putting up a sale show in the exhibition rooms. Now my watercolors will be on the walls from December 15th to 20th, one part for two, the other for three days. Since so shortly before Christmas nobody will be here to see them anyhow, it is O.K. with me. About myself I am working at the tower picture every day. I have just managed to ruin it completely. But at the same time I finished the first composition on the same motif. This now, compared to the second one, appears noble, simple, and strong—whereas the other is disorganized. The snow has a brightening effect on the mind, but too bad that it got warm, and it is melting into the inevitable mud. Several times I have been to the movies with Laurence. It is exhilarating to watch him enjoy the absurdities, bursting into delighted laughter, as for instance yesterday, over Buster Keaton as Boxer. . . .

---

Friday, March 22, 1929

. . . I had to work hard to finish *Gelmeroda XII* in time. In certain parts it was overelaborate. I had to simplify, but now it is done with

* Hans Wittwer, an architect, was brought into the Bauhaus as a member of the staff by Hannes Meyer, who succeeded Gropius as director of the Bauhaus from the spring of 1928 to the summer of 1930.
† Kállai, a Hungarian writer, was editor of the *Bauhaus Journal*.

the most sparing means, and I let it be. Later I can make changes if I still think it is necessary.

Yesterday I went out with my camera at 10 to take night pictures. It was magically beautiful. High up in the sky the moon, almost full, in a haze; along the horizon the lights from street lanterns. On purpose I didn't focus sharply. One exposure will be especially interesting—the railway station taken from the other side of the embankment across the low-lying grounds: layers of bright and dark stripes alternating with lamplights as round accents here and there. . . .

---

Dessau
April 16, 1929

. . . *Gelmeroda* in the morning, afternoon, and evening! I *must* get the picture into shape. The Old Masters are to be envied. They were left time to complete their works and sublimate them. No deadline for annual shows. Whether a painting is slapdashed in a decorative way on rough canvas in a few hours or brought to its utmost possible perfection in months of work does not make the least difference as to its evaluation at the salons, or its handling by the porters in exhibitions. They are all treated with the same carelessness. No wonder an artist becomes dejected at times. I finished the large watercolor *Greiffenberg* and it is good. . . .

---

Dessau
April 19, 1929

. . . Today I got up at 6, went for a walk from 6:30 to nearly 8, getting home just the right moment to meet Andreas and have breakfast with him. I did not engage in this adventure from a feeling of spiritual high pressure, rather from the contrary. I was so mad at my condition that I decided to finish this sort of hibernating, laziness, or whatever it is called. And I shall keep up this treatment. By 11, I had once more spoiled *Gelmeroda,* so I went up to the roof garden, stretching myself for a rest in the deck chair in the sun, doing nothing, and that was very wise. After this relaxation, I worked so well that even *I* was pleased. I altered a few proportions whereby the balance of space was restored, and thus the picture gained in importance. As yet I have not replaced the figures. It looks well without them also, though maybe I shall need some such accent to produce a scale of contrast for the

architecture. But no dolls as before. I can hardly tell you how delightful that early walk has been, the pure clean air of morning, the park sweet-smelling like honey. Here all is well, the boys good and cheerful, Papileo deep in work. . . .

---

Monday evening, April 22, 1929

. . . The sun is shining into the studio through the corner of the window above the picture on the easel. Spring is approaching. At least for short moments, and geographically or astrologically (or whatever?), the sun cannot help appearing every day at the same time in the same spot. The few hours last week which I spent on the roof have given me a tan like an Indian, and with the cunning of an Indian I am planning each new dot of color for *Gelmeroda*. It had to go through a number of alterations. Now at last it stands up. Friday it will be shipped to Cologne with the other paintings.

Today good old Schardt called, quite worried, asking why I haven't turned up yet. I promised to make it at beginning of next week. I had to finish here, get the pictures off my mind. I want to be entirely free for new things to start in Halle. I have in mind sticking to drawing at the beginning. Later, in the fall, I can paint in the tower [at Halle].

Yesterday we had a terrific storm with snow and hail, this morning heavy frost, and it was icy cold. Then, a few hours later, the upheaval quieted down. Now it is fine and the sun is shining. Tomorrow the moon will be full again. Perhaps we will have a few days of warm spring weather. I always feel rested around 5 A.M. The body (mine) is very grateful for being well treated. Its reactions are spontaneous as soon as I live according to its needs. If, in summer, I took to rowing regularly, I could regain, I think, my former cheerfulness, overcome this state of hypochondria which, at times, makes me almost unfit for life. . . . The boat, by the way, will be just as I want it. We talked it all over with the boat builder last Saturday—a long cherished dream of mine coming true.

---

Moritzburg Museum, Halle
May 3, 1929

. . . Yesterday I felt very poorly, had slept badly, and had a headache. Since I could do nothing in my tower I slept for an hour in the chaise longue. I went about town a little in the morning and afternoon, taking some photos of the cathedral and the market church. Today, after a

Lyonel Feininger

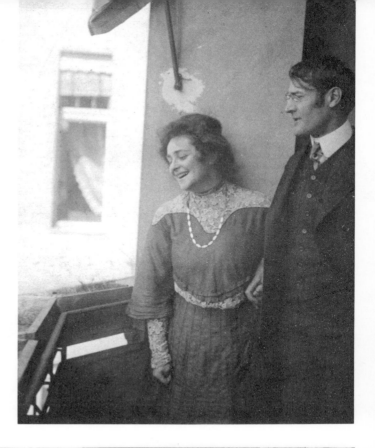

1. Julia and Lyonel Feininger. Ca. 1905–1906.

2. Lyonel Feininger with his three sons, Laurence, Andreas, and Lux, at Braunlage, Harz Mountains. Summer, 1918. Photograph by Julia Feininger.

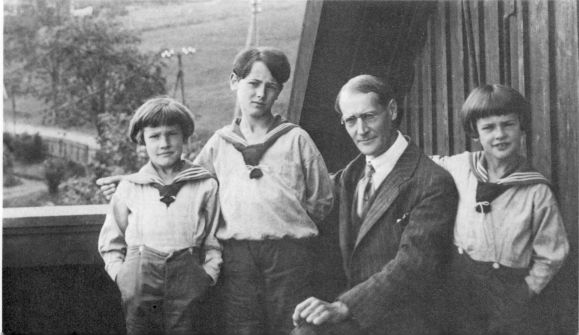

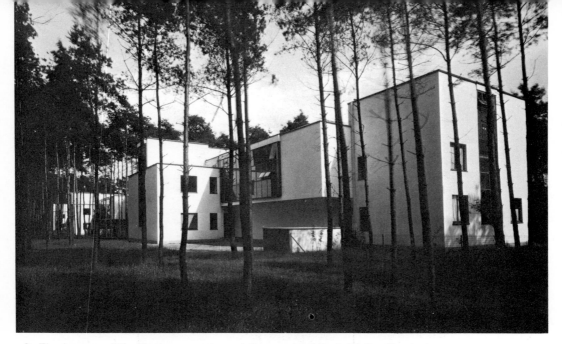

3. The houses of the Bauhaus masters at Dessau (architect, Walter Gropius).
   Ca. 1926. Photograph by Lucia Moholy-Nagy.

4. Lyonel Feininger's studio in Dessau. Late 1920's.

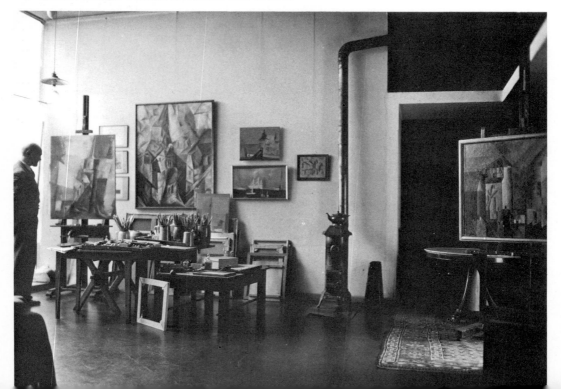

5. Julia and Lyonel Feininger in New York. 1936.

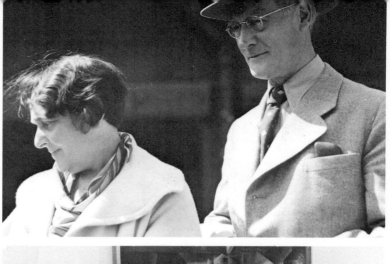

6. Lyonel Feininger (*center*) in his apartment in New York with two friends of the Bauhaus days, Gerhard Marcks (*left*) and Josef Albers (*right*). 1950. Photograph by T. Lux Feininger.

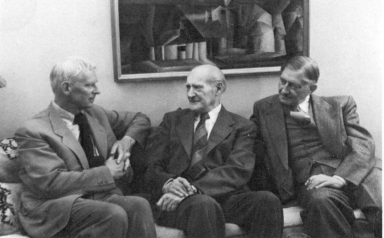

7. Lyonel Feininger in New York. 1951. Photograph by Andreas Feininger.

College St. Servaise, Rue St. Gilles.
Liége, Belgium;
October 7th 90,

**M**y dear, dear old Al!

Old man, I dreamt about you last
night, and this morning I read your dear letters through, that
I always carry in my pocket, and now, as if these incidents
had been a presentiment, I receive, forwarded from Berlin,
your "News paper". Oh! how glad I am, old man, to be
again in corresponce with you, after having considered you
as lost to my further knowledge. Edit your blooming
type concern as regularly and often as you can; or I'll
bust your "crockery optics" for you; you hear me. What
am I doing here in a french jesuit college? I'm here
for the distinct purpose of learning the french parlyvoo,
and to suck in as much other information along with the
language as can enter my aural cavities and impress itself
upon the malleable tablet of my intellect. Dear old Al!
to speak plainly, the french language will be of use to me
in the french capital, Paris, where I will most probably
go, after I am finished here! The reason I am not in
new York is principally, because my father came to Berlin
on a visit of nearly two months, and we had a grand
consultation, the upshot of which was that first I should
get what education I could, within the next two or three
years, so as to sufficiently develope me, and then I may

8. Letter to Alfred Vance Churchill, page 1. October 7, 1890. Courtesy of the Archives
of American Art, Smithsonian Institution, Washington, D.C.

yes yes! Ludicrous indeed. You see the victim with a face
like decomposed sauer kraut, awaving his leg like
a liberty pole, with the hoop gyrating according to
strickt centrifugal rules, and his own ring a-scattering
a crowd of small fry at the other end of the playground.
———————————— Dear Al! I must stop now until
tomorrow, as it is supper time and we go to bed immediately after,
at 8 oclock P.M. Good night! old chap. = Dear Al! I must have
been a grand specimen of cube-headedness, not to have
understood "ta lettre," in which you told me to send the
pictures (Etchings and Photos) to Oberlin! Dear old fellow!
be good to me! I thought it should be after I heard from
you in America, and even now they lie at Berlin, with
mother, who has full directions for sending them on as soon
as I should here from you. So be comforted! They have
niether been lost in the mazes of the Einschreibeamt of Berlin,
nor have they been sent and possibly on account of thier cylind-
rical form been been mistaken for the Rohr post dept. Only,
when I left Berlin, I had not yet received. The Photoes:
"Jepthas Tocher Lavinia" or the "premiere studien-
Reise-" of Defregger. I have brought 'Verstimmt'
along with me and will send it from here,
and as there are several marks (3 I think, of
yours still un layed out, if you can direct
any use for them, or still wish me to try
for the other two Photoes, I will do so. But
in this bally town I doubt whether they could
be had. Other wise I will send by P. O. order the

SPECIMEN OF
CUBEHEAD

8

"his cubiform head, in
the New York Museum
of un-natural history:"

charge which

9. Letter to Alfred Vance Churchill, page 6. October 7, 1890. Courtesy of the Archives
of American Art, Smithsonian Institution, Washington, D.C.

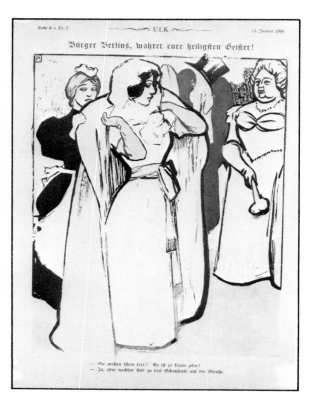

10. Illustration from *Ulk*. January 14, 1898. Courtesy of the Archives of American Art, Smithsonian Institution, Washington, D.C.

11. *Cityscape.* 1889. Watercolor. Courtesy of the Archives of American Art, Smithsonian Institution, Washington, D.C.

12. *The Kin-der-Kids.* April 29, 1906. Newsprint halftone. Collection, The Museum of Modern Art, New York. Gift of the artist.

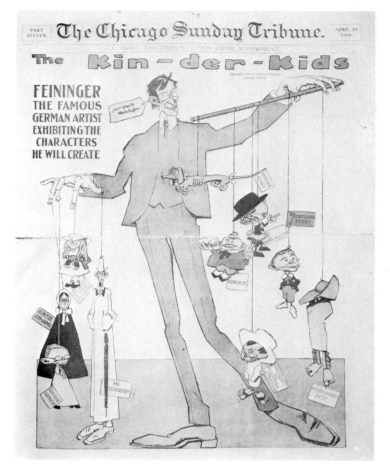

13. *Wee Willie Winkie's World.* 1906–1907. Newsprint halftone cuts in three colors plus black key plate after pen-and-ink drawings, colored with watercolor washes. Collection, The Museum of Modern Art, New York. Gift of the artist.

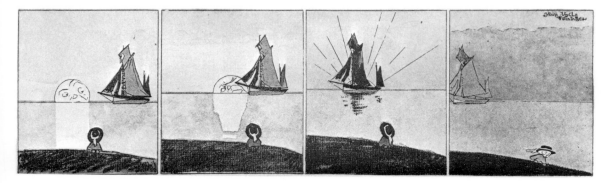

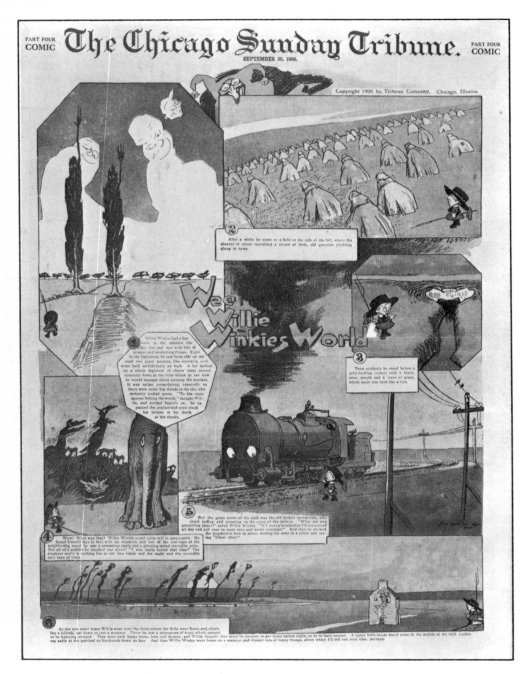

14. *Wee Willie Winkie's World.* September 30, 1906. Newsprint halftone cuts in three colors plus black key plate after pen-and-ink drawings, colored with watercolor washes. Collection, The Museum of Modern Art, New York. Gift of the artist.

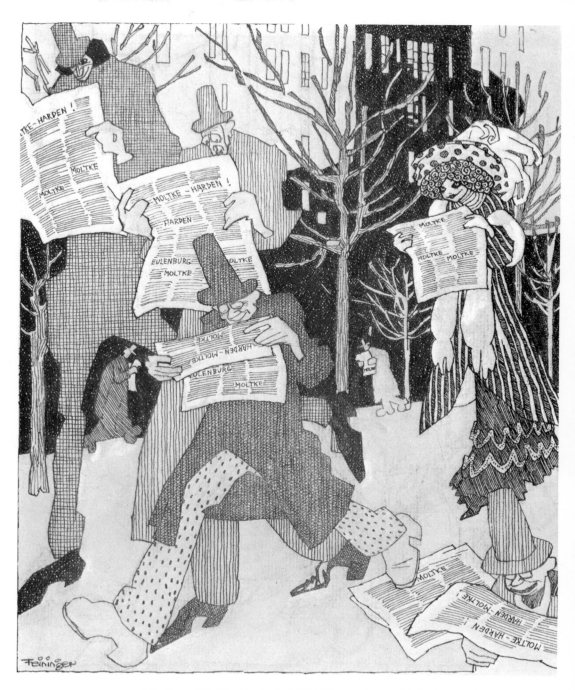

15. *Paris (Moltke-Harden)*. 1908. Watercolor and ink, 10½″ x 8½″. Collection of Andreas Feininger. Photograph courtesy of the Marlborough Gallery, New York.

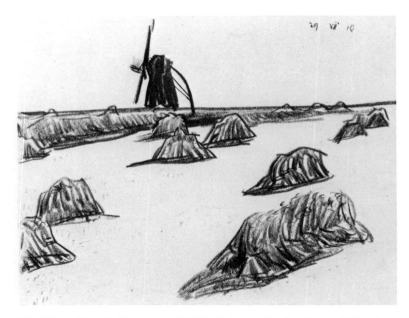

16. *Windmill and Haystacks.* 1910. Soft pencil. Courtesy of the Archives of American Art, Smithsonian Institution, Washington, D.C.

17. *Old Railway Train (Alter Eisenbahnzug).* 1911. Watercolor and ink, 9½"x12½". Collection of Mr. and Mrs. T. Lux Feininger. Photograph courtesy of the Marlborough Gallery, New York.

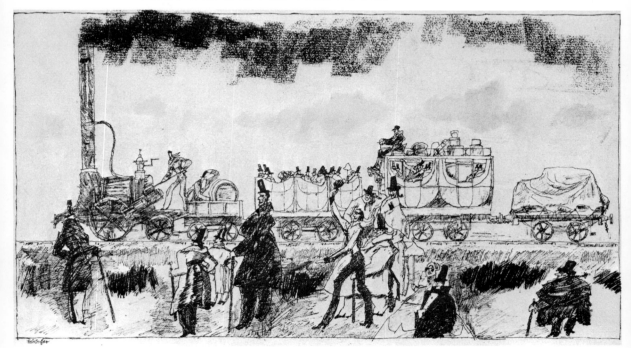

18. *Bathers*. 1912. Oil on canvas, 19⅞″ x 25⅞″. Busch-Reisinger Museum, Harvard University, Cambridge, Mass. Purchase, Museum Association Fund.

19. *Sailboats*. 1912. Pencil. Courtesy of the Archives of American Art, Smithsonian Institution, Washington, D.C.

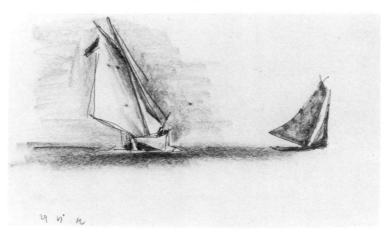

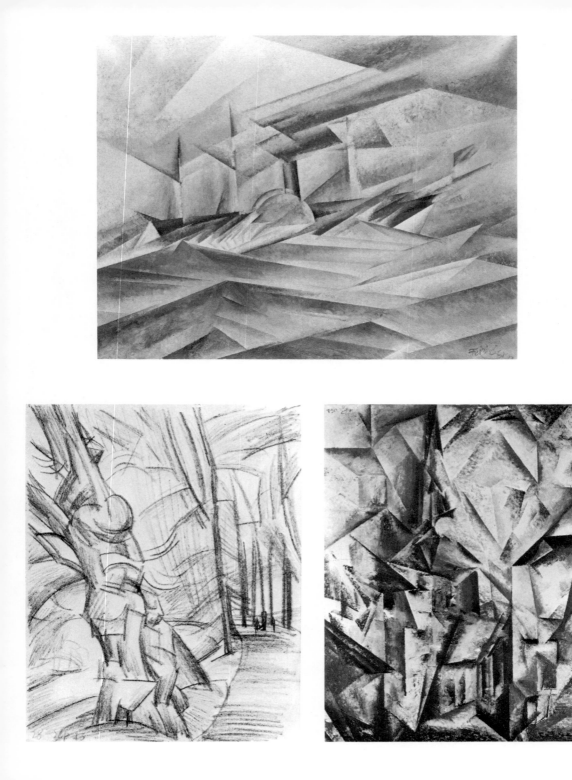

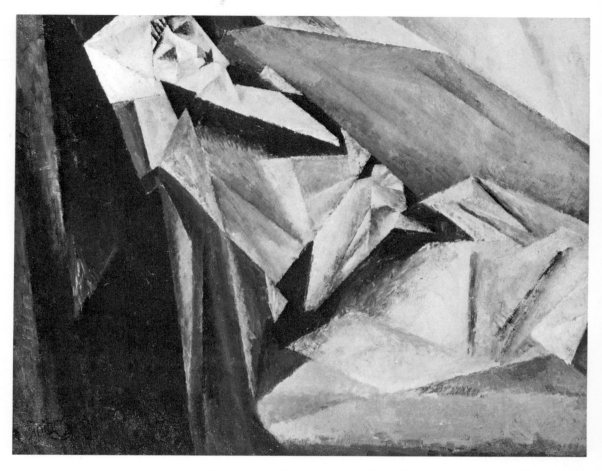

23. *Sleeping Woman (Julia)*. 1913. Oil on canvas, 31½" x 39½". Courtesy of the Marlborough Gallery, New York.

Opposite page:

20. *Side Wheeler II*. 1913. Oil on canvas, 31½" x 35¾". Courtesy of The Detroit Institute of Arts.

21. *Road*. 1913. Soft pencil. Courtesy of the Archives of American Art, Smithsonian Institution, Washington, D.C.

22. *Umpferstedt II*. 1914. Oil on canvas, 39½" x 31½". Philadelphia Museum of Art. The Louise and Walter Arensberg Collection.

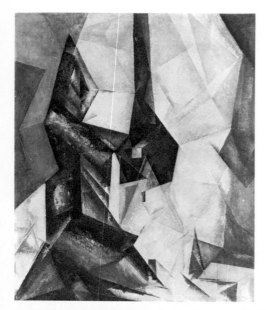

24. *Gelmeroda IV*. 1915. Oil on canvas, 39⅛″ x 31¼″. The Solomon R. Guggenheim Museum, New York.

25. *Zirchow V*. 1916. Oil on canvas, 31⅞″ x 39⅝″. Courtesy of The Brooklyn Museum. J. B. Woodward Fund and others.

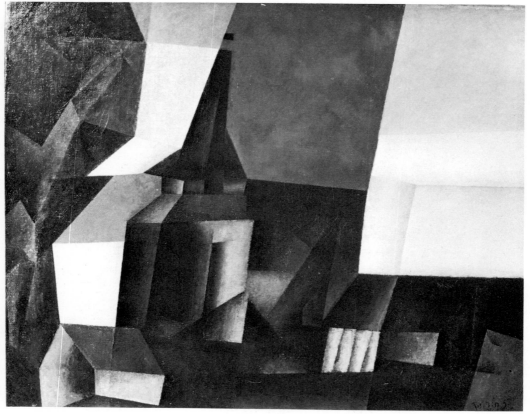

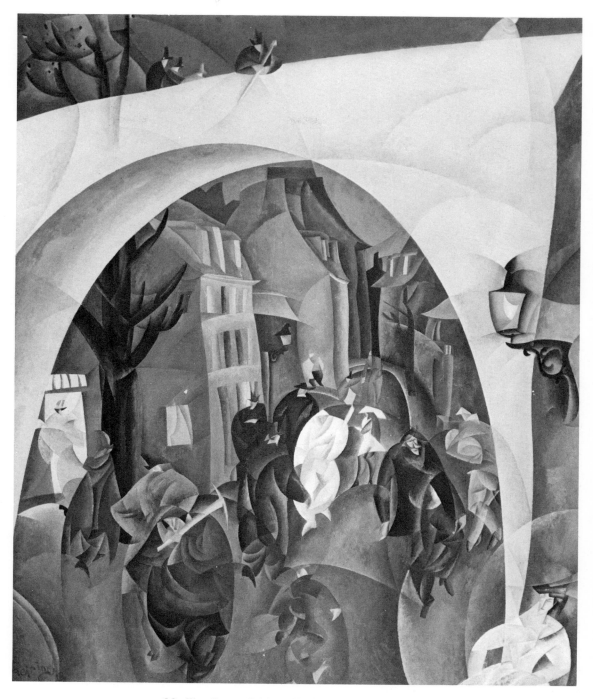

26. *The Green Bridge.* 1916. Oil on canvas, 49½" x 39½". Courtesy of the North Carolina Museum of Art. Gift of Mrs. Ferdinand Moller, Cologne.

27. *Gaberndorf*. 1918. Watercolor and ink, 9⅜″ x 12¼″. Courtesy of the Marlborough Gallery, New York.

28. *The Gate*. 1920. Woodcut, 16 1/16″ x 17 5/16″. Collection, The Museum of Modern Art, New York. James Thrall Soby Fund.

good long night's rest I'm feeling quite well. The sun is shining most of the time. I have made a number of studies and am venturing all by myself through the streets. I enjoy it very much. The city is a thousand times more interesting than Dessau. I think that I shall paint not only one but several pictures. I can say nothing positive until I have started the compositions, seeing how far I get with the many motifs. It is *fine* in my tower. . . .

<div align="right">

Halle tower
May 8, 1929

</div>

. . . I am still involved in developing films. I'm very eager to get copies and make enlargements. I intend to photograph a lot more before the foliage is full grown and the architecture hidden behind the many trees. . . .

Monday I had to meet the governor of the province of Saxony, an elegant, very aristocratic man. He is interested in the picture which I have been commissioned to do, wanted to hear about my plans, of which I couldn't tell him very much. He spoke of the room where the painting is to be placed, hinted at possible measurements: 160 by 200 centimeters—a size surpassing by far my largest canvases up to now. But he readily agreed it would be left to me to decide upon the dimensions, if only—as he put it—the work is as beautiful as the *Church of the Minorites* in Erfurt. I took the hint. It was quite important for me. I shall see to what extent I can master a larger composition. The one thing I know for certain is that I am going to do several paintings of Halle. I am enthusiatic about the motifs.

Today we had Herr von Manteuffel from the Dresden Museum to dinner at the Schardts'. As a student in Halle 20 years ago, he knew what the museum had been. He was quite surprised and full of admiration for what Schardt has accomplished since then, during the short period, about 4 years, that he has been the director of the museum. For my part, the longer I am here the more I love it. There is very little that is worthless, that might be thrown out, but this of course is nothing but my personal opinion.

<div align="right">

Halle
May 11, 1929

</div>

. . . Again I am alone in the house, enjoying the tranquillity of the cave-dweller minus his dread of wild beasts. I'm through with prepara-

tory work. In my mind I see a whole row of beautiful pictures of Halle. But I doubt whether I'll be able to paint them here on the spot. I would feel the proximity of the motifs too much, bound too closely to the object. Between the immediacy of experiences and final completion, an interval of time has to elapse. In West-Deep I shall start composing drawings for the oils. Then in the fall, either in Dessau or even here in the tower, after having gained enough distance, I shall paint.

Every day I have been out here and have seen and absorbed so much. But since I want to do some painting here and now, I shall begin with a few smaller oils, of which I hope to get two or three done before I leave, by the end of May. . . . In the meantime I have decided to give the boat a name after all, I want it called *Junx*. All my love to the boys. . . .

================================

Halle tower
May 15, 1929

. . . Last night Schardt and I were at the Marcks' for supper. It was very nice as usual, a beautiful warm evening. We could eat outside on the veranda. Marcks is one of the most lovable fellows in the world. He talked with such quaint humor of his voyage to Greece and also about his experiences as a soldier. There is much mysterious talk about the possibility of my coming to live in Halle. The mayor, as Schardt says, has taken a great fancy to me. They think of offering me a position at Gibichenstein as head of the bookbinding department. Of course I know nothing of bookbinding, and there are about 30 girls in that workshop. If they really decided to want me, it would be absolutely *terrible!* They would get at me. Once and for all times I have done with young ladies. To be quite truthful, I don't even like the appearance of an obligation. I should prefer to be entirely free to come and go in Halle as now in Dessau. So much would have to be considered thoroughly anyhow before we ever gave a thought to leaving our house there. It's no good talking too soon about new plans. . . .

================================

Halle
May 18, 1929

. . . Only a greeting for Pentecost. Since yesterday afternoon it has been pouring and cold. It looks as if the holiday would be spoiled by rain. Since I like to study my motifs in whatever weather, I made

Lyonel Feininger

several snapshots yesterday and today in this deluge, with reflections on roofs and on the pavement. But I myself also "reflected" on my hat and shoulders—my, wasn't I soaked and dripping! Enthusiasm knows no inhibitions. . . .

════════════

Halle tower
May 21, 1929

. . . I agree to everything you write about working after photos. I believe, though, I am sufficiently well founded in my conception of pictorial vision and [my understanding of] compositional demands as against naturalistic conception to overcome the difficulties that might arise. I have received much deeper impressions here. My response to this town is so strong that I see with the inner eye the picture that I want to paint. I can almost say that I hardly need any material studies. My recent attempts at photography have contributed to my observing in a new way, with greater intensity, but also have taught me the old lesson over and over again: concentration is needed to transform impressions before they will become a picture.

Now the curtains are fixed. The tower is just beautiful. It is the most wonderful place to paint in. I have good light from the north and the east, and I can shut off the sun when it is setting in the west. . . .

════════════

Halle tower
May 23, 1929

. . . I went home on foot. From the station to our house one passes through all the ages, all the periods of building in Halle, that make it what it is—a most delightful town. It was very quiet and warm. You said that I was looking young? But it seems to me that my expression is not that of a young person. Besides, the foreigner in me is indicated to such a degree as to make my face different from the simple German ones, to be looked upon as uncanny and suspect. Of course this has nothing whatever to do with looking young or not young—but nobody except you thinks so.

Here in my tower I can live in seclusion almost like a monk. This is very precious to me. In my mind I correlate and put order in the chaos of impressions and experiences accumulated within the last ten years, thereby building up a wealth to draw upon, maybe the wealth of an old man? Well, soon there will be West-Deep, and then another facet

of Feininger will show: the open-air man, elder brother of Lux, model-yacht enthusiast, unembarrassed, free and easy. Give my thanks to Lux, please, for the jolly drawing he sent to me. I am looking forward to seeing his paintings. . . .

---

Halle tower
May 26, 1929

. . . Yesterday again we had an electrical storm, uninterrupted lightning and thunder. Watched from the height of my tower, a storm looks very different from what it is when seen from below. The whole proceeding, so to speak, is spread out before one's eyes like a battlefield. Besides, I can observe the weather vane on top of the Institute of Physics, watch how the wind is veering. All this is very instructive. The temperature in my tower is very agreeable, nice and cool when I open the windows to have cross-ventilation.

Allo [Schardt] had to go to Berlin yesterday. His brother the priest is here, and stays until tomorrow. He is living with the dean of the Catholic church of St. Elizabeth, but we have our meals together. He resembles Schardt in a certain way. He is a rather massive man, wears spectacles on a broad nose, has a kind face. We get along together very well.

The Father asked me about [Emil] Nolde. He wants to find the key to his art. He knows that Schardt has been talking to the mayor about the acquisition of Nolde paintings for the museum. But the mayor, as Schardt put it, "always gets mad if Nolde is even mentioned," and for the time being it seems impossible for them to buy a picture.

It has become a custom with me to go through the Nolde room to look at his paintings on the way to the tower every morning. So I tried to interpret them. The phenomenon of Nolde certainly is unique in the history of modern art, and for that reason he is not to be judged in terms of good or bad in comparison to other painters. I see in Nolde's religious pictures a religious feeling expressed in a strong way, not in wishy-washy, everyday humble sweetness. It originates in dark promptings, in deeper sources than those the Father may be accustomed to in other painters. I called it plutonic. I can imagine Nolde's being driven at times by demoniacal powers. Certain canvases are almost superhumanly badly painted. They are in contradiction to almost every rule of composition. Nevertheless, even to those paintings one cannot remain indifferent. They always strike one as remarkable manifestations of a strong spirit. Cyclopian matter, glowing from within, for that reason

perhaps no longer matter. Comparable to runic stones from past ages, bearing a deep meaning and exciting our fancy. . . .

To watch a whole sunny day, finally a sunny evening, ever more gloriously pass through the windows of my tower, casting a spell of yellow and reddish gold over the walls—I have the miracle of light constantly before my eyes.

I am working at the small painting *Calm at Sea III* with utmost tenacity. It is not smooth sailing, but I'm getting into the painting and am not afraid to go ahead; placing color on color, washing off again, energizing form, compelling the picture into super-nature. Inch by inch, however, I have to struggle to transform the object into terms of picture space. . . .

------

Halle tower
May 31, 1929

. . . I have made some drawings which are not bad. I'm getting a feeling for line, perhaps for the work in summer. One thing is clear to me: all the photography I have been doing lately has led to a less matter-of-fact way of expression in my drawings. I can almost speak of a new formal strength. In contradiction to all expectations, an ossified style has regained life and vitality. I have entered some sort of renaissance. I am looking forward hopefully to the work to come. But I have to stop soon in order to get to the seaside. Keep my room ready, for one of these evenings I shall turn up around 10. Perhaps I felt my loneliness too much after that lovely Monday with the boys. When Allo is here I have at least a good friend around, somebody to talk to, and then I don't tend so much to melancholia.

Today I had a very sweet letter from Gropi, thanking me for having remembered his birthday. I love the man throughout, come what may. I always feel my heart warming to him, and he also stands by us. So much to the good. For ten years we have known each other, and the wonderful time at the beginning in Weimar. To think of giving up Dessau is not easy, especially with regard to Klee and Kandinsky. But it will never be more than a separation in space, the inner attachment cannot be severed. On the other hand, for me it is right to leave a place where the atmosphere has a numbing and chilling effect. And who knows if it would not be an advantage for them also to detach themselves? . . .

------

. . . I'm at work with great intensity. Three paintings are under way. I am hard put to determine the formal structure right from the beginning. It takes a lot of strength. In the evenings I am very tired and go to bed early. As long as I am here in Halle, I have to live for the sake of work only. The days are getting shorter anyhow. I have to make use of every hour of daylight.

The museum is closed now in the evenings. Expenses are too heavy on the budget to keep it open for the few people visiting during those hours. It is a great pity. For me the building is a lonesome place in the afternoon. In the evening I have to grope my way through the dark rooms by the light of my small torch. It is very desolate. . . .

Halle tower
October 9, 1929

. . . Schardt has left for Berlin. He will be gone for about four days. The Simon collection of Old Masters is to be sold, and Schardt wants to attend the auction. The weather is lovely, almost too warm, but so pleasant. The tower is the ideal place for me, and work goes well. I never had a room more suited to my needs. I have the windows open all day. According to the sun, I shift from one window to the other with my easel, but the light is always good.

Yesterday we had the Franks for supper. Most of the talk was about the new watercolors by Kandinsky, which were highly admired by all. Schardt would like to have a room in the museum devoted to them alone, but the prices are forbidding. He asks 1,000 German marks for some. Schardt says he will never get permission to pay that much. Some oils are as high as 20,000 German marks. Even 5,000 is considered a big sum to invest in a painting nowadays. Besides, who has the time and leisure for art? All the world is leading an outdoor life with sports and traveling around in cars. . . .

Halle tower
October 18, 1929

. . . The memory of the summer in West-Deep, and especially of those last weeks in September, forms a beautiful and rich basis for the

intensive work in my utter solitude now. If I am overwhelmed by lone-liness, I try to remember vividly. Then I am comforted, and a feeling of quiet happiness fills me in these days of undoubted achievement. I don't think I have been in this condition since the happiest years in Zehlen-dorf. The last thought at night assures me of the morning with its prom-ise of being able to continue.

I was glad that the Americans didn't come yesterday, but today they turned up shortly after 3, and it really was nice. The tenor of their comments was honest admiration for the museum and its collection of modern art, for which they seem to have a practiced eye and good feel-ing. Unfortunately they were rushed. They wanted to see the Kandinsky show, and they had to be in Leipzig in the evening for the Bach concert. Mr. Johnson is a very good-looking young man, somewhat resembling Gaidaroff. We shall see them in Dessau. They intend to come when I am back. Besides, they are deeply impressed by the Bauhaus.

Schardt, as director of the museum, has no end of troubles. Exchang-ing letters and telephone talks with Kandinsky has harassed him ter-ribly. He is in despair about him because of his obdurate insistence on prices. Naturally I cannot discuss this well in a letter. For Schardt it is a question of not having enough means at his disposal. Suggestions pour in from all sides, and then everyone bears him a grudge for not complying with Kandinsky's demands because of his lack of funds for acquisitions. As I told you, Schardt wants to have a Kandinsky room in the museum. He could get watercolors, even oils, as good and as many as he needs in Berlin at much lower prices than Kandinsky is asking for here. But Schardt simply doesn't dare to make use of this knowledge, knowing too well what a hornet's nest he would stir up. At bottom, it is a matter of prestige for Kandinsky. He, or rather Nina, is intent on keeping up his illustrious reputation. Repeatedly they refer to the acquisition by the museum of my many watercolors and paintings last year, taking this as a precedent. Woe to a friendship between artists if such questions arise. . . .

Halle tower
October 29, 1929

. . . Scrutinizing today's work now, at 10 minutes before 5 P.M., it appears like a phantom—a pale, though promising layer of the many layers which will be needed to bring to completion the church picture I talked about yesterday. Working today, I had moments of extraordi-nary concentration. I felt a flux of great powers (also of inexpressible

loneliness), free from inertia, no longer earthbound. Awakening from this sort of hypnosis, I see what actually has been accomplished, a faint image only of the inner vision. Therefore tomorrow, and many more morrows further, I will not spare *la bête,* as Van Gogh expressed it. This period of intense work makes me feel happy.

Even the criticism yesterday was healthy. Your words "picture postcard" worked wonders. Self-criticism serves only to reveal what one is aiming at. One has to be reminded constantly on the way to accomplishment. For consummation is shrouded. Conscientiousness too easily produces postcard pictures. One may run through the entire gamut—love, scorn, hatred, longing—only beware of contentment too easily acquired. There are but few hours when the artist's mind is at rest. . . .

———————

Halle
November 7, 1929

. . . Yesterday Schardt came to see me in the tower and asked whether I was willing to receive a visit from the mayor. Did you ever meet Mr. Rive? He is an extremely clever man, very warmhearted, of great modesty, who takes care of his citizens in a fatherly way. At the beginning I was rather shy of showing the unfinished pictures, but seeing him completely enthusiastic I was so pleased that I talked to him freely of my work as well as of the beauties of his city. He left with Schardt. Later, when Andreas and I went to Schardt's office to meet him for dinner, he delightedly told us about the mayor's impression of the pictures. This is what he said to Schardt, "Don't you agree that we have to keep them all for ourselves?"

While showing the pictures, I myself was amazed at the state of completion of some of them. Two or three can be left almost as they stand now. I had no idea how far I had gotten. I see that I have to be careful not to over-elaborate them, avoid getting them too smooth. Ten or fifteen years ago I was able to paint valid pictures in three days, and these are like them, bold with telling effect, and I would like to see them framed in order to judge how they hold their own. I think that in some I have attained the breadth and space that I have been striving for for years. But I cannot describe them, I have to let you see what I did today. I had worked at it for ten days, at the end ruining it completely. Then within three hours this forenoon I produced as if by magic a strangely remarkable piece of work. . . .

———————

Lyonel Feininger

. . . Thank you for your letter today. My, how you are caught in the whirlpool of life! I'm glad that you for once are out of the everyday rut and gay with the liveliness of your surroundings. I am here industriously at work and, strange as it may sound, my almost monastic way of living is not in contradiction to experiencing pleasurable excitement as well. It wasn't for naught that we learned about relativity. I have the feeling constantly of devouring work, not having time left for all I want to do. All the same, I have nothing new to report. My news is what you tell me in your letters. They provide a good background to make me cheerful. When I try to write, and come to think of you—in contact with you but no word uttered—when attempting to impart all the wealth of perception and feeling which I carry within me, then I find words hopelessly inadequate. But it seems as if I were painting it all into silent pictures, or giving it expression in my musical compositions. The pictures speak to you because you have the rare gift of understanding that language, all that is contained therein. For me, who paints them, they are often puzzling, but music is the language of my innermost self which affects and stirs me as no other manifestation ever does.

Schardt came back from Erfurt yesterday. He had met the righthand man of the governor of Magdeburg, Mr. Rinteln, who was very eager to see the Halle pictures. He intimated that, without a doubt, Magdeburg would have the prerogative of selecting, which absolutely infuriated Schardt. He called it a presumption on the part of Magdeburg to exercise the right of selection while they are to receive a painting as a *present*. Nice prospects if they start that way. . . .

. . . 7 P.M. The enchanting light of the bright moon is filling my room, and the air is flowing sweetly through the open window facing the Red Tower. They are working day and night on the new building at the Trodel. All over the 6–8-story-high scaffolding, on every beam and platform, small electric bulbs have been attached which, at night, glow like miniature stars, mocking the heavenly constellations. Like a ghostly pattern, the towers of the Market Church reach up into the dimness of the evening sky, and from the bridge between them, as in medieval times, at 7 the town trumpeter blows a soothing lullaby down

on the swarming crowds. Work goes on at a good pace. It is true, though, that I live for nothing else and am not very companionable. But soon there will be a stop and a time of rest. As much as I love our home, it is not the best place to work. Seeing how concentratedly I can work here, and then remembering the condition I was in last year. . . .

<div align="center">═══════════════</div>

<div align="right">West-Deep<br>June 5, 1930</div>

. . . I have to think hard trying to remember what I have done since the day before yesterday. It takes an effort to call back to recollection all that happened during the long, gray day of my journey. Since it is so early in the season, there were no express trains between Berlin and Stettin. I had to take a local, which was terribly crowded. All the lower-class travelers were going on vacation with heaps of babies and dozens of collapsible prams. We didn't arrive in Stettin until 2 P.M. There was barely time for a bit of dinner, my demitasse of chocolate as usual served in the pot, with a drop-catcher in the shape of a parrot (made of wool!). I had to swallow hastily in order to get a seat in the train to Treptow, just pulling into the station. All day it had been gray, foggy with heavy, dark clouds. Around Stettin they were almost black. From Naugard on, at last, the sky got lighter and high. Soon there was blue in it, a blue such as in Luxi's last painting, so delicate and pure. I noticed the strong wind blowing from the northeast and, though the sun was shining, the wind was icy cold. Yesterday we had an incredibly hard blue sky, no clouds from morning to night, but still a low temperature, the wind howling and the sea wildly agitated. In the afternoon for more than three hours I was in the woods on the beach. I walked toward the setting sun, helpfully shoved by the wind blowing from the east. All the more difficult was my way home, fighting against it. But I enjoyed it very much. It was pleasant. I got warm and very hungry. Then for supper, I had bitter black bread and sausage and then stomach ache. Shortly before 8, stiff and lame from walking, and with teeth chattering from cold I went to bed.

This morning after a good long sleep I feel refreshed. All the fruit trees and berry bushes are in full bloom. But these last nights the cold has been such that potatoes are frozen. On the other hand, the winter has been mild, and the fishermen had to cut ice in the Camper See, since the Rega froze only for a few days. I shall not have a feeling of really settling down here until my chest arrives. But this hybrid condition also has its charm. The day seems never ending if one has no other work but to get rid of a silly endless cold, in order to accumulate an

Lyonel Feininger

ever so thin layer of fat. I am scared when I see myself in the mirror (while shaving); I look like a ghost. . . . It will be good when you are here. You will be happy and gay as last year, yes? You simply *have* to be well. You have had to withstand so much lately. Your life has not been too easy. I am thinking about Lux's pictures. How beautifully they are painted! Comparing them to my own works of some years ago with their tormented surfaces! But though—and you know it—my *beau idéal* formerly was to paint clearly and simply, only the fallacy of wrongly interpreted vigor got hold of me, and I worshipped Van Gogh. . . .

Saturday, June 14, 1930

. . . Yesterday the meadows were cut for the first time this year, and the lovely flowers were mowed in their full glory. It is a pity that you have never seen West-Deep in its spring loveliness as I have now for the second time, since I have been here twice so early in the year. At last the pre-season guests are arriving, and as usual in all their inelegance and lack of beauty and taste. As if inborn, these features run in the blood of this class of Germans. Late in the evening I went down to the beach. The water was very smooth, light against a pretty, high cloud bank in the northwest. In the violet haze a lonely freighter was to be seen on the horizon, and above it a mirage in the sky. I wondered, looking at the apparition, at first taking it for a ship with square sails, though the rigging seemed strange. After a while I saw what it really was: the mastheads, funnel, and hull of the steamer meeting their double upside down, mirrored in a clear cylindrical zone, the only part of the horizon which was not in a dark haze. There was a faint breeze in the air coming from the east, wonderfully cool and refreshing after the suffocating day. But try to paint such a picture!

Dessau
January 11, 1931

. . . I am working at the picture of the Halle Cathedral. It is growing. You will be pleased and praise me.

Yesterday I went to a talkie. I saw *Alraune* with Brigitte Helm. It is a successful imitation of theater, the voices clear, easily understood, even expressive, yet with all the drawbacks of the old stage acting. The chorus of students at the beginning: exit left, exit right, exit through the center, nothing of the possibilities the screen offers with regard to

new space conception, the scenery more elaborate but stage-bound from beginning to end.

———

<div align="right">January 14 and 15, 1931</div>

. . . Have been painting until almost 5 P.M. A fine, prickly snow is falling. The Stresemann Allee is getting white, and noises cease. People are fighting their way through the drifting flakes. Bicyclists are creeping along. The horses lose their footing and slip—a mighty big snow. The temperature is around zero. In Russia, according to the newspapers, they are experiencing something like 40 below, and terrible blizzards are cutting off entire villages from communication.

It is a dark night, but the luminosity from below reflects on my ceiling. While I was making contact prints and some enlargements from film made 30 years ago, it struck my fancy to analyze the features of the strange lad I was, and whom I had almost forgotten. It seems as if my physiognomy then was principally determined by an abundance of hair. The face was so entirely without signs of inner development, but wonderfully young. I could look upon it almost with envy. If I were to come across one like it today, adorned with a collar resembling a marmalade pot, I would probably regard the type with suspicion, not bothering much about it. Yet those years between 20 and 25 were the happiest of my life, the paradise of youth lost forever. The mind so full of tender expectations, my sisters still alive, and they my only female companions. Dreaming of this, sometimes at night, it almost makes me weep. With so many of these photos at hand I was permitted a glance into the past. And following that, as usual, I drew a comparison with the present. I smiled and had to admit that—*quand même*—I'd rather live today and be what I am. But I think that it is a very good idea to collect a number of these old photos of us all.

Now I want to go on with the work. The snow light is most wonderful for painting. Rome (meaning *Dome*) wasn't built in a day, nor without effort. Alternately, I derive pleasure and worry from this picture, at the moment the latter. I have become too factual. . . .

———

<div align="right">Thursday, January 22, 1931</div>

. . . I am toiling and exerting myself over the dome picture—but the trouble, and I see it clearly now, is that I haven't solved it as a composition. This I must do or it will be nothing but an oversized monstrosity.

Lyonel Feininger

Never in my life shall I work again after a photo. It disgusts me. It is leading me away from any possible conception of painting and picture.

━━━━━━━━━━

. . . At the end of this day I feel satisfied with my achievements, having at last found the solution for *The Dome*. Three times yesterday and again this morning, I washed it off completely. At first it seemed like a hopeless task, but finally I managed to overcome the hypnotizing influence the photograph had on me. . . .

━━━━━━━━━━

. . . Here once more is a bunch of photos of the old days. If they give you pleasure I am happy to send them. Recently I have copied those shots we took in Lobbe, right into the sun. It was something unheard of then. It went against photographic respectability. Now everybody is trying these things, the more daring the better, but we were thought to be crazy to risk it—and it was only 25 years ago. . . .

━━━━━━━━━━

. . . Beginning of spring, all is full of pleasant anticipations! In the tower from morning until late in the afternoon I stand at my easel by the wide open windows, painting successfully. I have a feeling for color. Everything around me is enchanting. On the sill of each of the east windows, gothic windows with the small panes ending in the pointed arc, I have placed a painting. From the west in the evening, sun pours in, striking the lower part of the picture, setting colors aglow with an absolutely fantastic intensity. It looks so beautiful and solemn, as in a chapel. If the paintings were put up in this way, they would not fail to create an almost magical impression. The *Bolber Gasse,* after having been worked at one day only, holds its own in composition and color scheme as an unshakable conception. It will be very different from the other pictures. In it I do not intend to do a painting of important architecture in particular—rather to show a piece of the place in its anonymity, which is *also* Halle and as provoking as any other of its historic features.

It is really amazing how I feel restored to being myself, reborn, the moment I am here. Everything is stimulating, the atmosphere—what it does to colors—my beloved tower, concentration, all at once is perfect. It is good to have this susceptibility recur after all these months of languor. . . .

------

<div align="right">

Halle
March 22, 1931
</div>

. . . The *Bolber Gasse* is finished. I may add a few touches of color tomorrow; then I shall start the largest of the series, the nave of St. Mary's Church: like a vessel seen from afar, and the towers rising above the roofs of the city.

I am well and happy. Even my face is beginning to look like a face. Best of all, though, is that I am aware of color, positively enraptured with it. It could never have happened to me in Dessau. Here it all comes naturally. Everything is alive and exciting. When, at noon, all the clock towers strike 12 in concord, it is like a salute to the climax of the day, a thanksgiving full of meaning. To be with Schardt is most valuable. What he has to say on art and people is the outcome of observation and reflection, always containing truth which I accept. You know that my conscience with regard to creative work and art is very strict. He is just as uncompromising. Today he led a group of 120 artisans and their wives through the museum. I attended part of the lecture. His way of talking is clever and straightforward, inspiring confidence; his words reached out to them and must have struck their hearts. He told of craftsmen of former times, when no difference existed between the accomplished handicrafter and the artist: in his best achievements the craftsman's work attained the high standard of art, and the artist had to be a well-trained workman anyhow. He showed works which were done in the old times when the man who created them was driven by a force within himself which called for expression. Then copies after such works made his listeners see how lifeless these reproductions were by comparison with the originals. I cannot repeat the whole lecture but I saw how overpowering and irresistible the influence of conviction is if put forth wisely and in a simple, human way, instead of being hurled at one as criticism.

I got the volume of the *Jahrbuch* containing the article on my paintings with reproductions, also the periodical with Schardt's monograph on the Halle pictures. It has the *Market Church at Night,* covering the entire page, well printed.

The mayor is not back yet. Schardt could not reach Justi* to talk

------

* Ludwig Justi, director of the National Gallery in Berlin.

with him on the subject so much on his mind, but he says he won't give it up. I'll tell you this: *I* do not give it a thought. There is one thing only that counts for me, now as ever before, which is most important, that is, being able to work and work well. The interim in Dessau brought only unrest, no concentration, and, as a result, a row of minor works, most of them mediocre. . . .

Halle
March 24, 1931

. . . I think too little of your loneliness. With a generous gesture you send me to where you are certain I'll be able to do better work than in the Dessau atmosphere, but you stay behind in our everyday life, surrounded by all sorts of worries. It gave me quite a shock. I was sad all day yesterday. Feeling less low today, yet my attitude toward my work has sobered. Scrutinizing what I have on canvas I feel the glad transport slowly changing into a critical mood. What gave me pleasure yesterday I disapprove of now. And there is not a single movie in Halle where one can go to relax, be nicely entertained. They all have programs of sheerest nonsense.

Only the weather has been good again, though no more frost at night. It was so beautiful when, after a night frost, the sun shone during the day through a magic haze, and shadows like monstrous brooms were cast from all the towers.

On Friday Schardt is giving his lecture on Barlach and Lehmbruck, and Mary will be reading poetry. We all expect you, and you can stay overnight. There is plenty of room in the house.

This afternoon I have started painting on the *Market Church*. *Bolber Gasse* is not going to be touched any more. Of course, one should not try to compare it to *Zirchow V* and *VI*. If you come, please bring paint rags. . . .

Halle
March 26, 1931

. . . We anticipate your and Andreas's arrival tomorrow. I would like you to bring me the canvas of *The Dome*, which went to the dogs three times. You can roll it with the paint surface on the outside. At Schardt's, I saw a marvelous photo of the picture, which he had taken at one of its stages. I shall try washing off resolutely to get to the original paint surface, and finish it as I had it then. I know that I got disgusted because

the color scheme went against the grain. But what I saw now in black and white showed the composition to be monumental, and the whole powerfully conceived as to space. Schardt praised the *Bolber Gasse* highly, said that I had surpassed the drawing by far. Thanks for the paint rags, so good of you to send them. They came in handy, just when needed most.

<div style="text-align:center">━━━━━━━━</div>

Halle
March 28, 1931

. . . What a day it has been, so quickly passed it seemed that we had to say good-bye before we had had time to talk to each other. Yet so much has happened in these few hours. Schardt's lecture was very good, don't you think so? His interpretation rests on a wider basis than art historians generally offer. He discloses the deepest meanings. He thinks of giving a lecture on Mr. Schulze of Naumburg. Whatever this gentleman puts forth and hotly defends as "German" is as un-German as can be. Schardt says it is monstrous and plain insolence what the man writes in his book on the races of man. Ever so many know it, and indignation is rising, yet nobody has the courage to oppose him and make mincemeat out of his trash. Schardt is the only one to do it, and do it well. Sneering and using bad language doesn't help.

I told Schardt that I would like to send one or two of the Halle pictures to Essen to the Künstler Bund [Artists Group] show. He willingly agreed. What do you think of the idea? I could not show a more beautiful painting than the *Market Church,* and a small one of those in Dessau would go well with it. I put a few finishing touches in the sky of *Bolber Gasse.* Now I am working at the night picture. We got the rain, which most unwillingly I had prophesied from the looks of the moon yesterday. The light is bad for painting. I hope that it won't last long.

<div style="text-align:center">━━━━━━━━</div>

Halle
April 1, 1931

No, my darling, don't you believe that it has been your visit which threw me off my tracks. It was just a coincidence. I was ready for a reaction, and I have only myself to blame. Instead of continuing to work at *new* pictures, on Monday I took up the dull and bungled version of the church at night. That was stupid, but now after 3 days it is, at least, not worse than before. Only I am out of all patience with this work, utterly

weary, and I won't try to do anything on it tomorrow. Instead, I'm going to play truant and shall make my appearance at your party (shortly after 8 P.M.), and we shall all be jolly together.

---

Halle
April 7, 1931

. . . It was very lovely with you. Here I found the house empty, when I arrived, after an uneventful train ride with a compartment all to my-self, and had a bite of supper and went up to my room early. Slept well. Now this morning I feel rested and bent on great achievements.

On my way to the tower I bought a big bottle of turpentine. For seven hours, in the morning and afternoon, I labored on *The Dome* canvas, scraping and scrubbing off one coat of paint after the other, altogether through about seven layers I had to plough my way until, at last, I got down to the original stratum. It has been the dirtiest piece of work I have ever attempted since the famous disinfecting of our chicken coop at Weimar ten years ago. Even I could hardly believe into what compositional extravaganzas I had ventured. When, at the end, really nothing came off any more, the picture looked like an "Old Master." But notwithstanding its unsound color scheme, I saw that it is most effective as space structure.

Yes! This day deserves to be called "a day" all day long—warm spring air through open windows, gratifying though dirty work, then cleaning up—but you have to imagine the look of my hands for your-self—words fail me for a description. On the wall of the old part of the castle opposite, a blackbird is singing its evening song. Through the west window the last ray of sun cast a horizontal line on the east wall, turn-ing pink, dying out. Now it is evening, almost 7. I have no flashlight. I forgot it today. It won't be easy to grope my way down the winding stairs and through the darkened rooms of the museum.

"Keep smiling"—be cheerful, be happy with the boys, and remember that I am fine here. . . .

---

Halle
April 11, 1931

. . . This morning I watched out for the mailman. To my surprise he handed me a registered letter from the mayor. I was exceedingly pleased with its contents. I shall write my answer, if not today, at the latest tomorrow. If I leave here now, I don't see why I should return later. I

shall stick it out as long as I am progressing with the pictures. I would be restless wherever I go. Here, at least I have my quiet workroom and nothing to irritate me. It seems very inappropriate to think of an exhibition at present. I don't want to put myself before a public now at the age of sixty. Either it is too late—and should have been done when I was fifty and had reached a certain "high" of attainment—or too early. Let us hope that my work comes to some sort of completion when I am seventy. At present I feel like living in a vacuum. I am scared. And not for a moment do I think it possible to have a show at the Kronprinzen Palais in Berlin.

Halle
April 12, 1931

. . . The days are passing in an oppressive hush. Schardt's condition is unchanged. He is in pain all the time, and his weakness worries Mary most of all. I do not know exactly what is the matter with him. Work progresses by snatches. *The Dome* is the most difficult task I have ever attempted. The ground has become abominable. I have to refrain from covering certain patches or everything falls to pieces. I absolutely have to stick to the old composition. As cautiously as possible I am feeling my way. The right thing would be to begin once more on a new, clean canvas. Besides, I am freezing. I cannot get warm. After 5 P.M. the light is too bad for painting, so I idle away my time, giving the radiators a try, but they get continually colder. I'm bored stiff, and the world seems a vale of woe. The movie programs could not be more stupid or less interesting. It is hard to believe what sugary trash this hapless nation asks for, and gets.

In my distress I bought two Ullstein books, criminal fiction, not too bad, since I had nothing to divert me. I even wrote the letter to the mayor.

Now my conscience is causing me pain for having written such tiresome stuff to you. But the moment one unloads one's blues (at the cost of the beloved reader), one feels at least relieved. By Jove, I shall start a new picture tomorrow, for my own sake. This tinkering at *The Dome* makes me sick. If only Allo would get better soon. . . .

Halle
April 15, 1931

. . . How wonderful it was yesterday—and today I haven't stopped thinking of you and being happy. The weather has gone from bad to

worse. It is absolutely wild today, reaching a climax in the afternoon with a hailstorm, snow and rain, at the end crowning it all with blazing sunshine—through the entire gamut full blast.

In the tower it was nice and warm today. The staff was dismayed at the news that "Herr Professor" was not pleased with the lack of heat. My, what they lugged into the room! An electric sunlamp and an electric stove, besides the smelly kerosene affair—and when the sun broke forth to help, it got so hot that I had to turn off the entire parade and tear open the windows. I had dinner in the Tour la Mars and drank my coffee at the König looking at the glitter of rain on the Red Tower, which was magical. . . . I've been working with great intensity, in the A.M. at the Lüneburg motif, which stands up now. In the P.M. took up the evening picture of the market church. I am getting it, large in form and integrated in color, monumental and free in space. I haven't had news about Allo's condition yet, but I left the house at 8:30. I'm sure to hear from Minna this evening. She always goes to see Allo in the afternoon.

Now it is getting dark; I have to stop. It was so nice yesterday. Next time you come, we shall go to see Chaplin.

Halle
May 7, 1931

. . . No, I simply can't face going to Dresden now. Do come here on Saturday and see for yourself what it would involve if I were to interrupt work on these two last pictures at this moment. I cannot possibly consent to something which would utterly disturb me. Soon, when these two canvases are finished, this double existence will be at an end, which I hope will be by the end of May. And I mean finished to the extent that no more changes will have to be made. Then, too, everything will be settled with regard to the purchasing for the museum. How pleased we shall be with the security this sum of money means for us. And soon we shall be off on our trip—for months—later in Deep. But now I have to stick to my work here. I am not the sort of casual artist to leave a work vaguely finished, and run away to bask in the sunshine of society. If it were to be an exhibition of the hundred or more pictures—but this show in Dresden can hardly be called more than a temporary expedient, a preview with the latest works absent, and the old man himself not there, even on the day of his jubilee, when a celebration was warranted. Last week, quite secretly I started two large paintings, new subjects which not even you have seen. Without this stratagem, this tour de force, I couldn't have survived these last days. . . .

. . . I am still under the spell of our day yesterday, though today it is all gray with a north wind. In the streets a political demonstration of fanatical youngsters has been marching for hours with horns and piccolos and the idiotic whacking of a kettledrum—enough to drive one crazy.

In the morning Allo and Mary came to pay me a visit. Good old Allo! He really managed to creep up the winding stairs of my tower, and it didn't tire him too much. He was very happy to sit among his beloved Halle pictures again. We put them all out, trying to group them as best we could.

Now listen to what has been agreed upon. In the museum, three rooms will be cleared; everything will be taken out, and we are to hang all the Halle oils and drawings, arranging them to their utmost advantage—as a rehearsal, so to speak. Then we have to make a sketch of the grouping in order to have it ready to put up on the day the commission appears for inspection. Will you come and help me? You have a special talent for such things. Schardt won't be here any more. He is leaving for Zurich on Wednesday. But he will instruct the staff to give all the necessary assistance. I shall do everything I can to be finished by the end of this week. After the hanging we go to Dessau together, and then I shall cry "Hurrah!" My presence is not needed at the inspection. Soon we shall be on our way, out into the world. If only we were sitting in the train already. . . .

. . . Mary has talked to the mayor about the monetary arrangements. Dr. Rive showed perfect understanding with regard to the question of taxation. He is going to propose two ways of payment. The first, as we know, is to have the full sum paid out at once. But the second one shows his concern [about the financial arrangement for us], and it is to this that we shall agree. The town of Halle is to invest the amount of its payment to me at an interest of 6 per cent in my name. Any sum at any time will be paid out of this to us on demand. In this way we will have to pay taxes only for what we actually use during the year, and not for the entire amount of the payment at once, which would be a sum of astronomical size.

Schardt was out for a walk early this morning. He has lost much

weight. He is partly shocked, partly glad at being so thin. In fact his clothes are sagging, are dangling on him. But his figure is as youthful now as befits his age. I praised him for his appearance, told him to be grateful for having gotten rid of his fat.

To see the unemployed in the streets by the thousands makes one perfectly miserable. God knows they are a patient and peaceful lot, though. I read that in America there are 9 million of them—and no social organization to provide a minimum of help. How can a mighty and rich nation be so callous? Instead of help, they have the police shoot tear gas at them from guns specially constructed for the purpose, to disperse the gatherings. To create some sort of social security would be an act of great human kindness, and the man in office who could achieve this ought to be celebrated as a national hero. But what are the chances that such a thing will take place?

West-Deep
September 7, 1931

. . . Separation, even the shortest, is cruelly heartbreaking, but it stirs the soul like a tonic. It brings in its train enlightenment, and with new understanding we are aware that intrinsically everything has been, and still is, right, having only been somewhat obscured by routine. Discerning the beacon in darkness, we feel safe again. We know that nothing is wrong. The heart has put forth a new rootlet.

Repeatedly the sun has broken through the clouds. I am working at two watercolors with the possibility of getting them to dry the way I like it, in the sun on the table in the open porch. The wind has almost stopped. The clouds are softer, no longer as stormy looking as yesterday. If you and I could go out walking together—but now you are away.

5 P.M. No change, the old story, the sky has opened its sluices again. It is raining cats and dogs. I could not finish my watercolors. The paper does not dry. I am all alone sitting with the doors closed. The ink-black silhouette of the Wald Hotel, set in an arch of dark masses of clouds in a threatening sky, is what I am staring at—gruesome. . . .

September 9, 1931

Yesterday, in the afternoon, I walked east through the woods to the beach. I saw ravages caused by the storm. I counted 58 of the huge

breakwater piles wrenched out by the fury of the waves and thrown on the land, some high up in the dunes. The lower parts that have been imbedded in the sea for years were all covered with barnacles and small shells, while on the upper portions moss and gray algae were growing. A strip of 6–9 meters is all that is left of the beautiful wide beach. The dunes are deeply undercut from the onslaught and the backwash of the waves. Since I cannot do watercolors in this wet world, not being able to dry them the way best suited to get the effects I am after, I shall stick to drawing. I have wonderful motifs from Concarneau and Triboul [France], which, I hope, will be successful.

West-Deep
September 10, 1931

. . . This date brings a recollection which is very dear to me. It was in 1892, in Seedorf, where at the dock in the estuary the wreck of the *Triton* was lying, and I was making a drawing of it. I remember how suddenly, almost with a shock, for the first time in my life, I became conscious of a feeling of unspeakable peace and harmony, such as a quiet, sunny September day gives to one's soul. I was so happy sitting there in my little rowboat which I had tied to the wreck while drawing. . . .

West-Deep
September 12, 1931

. . . Why do we write about the weather? Because we want to share with another the feeling of the day which, for people like us, is built upon the weather. The few hours of daylight, the year nearing its end, feeling my loneliness the most, and the fall season, make me unspeakably melancholy. With regard to the exhibition in the Kronprinzen Palais, I can only say that I am glad the Halle pictures will be shown. Otherwise—and this is between you and me—I have no confidence at all in their genius for hanging, nor any expectations as to the foreword of the catalogue. In my mind's eye, I see the words racy and piquant. This show will mean publicity for me. I wonder what you have to tell. . . .

Lyonel Feininger

. . . Yesterday it was cold with rain and fog; today it is warm with fog and rain. What it will be tomorrow we do not know, but on the mast at the mole the storm-warning signs are up.

Tell me, do you think the show will be good? I have the feeling that it will tear away my anonymity—there is almost a feeling of exhibitionism, even the word sensationalism rings unpleasantly in my ears. What effect can it have on the public except to satisfy curiosity? I honestly declare that if I could prevent it now, I should gladly do so. I don't think I even care to see it.

Here I am doing work every day, but I cannot find color, so I must content myself with preparing form, which this year is especially important to me. I am too melancholy to take pleasure in color, but to seek form gives me a support spiritually. Color will come when I am once more seated in a warm room and have no irritation of body, but now it taxes me too much to jump about and run from the drawing table to the kitchen to dry a watercolor, or to get fresh water or wash off a drawing. A good Feininger aquarelle takes a lot of nervous tension and bodily activity to accomplish.

If you really decide to come, it will be very cheering to have you here. I am eagerly waiting for news from you about the show. . . .

West-Deep
September 17, 1931

. . . Yesterday I thought of dispatching a second letter after the first one, to moderate its dismal mood. But it would not have been of help since the mail leaves only once a day. As a whole, the day ended not too badly. I was alone in the small glassed-in veranda, having just finished a drawing that I thought not bad. Looking up I perceived the landscape bathed in a warm, rosy golden shimmer. Impulsively I set out on "our" trail across the dunes and along the beach to the east. It did me good. I know I would be less depressed if I were not so impeded in walking. This bit of getting about quite pepped me up.

Of course I am terribly preoccupied thinking of the show, if only you could convince me that it won't be a failure. . . .

. . . I am so happy about your decision to come here. It has been terribly lonesome without you. Your fine long letter from Berlin has cheered me immensely. The moment I received it, I felt ashamed of my despondency and mistrust. Your applause and [expression of] gratification with regard to the show did me so much good, and I know what it means to you. But I am too much preoccupied and involved in producing pictures, never sufficiently free to enjoy them to my heart's content. I probably also like the pictures, but this is not what compels me to paint. I ask myself what it might be.

Do you remember how even in Graal I never could feel satisfied with colors as they occur in nature when thinking in terms of the picture and when visualizing the possible painting—and how pitiably my efforts turned out when, in Lobbe, I sat in the midst of a landscape, painting after nature, trying to portray it? Here I have done much drawing. I have begun to see more clearly the tendency of my striving. Something different dominates my work every year. This tendency will last to the end of my days, and the question is whether one ever comes close to the realization of one's conception and insight, which for me is order in its widest sense, probably derived from the order I see and feel in the universe.

I am so pleased that Justi had the walls painted white as a background for my oil paintings. We have to thank him indeed for his devotion to the show. You write that the American Embassy has been invited to attend the opening. God knows how they will respond. I had been considering something of the sort myself but my equivocal position in Germany embarrassed me. Now the newspapers make me serve an international role, "friendly relations" between the country in which I am now living and the United States "are documented by Germany honoring an American artist with this show in an official place." I would have liked to have had Barr present.

I am so glad that you are coming. I am glad about and anticipating everything—at the moment, the work I intend to do. In the afternoon it will be the mailman, who for three days has delivered mail only once a day, at 5 P.M.; last but not least, the moment when our time will be up here, and that may be very soon (for this summer is already over). We all can look forward to Dessau. There, upon thinking back on this spring and summer, we shall remember the time as being as rich and glorious as it really has been for us as a whole.

Here now we are wrapped in fog, fog, fog. The nights are clear and starlit, yet during the day nothing but fog. . . .

I saw a little dead fish lying in the wet sand on the beach. With one

bulging eye it seemed to be staring into the setting sun . . . a melancholy sight. . . .

---

West-Deep
September 29, 1931

. . . Life here is very quiet, yet we have bright moments; best of all you will be pleased to hear that I am feeling 100 per cent better since I have given up drinking so much coffee.

Yesterday two long walks, one in the morning alone in the woods and another in the afternoon along the beach toward the east with the boys. Now I am home working at the wood block for *Schaffenden,* the street in Treptow. The structure of the wood is not satisfactory, in fact, it is no good at all. Yet I am glad to have the wood under my fingers once more to whittle at after so long an interruption. It is very good as discipline, and though I'm working under compulsion, I am grateful.

I received a letter from Adolf Knoblauch which puzzles me. He renounces (once again) my work, myself, or both. I can't make it out. You will have to see the letter. He talks of "wasted love," because I gave up cultivating the curved line in Weimar. He bears me a grudge because (as he thinks) I am not as lonely as he is, or something of the sort. Yet underlying all this there seems to be something vibrating in the man, something that seems to touch him to the depths. It is the old story: art and Evangelic doctrine are not to be united. . . .

---

Dessau
December 10, 1931

. . . Two days of good work—two paintings begun, several toy trains colored, Christmas mail to America dispatched, to Churchill and to Piper. To the latter I sent the *Two Yachts,* remembering how he had tried to find colored reproductions of my work two years ago. Yesterday I had a very nice letter from Benson from New York. He had had news from J. B. Neumann* [writing about the show in the Kronprinzen Palais in Berlin] that "every day thousands of people" crowd in front of my paintings in the museum—my grapevine is functioning well.

Please get two or three more catalogues. I could use them. Emmy Scheyer sent the catalogue (in Spanish) of the Blaue Vier show in Mexico—which will last a week.

* Director of an art gallery in Berlin where Feininger's paintings had been exhibited.

What you write about your talk with Probst made me very sad. We shall probably never fully realize the difficulties that he has had to overcome in his fight against anticultural influences, and now he thinks the Fides has lost the battle and that he cannot keep up the gallery. What is he going to do? The Kandinskys are in Berlin. Perhaps you could call up Gropi?

I am in good shape. My painting goes well, and I derive pleasure from it. The more I start, the better I get along. Soon a row of new things will appear. But how short these December days are for a painter. At three the light is already failing.

I hope that you have a good time and moderately favorable weather until Saturday, when we will have you back. There is a springlike quality in the air here, intermixed with the sweetish stink from the sugar factories—besides, it is raining off and on. . . .

———————————

Dessau
January 19, 1932

. . . We are fine. My small duties are not hard on me. I got to work. I am giving the finishing touches to two paintings, the new *Blue Marine*—so pretty! Now I shall take up the *Lighted Windows II*—of this painting I am sure, and two then will be finished in 1932. I have to attack new things and larger dimensions to loosen up.

Miniature painting isn't up my alley yet. There will be time for that in 10 years, when I may be forced to paint sitting in a wheelchair with bedroom slippers on my feet.

The show in the Kronprinzen Palais is closed now. My reign and glory are over. I'm looking forward, though, to having a room for myself there with my works on the walls—and among them a few ranging in the warmer tones.

Lux is working at his brig. The masts are up. He is almost through with the rigging and the stays. The long bowsprit gives it a very conspicuous physiognomy. It will look handsome in the water. . . .

———————————

Berlin
May 9, 1932

. . . I sent you a telegram that I shall have to stay until Wednesday, have to go to the dentist once more tomorrow. Also I must inquire at Stettiner Bahnhof about trains to Treptow. The travel bureau could

Lyonel Feininger

give no satisfactory information. I shall enjoy another day here, as it is now beautiful in Berlin. Right now I am sitting at the window at Hefter's on the Wittenbergplatz after my little dinner, at ease over a cup of coffee.

Yesterday all day with the Gropis in their really fine new auto, together with Schawinsky and Bayer, and a very pretty young film actress, Brigitte Morney, whom I saw in a movie last year. We were in Perch and Gatow in spite of the rain almost all day, no sun at all; in the evening we went with the Gropis to the movies—*Vampyr*. To bed very late, tired this morning, tomorrow off to West-Deep. The sun is shining now and we may expect good weather tomorrow. I am going to see *Shanghai Express* again, a wonderful film. This evening supper at Gropis. He is leaving for Frankfurt at 11 P.M. . . .

---

West-Deep
May 14, 1932

. . . I was very glad to find perfect order in my living conditions after the taxing days in Berlin and the journey. The train—with 18 cars—was terribly crowded, more children than I thought ever could exist—all going on a Pentecost vacation. In the meantime the freight arrived—*and* the boys yesterday afternoon.

On Tuesday I forced myself to look in at Mollers for a quarter of an hour to see Karl's [Schmidt-Rottluff] show. Karl has a few very strong paintings which I had never seen before. I did *not* go to the Kronprinzen Palais. On Saturday I lacked time. Sunday I spent with the Gropis. Mondays the museums are closed anyhow, and since I intended to leave on Tuesday, that day didn't count. Though I stayed on then, it did not make any difference, for I still felt unwilling and as shy as ever to risk seeing "museum people" without Pulu.*

And, don't you know, there seems to be a high degree of wisdom in resolutely trying for a while to turn away from—not so much one's former creations—but from one's idiosyncrasies and from imagery as a whole. I feel too much attached to my vein of last winter. I simply have to break away from it.

Today for the first time since my arrival I have no headache. I slept well and there is some energy stirring. The brain is not completely dull any more. I felt like planning something, if for a beginning—no more than writing this letter to you.

A pretty strong southwest wind is blowing. Yet it is warmer out-of-doors than in the unheated rooms. The trees are budding but have no

---

* Pulu was Feininger's nickname for Julia.

leaves yet. It is light and lovely in the garden when the sun is shining, no foliage jealously interfering between oneself and the rays of the heavenly orb. The beach is much changed: certain sections hardly wider than 18–20 feet, the dunes very steep, difficult to climb. At the mole the huge concrete boulders are broken and scattered by the gales of last winter.

It is lovely to be here in early spring. The air looks as though seen through rose-tinted glass. All the cherry trees have started to bloom at once, but the apple trees are late. May at the seaside is a grand experience.

The new bridge is not in use, so the car has to stay on the other shore at the Wilke's on the Bramberg.* Kasten has built a second story on his house. Gramma Wendt is in good health and sends her most cordial greetings to you. The entire place smells of cake which is being baked in every house for tomorrow, Pentecost. Most of the benches in the woods are as kaput as they were last year and are lying around as they were last year in October. Only the morning train is running. The mailbox is frozen in—ours is the one and only bath chair on the entire stretch of the east-west beach. . . . The boys saw my show in Hamburg. They thought that it looked good, one large room and, at right and at left, two smaller rooms with watercolors, drawings, and graphic work. One watercolor is sold. Now I have to stop. I'm getting a cramp in my fingers. Fondest greetings from your husband, who isn't worth much right now. Love also from the boys. Oh, the tranquillity and peace of the Pentecost. . . .

═══════════

West-Deep
June 4, 1932

I think that I was right reading between the lines of your pleasure in having my letter so soon after it was written. To get the letter to you quickly, I took it to the afternoon train myself in the pouring rain. Not much has occurred as to facts. All the more am I concerned with experiences of the mind and spirit, and then naturally everything is adventure. To try to describe them would be plucking them to pieces. For hours I can sit at the beach, looking out to the sea in its immensity, and to the infinite sky above. I am thinking of you. I feel the doors of my inner self open. Reflections revolving around the inarticulate continually shape impulses for creative work—and my pictures are my language which you understand. To express myself in words is not given to me. More productive than words is my taciturnity. But it is

* The Wilke family rented rooms to Feininger in West-Deep.

often a heavy burden. I have mentioned before that during these last weeks my work has been preparatory for a new way of composing a picture [*Bildgestaltung*]. In the medium of charcoal I have discovered a great relationship with pure painting. Jotting down one's first nebulously chaotic conceptions, one can gradually work one's way through to firm ground and precise form. That which has been halfway indicated is open to further evolution. Nothing is quite definite until it has reached final clarity in the accomplished oil painting. These weeks are for me a period of self-imposed new orientation. I have to accept that much may remain a mere hint of what later may come to fulfillment. This way of producing conforms to my wavering physical condition. I never quite know how far my strength will carry me. That is what makes me often terribly depressed. One is lonely within the confines of one's body, and often not less in the wide world. . . .

Here I am sending you Emmy Galka's letter which contains lots of amusing detail. I wonder whether we shouldn't consider sending some 20 or 30 new watercolors in the fall, also catalogues and reviews regarding the "Feininger Year" recently past?

West-Deep
July 8, 1932

I was almost certain that you wouldn't be able to return to our paradise by the end of this week. What you write about this new taxation is important enough for us to seek advice from an efficient counselor. It seems the limit to look upon—as in our case—unfinished pictures as taxable property. What else will they hit upon next to kill creative powers in this hapless country? At the beach innumerable swastika flags are hoisted, very few black-white-red ones strewn in, and not a single one of the German flag proper—the only place where the official black-red-gold is to be seen is in the east, flying from the flagpole on the mole. The beach has a decidedly oriental look with these insignia, whose symbol is of foreign origin, from the Far East—whatever the Nazis may think or say. It is not only in bad taste but shows a lack of breeding to fling one's political opinions into other people's teeth. Like everybody else, they are guests in this little place, and it is a terrible way to provoke a party quarrel.

At the Wilke's there are, besides us, three families with children. Every morning, walking to the beach, they carry their swastika flag, and at noon, when they come back, it is hung over the railings of the balcony over ours, and we have it dangling over our heads. The other day one of the little girls was frightened by a cow on the road. I heard

the mother trying to soothe her with the shocking words: "But you won't cry, my little Hitler maiden"—well, three more weeks and they will be gone and we at peace again. . . .

I enclose a letter from Dr. Bier. I answered in the affirmative, asking for paper sizes. I shall cut the wood block in a tough manner to make it withstand the 400 printings they need. For my birthday I would like to get a few books: *The Green Hat* by Michael Arlen and *The Dubliners* by Joyce. . . .

<div style="text-align:center">━━━━━━━━</div>

West-Deep
July 10, 1932

. . . With regard to your information about the forthcoming show at the Bauhaus, I can only groan out the name Schulze aus Naumburg.* *Anything* is to be expected from the present German government, no use commenting on their actions. One is simply sick at heart. I am curious as to how you will solve the problem of my unsalable, unfinished canvases on which they try to clap their hands for taxes. Judgment will be passed by later history writers. What a God-sent opportunity for the Nationalists to make short work of objectionable modern art, to quash it. . . .

<div style="text-align:center">━━━━━━━━</div>

West-Deep
September 21, 1932

. . . The letter you wrote Sunday (received yesterday) made me realize how distressing these days are for you—in Dessau as well as in the house. Comforting, though, is what you wrote about Theodore, the good man, and that with his help the practical side of the boys' stay in Paris will be eased. If all goes as we hope—if they are taken care of—it will make a great difference should we have to give up Dessau. Of course it is not easy to think of leaving the house, but to remain there all alone after our friends have left is unthinkable.

I am enclosing two letters which I received yesterday, one from Consul Busser and the other from Gunther Franke. You may have seen the consul on Monday in Leipzig. If so you will have told him that I'm not in Dessau at the moment. His letter and mine may have crossed. Anyhow, I wrote him that we would have liked very much to have had him and Mrs. Busser for lunch and to show them the Bauhaus.

* Paul Schulze-Naumburg, the National Socialist architect and art historian.

Rochus and I on our walks talk about art, theoretical aspects and art experience. He is working well. He tells me how he is advancing. . . .

---

West-Deep
September 22, 1932

. . . Your long letter yesterday contained answers to the many questions which understandably were on my mind, and I feel relieved with regard to the most important ones. I am glad that you visited the show in Leipzig. What pleases me is that not so many pictures are hanging. Many of the old ones would now be only gaped at by the public, and the critics would be floundering around helplessly, not knowing—or not daring—to think or speak or write about them. We shall have to reclaim many which were shown in Berlin at the big show to save them for later times. We can store them in the museum in Halle.

I should like to tell you now what is going on here and how we are spending our days, which are rather short so late in the year. Ah well, it is very quiet around us two left-overs. Rochus has become familiar with the place, its people and their dogs, in a rather uncanny way. A few new guests are said to have arrived, but they are hidden like the last apples up in a tree overlooked by the gardener. Off and on we meet one slinking through the woods or at sunset on the beach. But Rochus knows them all.

The new road leading from the new bridge to the schoolhouse is impassable. We pedestrians carefully avoid it. If we can't get around going in that direction, we prefer to cut our way through the brambles in the woods, not to become too terribly messed up, especially after the rains of which we have had a sufficient number. All the landmarks we liked so much on the old road have been destroyed. The humps we climbed up and down during nine summers here are flattened out. The road is a most tedious stretch with nothing to take pleasure in. We have been on the terrace of the Strand Hotel twice after 5, trying to persuade ourselves to behave extravagantly, but it was no good. It didn't work out right without Pulu.

The woods are full of mushrooms and toadstools, the yellow and red and brown, and less conspicuous ones deck the ground, making it very jolly. Some evenings we saw beautiful cloud-pictures when the setting sun's last brilliant rays were suddenly poured forth horizontally on the accumulation of clouds in the eastern sky.

I am alternating between sitting in the enclosed porch or on the open

veranda working at watercolors. I can be neither here nor there when storm and cold get too much for me. When I have to sit indoors I can do nothing but read. . . .

———————————

West-Deep
September 25, 1932

. . . Yes, it is our wedding anniversary today. Until you wrote about it I had quite forgotten—for the first time. It is as if we had always been together, perhaps born that way. I am thinking of you and sharing all that you are going through these weeks. Rochus said yesterday that he could not understand why we take it so hard that the boys are leaving home. But then he is not a parent. Of course it is lonesome, horribly so for you now, and the packing cases still standing around and the disorder make it all the worse, *and* the wretched Dessau atmosphere. Cheer up, we'll soon be in more congenial surroundings, and we shall travel when spring comes to see the boys in happier circumstances. . . .

———————————

West-Deep
September 27, 1932

. . . For the present we can do nothing except cross our fingers, wishing for the best, hoping that in the meeting on Wednesday a solution can be found that complies with our needs in the housing question. In the end it would be a comforting idea to have a home for the boys to come back to, at least until they have gained a footing in the world. For myself I really am looking forward to being in the house, a house with a music room—for music after this long pause is stirring within me again. How nice that you will be with Lily this evening. I hope that the Klees won't give up Dessau entirely, but stay in their house. It is good to have them close by. Perhaps with so many of the others gone, and our group thinned out, we might see more of each other. Most of all I shall miss my good Schmidtchen.* Our conversations lately have been stimulating for both of us.

It is difficult to understand why Schmidtchen is not valued to a greater extent. I talked to Rochus about it. He thinks that it is Schmidtchen's personality that exasperates those who have to work in close

* Joost Schmidt, former student at the Bauhaus, was at this time master of the sculpture workshop.

29. *Gelmeroda.* 1920. Woodcut. Courtesy of Associated American Artists, New York.

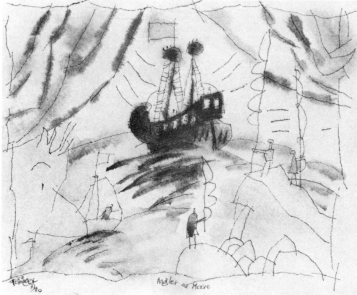

30. *Fisherman at Sea (Angler am Meer).* 1920. Watercolor and ink, 9¼" x 11". Collection of Rev. Dr. Laurence Feininger. Photograph courtesy of the Marlborough Gallery, New York.

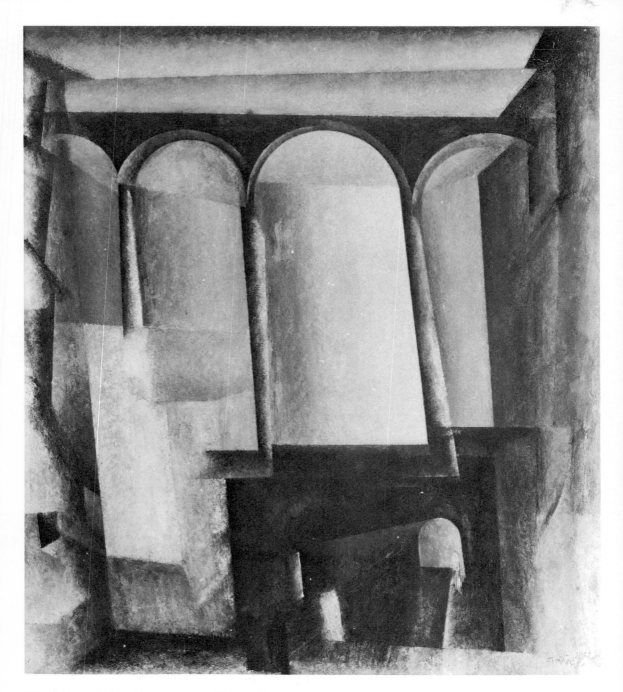

31. *Viaduct.* 1920. Oil on canvas, 39¾" x 33¼". Collection, The Museum of Modern Art, New York. Acquired through the Lillie P. Bliss Bequest.

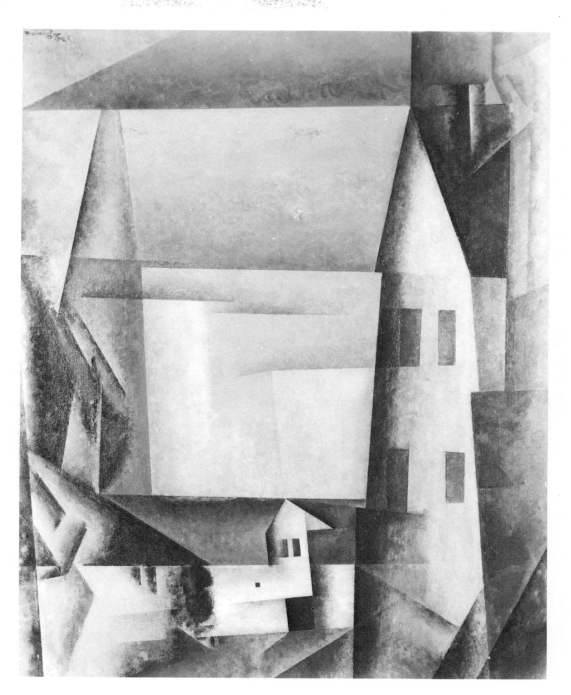

32. *Gross Kromsdorf III*. 1921. Oil on canvas, 39⅜″ x 31½″. Busch-Reisinger Museum, Harvard University, Cambridge, Mass. Gift of Mrs. Julia Feininger.

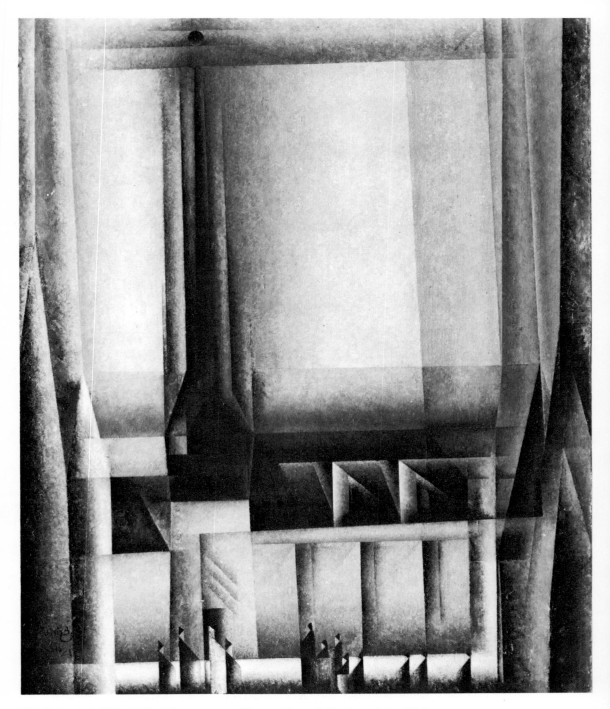

33. *Gelmeroda VIII*. 1921. Oil on canvas, 39¼" x 31¼". Collection of the Whit-
ney Museum of American Art, New York.

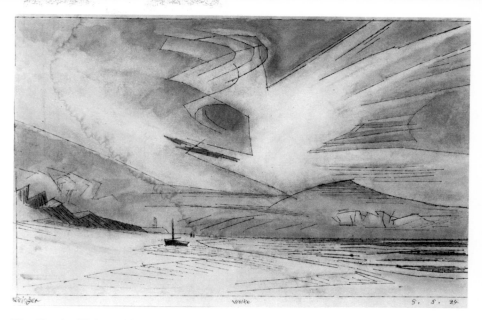

34. *Clouds* (*Wolke*). 1924. Watercolor and ink, 11⅛″ x 16″. Busch-Reisinger Museum, Harvard University, Cambridge, Mass. Gift of Mrs. Julia Feininger.

35. *Benz.* 1924. Watercolor and ink, 11⅛″ x 13¼″. Collection of Andreas Feininger. Photograph courtesy of the Marlborough Gallery, New York.

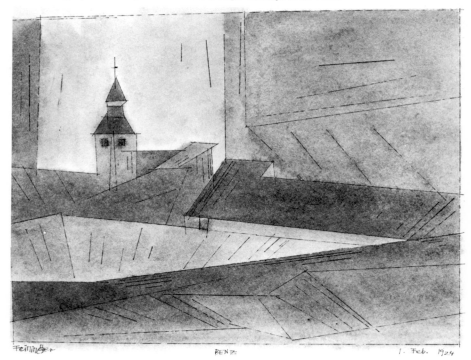

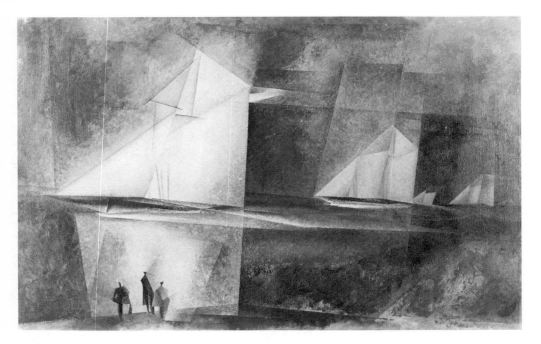

36. *The Glorious Victory of the Sloop "Maria."* 1926. Oil on canvas, 21½" x 33½". The St. Louis Art Museum. Eliza McMillan Fund.

37. *Bird Cloud.* 1926. Oil on canvas, 17¼" x 28". Busch-Reisinger Museum, Harvard University, Cambridge, Mass. Purchase, in memory of Eda K. Loeb.

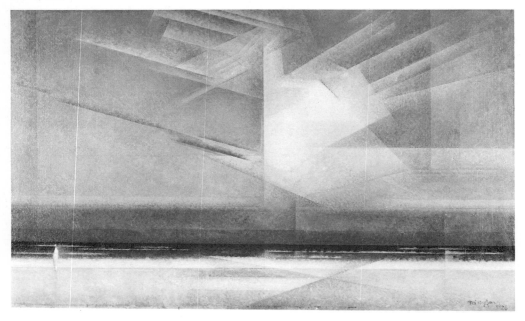

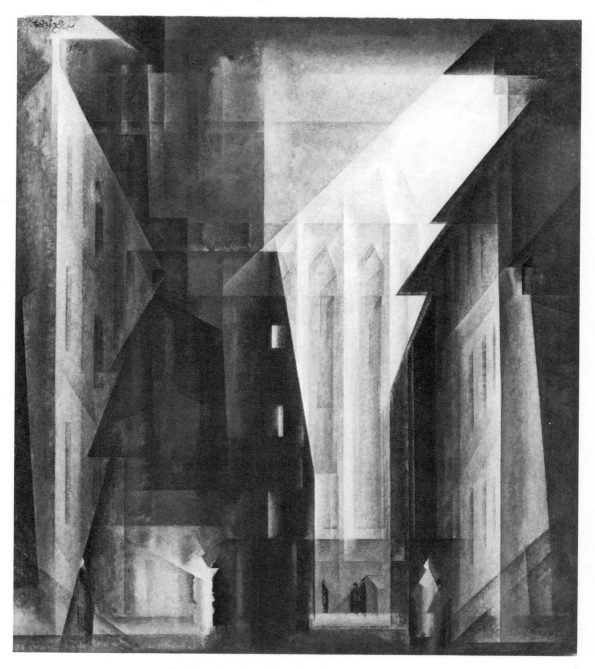

38. *Church of the Minorites II.* 1926. Oil on canvas, 42¾″ x 37″. Walker Art Center, Minneapolis.

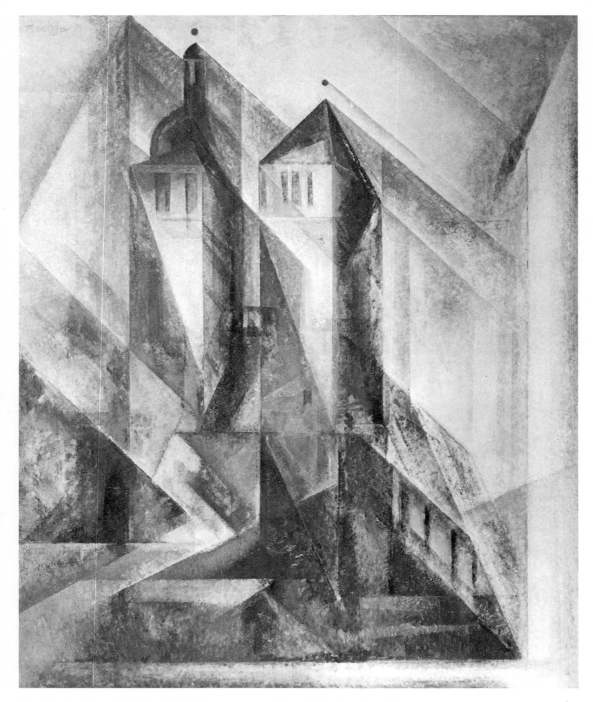

39. *Regler Church, Erfurt*. 1930. Oil on canvas, 50" x 40¼". Courtesy, Museum of Fine Arts, Boston. Charles Henry Hayden Fund.

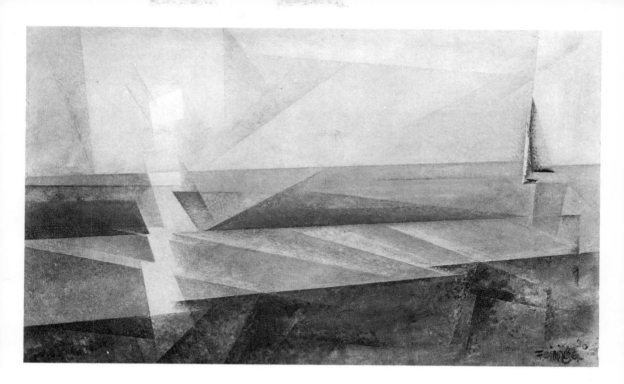

40. *Sunset at Deep.* 1930. Oil on canvas, 18¾″ x 30¾″. Courtesy, Museum of Fine Arts, Boston. Charles Henry Hayden Fund.

41. *Ruin by the Sea II.* 1934. Watercolor and ink, 12″ x 18½″. Collection, The Museum of Modern Art, New York. Gift of Mrs. Julia Feininger.

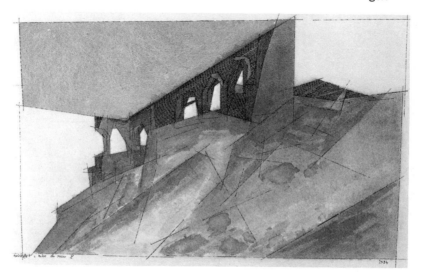

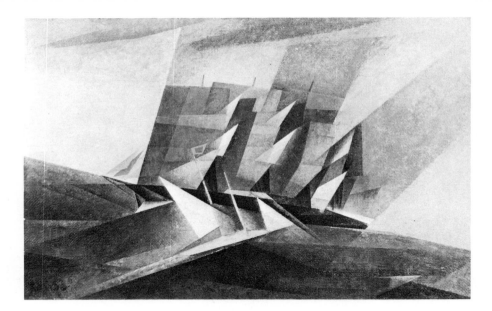

42. *Four-masted Bark and Schooner.* 1934. Oil on burlap, 15¾" x 24⅝". The Solomon R. Guggenheim Museum, New York. Photograph courtesy of the Marlborough Gallery, New York.

43. *Ship of Stars.* 1935. Oil on canvas, 6¾" x 28¼". Courtesy of Kennedy Galleries, Inc., New York.

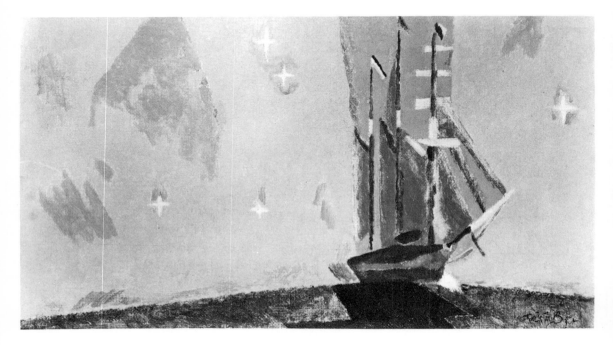

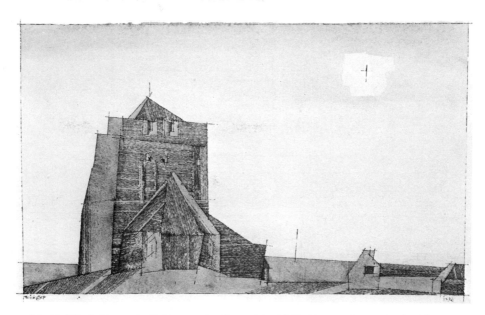

44. Untitled (Tower in Britanny, St. Quenole). 1936. Watercolor and ink, 12½″ x 18½″. Collection of Stephen and Jane Garmey. Photograph courtesy of the Marlborough Gallery, New York.

45. Untitled (Mauve sea sky). 1939. Watercolor and ink, 8¾″ x 11⅛″. Collection of Andreas Feininger. Photograph courtesy of the Marlborough Gallery, New York.

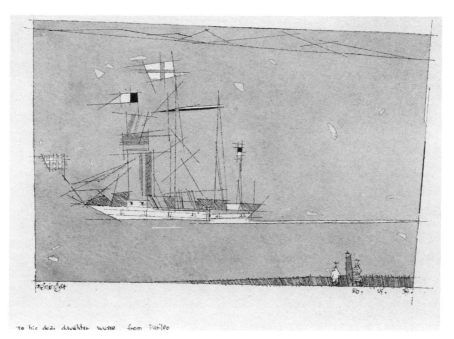

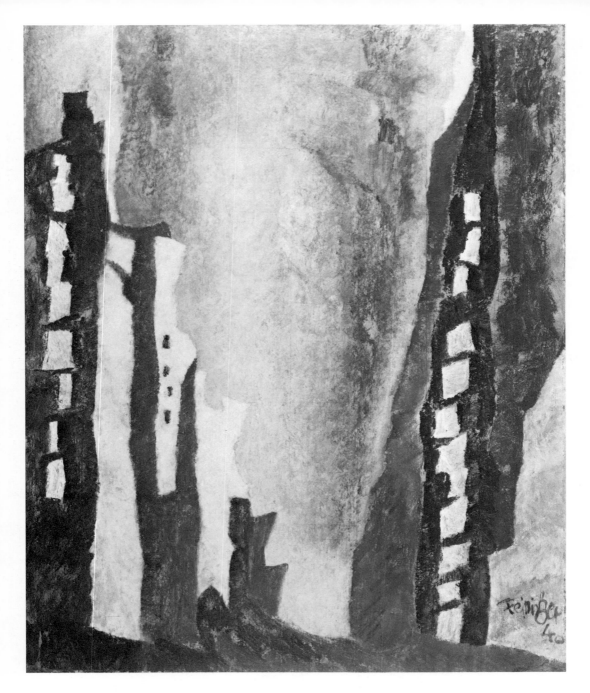

46. *Manhattan I*. 1940. Oil on canvas, 39⅝″ x 31⅞″. Collection, The Museum of Modern Art, New York. Gift of Mrs. Julia Feininger.

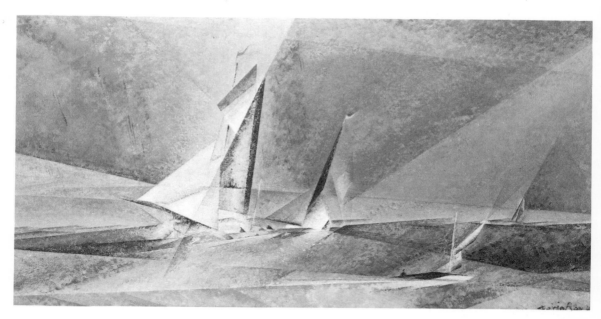

47. *Fisher off the Coast.* 1941. Oil on canvas, 18½" x 25½". Courtesy of The Detroit Institute of Arts. Gift of John S. Newberry in memory of Dr. William R. Valentiner.

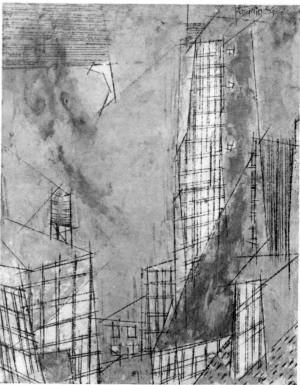

48. *City Moon.* 1945. Oil on canvas, 28½" x 21⅜". University of Nebraska Art Galleries, Sheldon Memorial Art Gallery, Lincoln. Collection of the Nebraska Art Association.

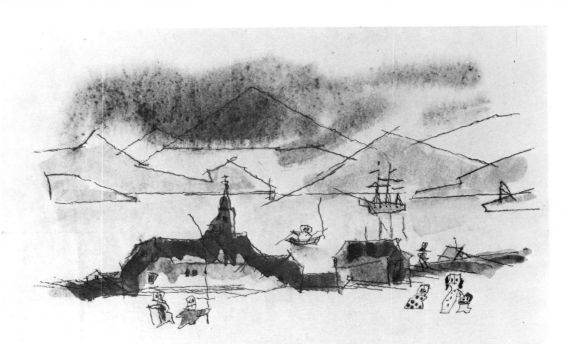

Dear Dan:

      Thank you for your card.  I am much obkiged
----- no, no! dashed if I am that!  ---- the word
is"obliged." I must be getting cross-eyed when I exert
the type-writer.  ----

      I shall seek an opportunity of visiting the
Turners very soon.

      Yes, it was good to see you both the other
evening. Next meeting: perhaps in the Curt Valentin
Gallery?  in the show of the 80-and-three-quarter-years-
old Celebration?

      Chirrup and toodleoo!

                 Leo

49.  Letter to Dan R. Johnson with watercolor as letterhead. 1952. Cour-
     tesy of the Willard Gallery, New York.

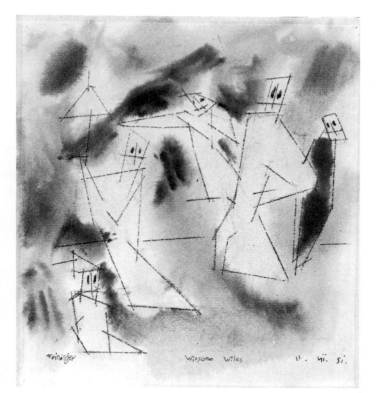

50. *Winsome Wiles*. 1951. Ink and gouache, 9½" x 8½".
Collection of Rev. Dr. Laurence Feininger. Photograph
courtesy of the Marlborough Gallery, New York.

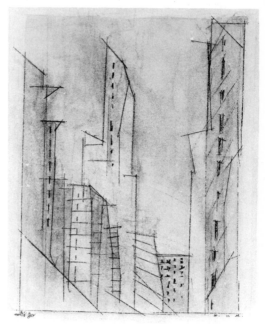

51. *Manhattan*. 1952. Watercolor and ink, 19" x 14". Cour-
tesy of the Marlborough Gallery, New York.

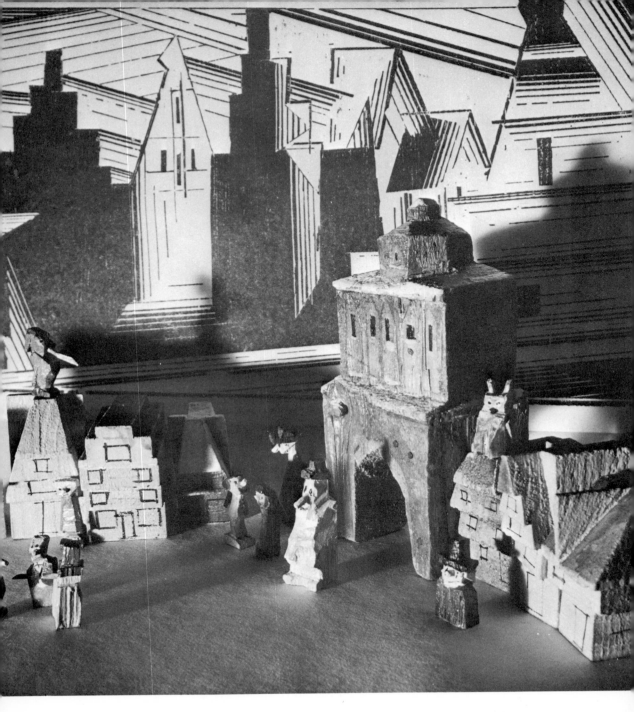

**52.** Toy houses and figures carved in wood and painted in front of a woodcut by the artist. Photograph by Andreas Feininger.

contact with him. Even Mies,* the easy-going one, mentioned something of the sort about his awkward manners. There is not much of the courtier in Schmidtchen; he is clumsy and often very abrupt and difficult to get along with.

The Bauhaus today seems to me to be based too firmly on theoretical principles. Such a system of art education encourages beginners too easily and consequently tends to produce a certain feeling of independence in the student which nonetheless easily cuts him off from his own path of trial and error, the search for a personally developed Weltanschauung, and his ability to find adequate expression in his works. To counterbalance this, a man of Schmidtchen's caliber, with his love and appreciation of the milieu [*Umwelt*] would be a valuable help in combating theoretical routine. . . .

———

West-Deep
April 6, 1933†

We arrived here without mishap after a pleasant trip. You know I always enjoy the journey from Stettin in a comfortable second-class compartment. I must get you a fine big hot-water bottle when I am in Treptow meeting you, for it is bitter cold in the evening, and I know that you could not stand it in bed without one, now *allons vous bassiner votre lit, madame.* The Wilkes are very glad to see us. They all look fine, so healthy, with out-of-doors complexions and plump faces. Mohr recognized us from far away and came bolting madly to greet us, quite crazy with joy. The bedroom and big room next to it have both been beautifully repapered. You'll be very pleased with them—and all floors freshly painted—tip-top style. I've hung two little framed woodcuts on the wall and they look nice. You can imagine how interested I shall be to hear about the Zuntz affair and the National Gallery prospects.

Max Reinhardt has been ousted from the theater, and his scenery banned! For 35 years, the world's greatest and most universally admired theatrical manager and genius! In France, the United States, in England, and Russia the indignation is so great against the persecutions that these countries threaten a world boycott. And where would that lead Adolf, who is helpless if he hasn't got unlimited money? All are agreed that he will lose control of the forces that he lets loose. . . .

———

* Ludwig Mies van der Rohe, director of the Bauhaus from 1930 to its closing in 1933.
† By 1933 the Bauhaus had been forced to move to Berlin.

. . . I got your good letter today—I don't know to what accident I owe this lovely surprise, for there is no regular train service yet, and only every second Sunday does a train run. Today was the trainless one. If only I could communicate some of the peace and bliss little Deep is giving me so that you could share it. The day started with a brilliant sun out of a sky of purest blue, a moderate breeze coming from the sea, no summer guests, only the unobtrusive friendly Deepians.

All that has happened these last weeks lies behind me, bygone. These four days here have made me new; once more I feel the sap rising and a determination to work. To file many hundreds of sketches stored haphazardly in portfolios revives unforgettable circumstances, places, and attitudes of years past. The runes on these pages resemble seeds full of magic, capable of germinating into future works. My mind is open to them now. It seems incredible—as if I had forgotten all I had ever hoped to achieve. Of the past years I can say: much ado about nothing. I don't want to be ungrateful toward Dessau, yet, when I think of my expectations when we moved there, that the door would open for me with regard to my work, I seem to have done very little, to say the least. It is very good that now, once more, we are at liberty, freed from all obligations. The pressure of the times, the developments are forcing upon us increased introspection, not unlike the war years of 1914–18.

Yesterday I lay sheltered from the wind on the dunes for a long time, the sun warming my face (and giving it the first hint of tan), the light breeze fanning my head, and the sound of the surf in my ears. Also I have been walking westward on the beach and back on the dunes. The outlook over the sea from this track on the heights is stupendous and, on the other hand, full of diverse adventure of the most modest and intimate nature. The smallest sandhill, each little hollow, every tree or stone may present something never noticed before which one gratefully takes in. And I stirred up a mighty fat rabbit—my, how he scampered away! One meets not a human soul. At intervals one sees fishing boats pulled up upon the sands. Among others I saw the *Siegfried*. I sat for a short rest on her gunwale remembering Lux's having been third in her in last year's races. The glitter of the afternoon sun on the sea and the wet sand called up memories of the sheen on rainy streets, of moonlit nights in silver or pale gold; such play of light holds a special fascination for me.

And here is another observation: I am feeling more than actually seeing—my own shaggy pepper-and-salt eyebrows filter the light, and this influences in a strange way the color scheme of the landscape.

I don't read newspapers here but I would like you to buy a *Chicago Tribune* in Stettin when you come. I am interested in the opinion of the world with regard to the happenings of the last 8 days. If only it remains as peaceful here as it has so far. The only one who concerns himself with politics, talking of the "party," is Peschamelke. Yet he has, in a friendly way, asked after you, how you are, and when you will be coming.

In the season, during school vacation, there will be, as everywhere now in Germany, anti-Semites here also. If Jacky and Ilse Neumann decide to come later, I am sure that nobody will trouble them, at least none of the Deepians. I am horrified at the fate of Dr. Michaelis, I cannot write about it. . . .

---

West-Deep
May 18, 1933

. . . Yesterday I wrote to Gropi for his birthday. I felt almost with pain the cruelty of what he has to go through now. He who was one of the first to assemble what was left in Germany after the war by way of spiritual and constructive potentiality, to build up methods of new development in a concentrated effort, who never faltered or was side-tracked, he is now suspected and hunted down. It was *he* who never permitted any sort of political attitude or party politics in the Bauhaus. He recruited and fought for the idealistic purpose of going back to pure form, and in consequence provided a new departure for design. Whenever such questions arise nowadays, he is not mentioned at all. Successes are ascribed to others. They are to reap the harvest they have not sown. . . .

## The Final Years in Germany (September 4, 1934– May 3, 1935)

West-Deep
September 4, 1934

. . . Just got your postcard, which relieved me, for you had hardly been out of reach when I remembered the most important argument against taking the very small apartment: two rooms only, besides the workroom. We should at least have a spare room to put up Lux in case

he comes back. And another reason: it would be so very far from Berlin. I'd really miss the stimulating activities of street life and the possibility of being with our friends. I know how important now is the contact with Karl [Schmidt-Rottluff] and [Erich] Heckel. I have been struggling alone too long without interchange of ideas. For 4 or 5 years my inhibitions have developed like a disease. You know it. I don't need to explain. It seems as if my efforts to attain perfection in painting were only leading to a torpor which is a deadlock. I have to find my way out of this psychosis, break these fetters. I need a dose of light-heartedness to snap out of my brooding.

It is so good of you to keep on chasing around looking for a suitable place. There need not be a studio, but the room should have good light and space enough for putting away things not used at times. . . .

---

Kuhtz
October 17, 1934

. . . The grand piano sold! It is hard to take this piece of news, to get accustomed to the idea of not owning the precious instrument any more, not having it at our disposal after our long absences during the summer. Laurence also feels the loss. But what else could we do?

Of course, I was very much interested in all you write about Halle, especially about the events concerning Allo [Schardt]. I'm pretty much aghast to think of him undergoing such persecutions. Not to have him in Berlin seems almost incredible. Is he in exile for political reasons? How can they treat him this way, a man whose attitude has always been so completely unpolitical? I shall miss him very much—but no more about it now. I have to know the details.

The other piece of news was all the more pleasant. I was quite amazed that you think I have a number of good paintings in the tower. All of a sudden I am impatient to get to work. These 18 months of being separated from all that I was formerly occupied with have forced upon me problems which must now be solved, but I am sure that I have prepared the way during this long interval since we left Dessau. How good to know that at last on Tuesday the moving will be started. I was afraid of delays occurring. How strange it will be after so many years to live with you alone under one roof again as at the beginning, only you and me. I am wondering how you will stand it, to be so restricted and with too much household work on your shoulders. I trust it will be all right. We should not succumb to the dangerous feeling of being isolated, as I am so easily inclined to be. . . .

---

Lyonel Feininger

. . . Last night I dreamed of our new apartment. The house was gigantic and splendidly fitted out, hallways 300 feet long and very wide, the floors covered with shiny aluminum, the banisters of silverplate. I couldn't find the way to our apartment. It was all so big and confusing. I had to ask the doorman. When finally I was in—I saw marvelous things belonging to us which were quite new to me, though, but lots of trash besides, broken picture frames on the floors, fractured toys partly unpacked in boxes, etc. In the studio—60 by 30 feet—were the most beautiful pictures hanging on the walls which I had completely forgotten that I had ever painted. It was enrapturing. It was all an unending source of pleasure. Wasn't that a typical Leo dream?

October 20, 1934

. . . I read that the Arnold Gallery in Dresden has also been closed. Butbier intends to open a new salon somewhere else in Germany, but he has to recuperate from the shock before he'll be able to do so. Dresden is in every respect definitely out for us. And it will go on until everything is dealt with in the same way. The Berlin Secession does not exist any more. It has been taken over by Kraft durch Freude,* which uses the building for its own exhibitions. . . .

Siemensstadt
March 24, 1935

. . . Karl rang up to tell me that our pictures were to be judged today by a commission—but he thinks our chances are very slight, for it is Rosenberg† who has ordered the action and he is *over* Goebbels.

March 29, 1935

Yesterday I received your letter and the card. Well, so you are now in quite different surroundings. Your description of the journey was most interesting. And now you are at work with Laurence, and that will keep

* A National Socialist organization.
† Alfred Rosenberg was a Fascist official.

you busy and your mind concentrated on the marvels of a different age, when spirituality was the very highest value of human existence, instead of the poorest and most negligible quantity, subservient to party politics.

I glance outside my window at the falling snow. It is chilly, wet, and wintry. The north wind drives the big wet flakes down the Lenthersteig, and the roofs opposite are grayish white, as are the glass enclosures in front of the houses back of the sidewalk. . . .

About my work—except that I am working—I still think it best to preserve silence. I will only say that I am hopeful. (Hopeful! In a hopeless period of cultural history, in a land where all vital cultural elements are systematically persecuted, one is hopeful only for one's own endeavors.) But I come more and more to the realization that ability is of no use unless the spirit is strong. So let us keep a stout heart by all means and "hope" all day long and even part of the night. . . .

<div style="text-align: right">

April 1, 1935

</div>

. . . Moritz talked about his and Eva's plans. They are trying to sell their car. They are thinking of moving to Zuoz and taking in boarders there. I don't know whether Moritz is in danger of losing his position. I don't believe it, but they do want to get out of here. Eva has been feeling uneasy since it became known that 1,000 writers, all members of the Kultur Kammer* so far, have been notified by letters that after April 1st they will not be allowed to publish anything any more, nor carry on professionally on account of "political untrustworthiness." That is a deadly blow and something similar is aimed at artists. . . .

<div style="text-align: right">

April 4, 1935

</div>

Julia darling, Gloria Victoria! I am getting on now with irresistible power. The longstanding jinx on my painting is at last overcome. I feel absolutely sure from now on of winning my goal. This period of discouraged effort and continual disappointment and, worst of all, deadly loss of confidence in my powers as a painter is ended. It changes *everything* for me. From henceforth I shall pile up painting after painting—all considered, it has been a question of technique rather than form; for I have labored on the way to form continually. It was in drawing, graphics—and not in oil painting. I have now cast aside all timidity and uncertainty in treatment of the oil paintings, which was a state I

---

* A National Socialist cultural organization.

Lyonel Feininger

had gotten into after 1924–25. I was too careful, too cautious, too un-impulsive. . . .

---

<p align="right">April 8, 1935</p>

I had intended to write to you yesterday but, ruthless painter that I am, I couldn't tear myself away from work. Moreover, I didn't dare stop. I haven't been for years so pervaded by a sort of madness, impetuously compelled to go on struggling with that hapless square of canvas on the easel, how often cursing, how often loving it. The promising but fallacious beginnings of the other day were carrying me slowly to perdition. Every new brushstroke was applied more timidly. Over-elaboration made the work look dull, slimy, yet harsh and hard. When all and everything around and within me became unbearable and I was writhing under the impression that never would I accomplish anything in a painting again, a dreadful madness got hold of me. Then like a flash it struck me—I felt that I had fought my way through. Matter and substance were obeying my will—no! Better still—as if some higher principle were forcing me into obedience. I arrived at a turning point. It seems like a miracle. Reawakened intuition has joined forces with my technical abilities.

In my drawings during the past years, I reached the stage of having the means at my disposal, and now during these last two months I have gained the power in oil paintings as well. It will not be lost any more. If love alone doesn't make the child, then demoniac powers have to step in. I think I observed the decline of my faculties first during the years 1928–29; about 6 years of suffering in slow and helpless debility followed. Not even the external success of the Halle pictures could conceal the fact from me, but only made it worse. Today I wouldn't even want to paint in the way I did 20 years ago, at the time of my "strongest" pictures. I want to paint as I am able to do now. . . . .

---

<p align="right">April 11, 1935</p>

Here, my darling, a letter in a hurry—I cannot write on an open post-card on account of the information enclosed. The Kultur Kammer: "Feininger will please provide evidence of his Aryan descent in all particulars." To hell with creative activity in this country. I feel like throwing the dirt-sheet, together with the *Doomsday Book,* at their feet. This probably comes as a result of the Munich affair, maybe in

connection with Lux's registering,* and therefore we must look upon it as serious. Of course. I don't have the baptismal certificates of all my ancestors, only the information good Werner Rothmaler was able to find in parochial registers some time ago. I dived for these papers and was lucky enough to fish them out. To my relief the birth places of my mother's parents are mentioned. One should manage to obtain official copies from the priests in those parishes—though probably not until the date mentioned, April 18th, since I received the trash only on the 10th. So now here I am sending you the stinking paper together with Werner's document (to be treasured like gold), for your orientation. . . .

---

West-Deep
April 30, 1935

. . . In the meantime you know that everything here is fine and that we are having no trouble. Mrs. Wilke bought some provisions for us, bread, eggs, butter, etc. When walking with Wilke, he told us of what is going on in Deep: an antiaircraft station is to be built on the dunes, an airport on Camper See, a strategic highway, barracks to house a garrison of 800 to 1,000 men. This will make such incredible changes that Deep will never be what it has been. Its wonderful solitude will be lost to us forever. . . .

---

West-Deep
May 3, 1935

. . . There is no indication of a "First of May celebration" *here*—but all over the country the people have been forced to march in processions. The employees don't have much time for themselves to use at their own free will. It is all cut to order, patriotic service; even recreation is under control and made to "benefit" the state. This is as it should be since it is the wish and vote of the people. . . .

* Lux was questioned about his Aryan descent in Munich.

# IV on feininger

# Feininger Paints a Picture      *Thomas B. Hess*

The period of gestation of a contemporary painting is usually about as long as the career of the artist. But if one arbitrarily defines this period as the time between the dates of the first sketch of the subject and of the finished picture, then it is rarely longer than a couple of years; more often a couple of months.

Lyonel Feininger is a brilliant exception to this generalization. One sketch rapidly executed in front of nature, one emotion recalled in the studio, will set off, in a series of delayed reactions, a progression of drawings, watercolors, and oils. A decade may pass before the progression ends. It is not that Feininger is a slow worker—many of his most ambitious oils were painted in a matter of months. Nor is he unproductive—as proved by his large retrospective at the Museum of Modern Art and as will be seen again in his exhibition at Boston's Institute of Contemporary Art this fall. He works steadily and methodically; like Stravinsky, he has set hours and habits for creation and contemplation, but ideas and feelings become clothed in visual form only after an astonishingly long and complex evolution.

## The Artist at Home

Feininger's New York apartment on Twenty-second Street reflects his methods and disciplines. Except for the easel, with its shelf crowded with containers, and the oil-in-progress covered by a white sheet, the room where he paints is not too different from the adjoining one where he and his wife sit and read or play the phonograph. In the studio, all but a few of Feininger's pictures are kept out of sight in drawers or closets; bookshelves, pottery, and a figured tablecloth give an air of neat propriety. In the living room are the magazines and books—a set of Conrad, volumes on the Bauhaus, locomotives, explorations; photographs of the children (painter Lux and photographer Andreas) and Mark Tobey. On a window sill near the desk, two small optical prisms shoot cool surgical reflections over the light walls and comfortable furniture.

Talking to Feininger one realizes that although the artist has spent nearly fifty of his seventy-seven years in Germany and that he sometimes forgets an English phrase and his German-born wife must prompt him with it, he is a completely American personality. The technical words of our sailors, architects, and musicians are almost as familiar to him as those of his own profession, and as Alfred Barr has written,

From *Art News,* Summer, 1949, pp. 48, 50, 60–61. Reprinted by permission of *Art News.*

Feininger's art has a refinement and lyrical precision most related to the watercolors of Whistler and Demuth to say nothing of the svelte lines of Yankee clipper ships and four-engine bombers.

## Subjects and Rough Sketches

All Feininger's paintings start with the artist standing directly in front of his subject and rapidly sketching with a soft lead pencil the image that has caught his interest. Literally thousands of such drawings have been made in trips through little German towns, like Lüneburg or at Deep, the resort on the Baltic where the Feiningers spent their summers from 1924 until they quit Germany in 1936.* A few sketches . . . contain color notations but most of them are simply shorthand hints meant to recapture mood and shapes for the eye and the hand that executed them. Some have a certain dash and vigor, reminding one that Feininger was a remarkably gifted cartoonist, but most lack the tense, precise sensibility felt in the more finished pictures.

The subjects that attract the pencil of the artist can be divided into two types; the horizontal ones with plays of clouds, oceans or hills across horizons with little ships, lonely figures, or cool suns or moons punctuating the patterns; and vertical ones with spires and skyscrapers rising to the sky and the sky shooting down to earth. For both subjects Feininger likes gray days with plenty of clouds: "There is something depressing," he says, "in sun-drenched hills under a cloudless sky."

After the sketch is finished, it is usually discarded for a time (two years in the case of *Gables*). Meanwhile, other sketches will be added to Feininger's files, which are a sort of storehouse of stimuli. Lately he has been sketching cloud formations observed from his window.

## Finished Drawings

The next step in the creation of a Feininger picture is the finished charcoal-and-ink drawing, which is made from the sketch. A linear pattern is carefully established with charcoal, a process that often takes days of work, and then the lines are redrawn in India ink using a very fine pen point and ruler. These ruled lines with their pulsating quality achieved by constantly changing the pressure of the pen on the paper have become almost signatures to Feininger's style. Appearing also in watercolors and oils, they define form and direction in a large variety of ways. Long and brittle, they interrupt or complement the horizon; in short hatches they work into stiff graphic planes, often reminiscent of wood-block prints. At times they break into free improvised curves and playful variations.

* The Feiningers took up permanent residence in the United States in 1937.

After the lines comes mass. Scuffing and rubbing charcoal across the paper, and using the grain of the paper as a texture, Feininger builds up his feathery blacks into rigid constructions of architecture or ocean. A method reminiscent of cubism is at work here, as the shapes are visualized from constantly changing angles of perspective and are faceted and ordered into flat spaces. However, there is none of the rationale of analytic cubism (which Feininger observed in Paris as early as 1911) but rather a method of distortion and simplification which facilitates the expression of mood and of the artist's feeling toward his subject. Thus in the drawing from the sketch of a sunset at Deep, the zigzagging track of the sun on the Baltic and on the little river in the foreground breaks across the spit of land and into the beach, while this vertical movement is balanced by the projection of the mainsail's edge into the sky. The emotional impact given by the sun's track is enhanced and yet secured in the balance of forms and space.

### Watercolors

After the charcoal drawing is finished comes another period during which the subject is allowed to hibernate. Feininger works on other pictures, continues his routines of creation, and it may be several years before he returns to the motif. When he does pick up the subject once more, he usually goes back to the first sketch from nature and makes a watercolor from it. The linear skeleton is established all over again, much as it had been done in the charcoal drawing. After the lines have been ruled in ink, the paper is wetted and fixed on a sheet of glass.

Over this Feininger floats delicate washes of color, controlling the seeping motion of the pigment in water with remarkable virtuosity. Color is often rather naturalistic . . . but Feininger does not hesitate to float umbers up through the sky and stop the vertical motion of the yellow area at the left with an invented cruciform pattern in dashes across the sky.

Feininger refers to his charcoal drawings as "formulating of the subject for solutions of space"; the watercolors are solutions of "volumes of light." But such "solutions" are not simply answers to be used in later works. The watercolors have an independent existence and, in their own right, they are among his most successful works. Lately he has devoted his summers to working in this medium, taking to his country place a whole sheaf of little sketches that served as starting points.

### The Oil Painting Begins

Unlike the watercolors the finished charcoal sketch is generally Feininger's reference for his oils. As seen in the photograph of *Sunset,*

*Deep* in its unfinished state, he follows both the lines and indications of volume rather closely—indicating even some of the subtle gradations of charcoal smudges. But once the picture jells into this state, all earlier drawings are discarded and the artist works with concentrated patience and guile toward the new image that must express its different medium.

In comparing the oils with the charcoal drawings and watercolors and also with photographs of unfinished works, it is obvious that Feininger's creative method is one of addition, of increasing complexities and implications. This process, however, is by no means cold and calculated. Feininger has always worked standing up: "That is," he said, "most important." He waved his head and arms slightly from side to side. "I must feel the rhythms," he said. Subjectively felt rhythms and emotions are important factors in this art that looks so coolly planned. Until recently Mrs. Feininger read to her husband while he painted. They were books in which he was interested, and he heard every word. Thus, intuition was allowed considerable freedom, and Feininger emphasizes the fact that he looks for and exploits accidental elements in his painting. But, of course, this is not surrealism, and the intellectual content of Feininger's painting is most important. The plays of perspective . . . that create a constant shift between illusions of two and three dimensions; the interpenetration between abstract and figurative elements and of intricately repeated colors and textures—these are parts of a style that not only communicates an attitude toward the subject but also re-creates the subject according to Feininger's own rules of paint on canvas.

Feininger uses commercial colors which he mixes from the tube on his large palette. Until recently he used very little medium, working with a thin coat of paint that often reveals the structure of the canvas. Color was applied directly without use of underpainting or transparent glazes. Embellishing areas with his characteristic crystalline textures, or radically changing the composition, usually involved fast work—keeping all the paint wet—or waiting until the underlayers dried. This method was entirely self-taught, and in a certain sense, naïve. But it was admirably fitted to produce Feininger's razor-sharp forms and subtly linear schemes. (For a few months, Feininger studied portraiture at the Berlin Academy, but this had little effect, he believes, on his techniques.)

In his recent paintings there have been radical changes of method. The hand obviously works harder, more uncertainly, and the artist can no longer allow his concentration to wander while he paints. He prepares thick, tinted grounds, spreads brightly colored glazes over them, sandpapers through, scrapes off, adds more layers until the surface gets a heavy enamel finish. On this he rules his lines—much as he does in the watercolors. Whether these oils are as successful as the earlier ones, time will tell. Certainly they are richer in color and texture, even if they

After the lines comes mass. Scuffing and rubbing charcoal across the paper, and using the grain of the paper as a texture, Feininger builds up his feathery blacks into rigid constructions of architecture or ocean. A method reminiscent of cubism is at work here, as the shapes are visualized from constantly changing angles of perspective and are faceted and ordered into flat spaces. However, there is none of the rationale of analytic cubism (which Feininger observed in Paris as early as 1911) but rather a method of distortion and simplification which facilitates the expression of mood and of the artist's feeling toward his subject. Thus in the drawing from the sketch of a sunset at Deep, the zigzagging track of the sun on the Baltic and on the little river in the foreground breaks across the spit of land and into the beach, while this vertical movement is balanced by the projection of the mainsail's edge into the sky. The emotional impact given by the sun's track is enhanced and yet secured in the balance of forms and space.

## Watercolors

After the charcoal drawing is finished comes another period during which the subject is allowed to hibernate. Feininger works on other pictures, continues his routines of creation, and it may be several years before he returns to the motif. When he does pick up the subject once more, he usually goes back to the first sketch from nature and makes a watercolor from it. The linear skeleton is established all over again, much as it had been done in the charcoal drawing. After the lines have been ruled in ink, the paper is wetted and fixed on a sheet of glass.

Over this Feininger floats delicate washes of color, controlling the seeping motion of the pigment in water with remarkable virtuosity. Color is often rather naturalistic . . . but Feininger does not hesitate to float umbers up through the sky and stop the vertical motion of the yellow area at the left with an invented cruciform pattern in dashes across the sky.

Feininger refers to his charcoal drawings as "formulating of the subject for solutions of space"; the watercolors are solutions of "volumes of light." But such "solutions" are not simply answers to be used in later works. The watercolors have an independent existence and, in their own right, they are among his most successful works. Lately he has devoted his summers to working in this medium, taking to his country place a whole sheaf of little sketches that served as starting points.

## The Oil Painting Begins

Unlike the watercolors the finished charcoal sketch is generally Feininger's reference for his oils. As seen in the photograph of *Sunset,*

*Deep* in its unfinished state, he follows both the lines and indications of volume rather closely—indicating even some of the subtle gradations of charcoal smudges. But once the picture jells into this state, all earlier drawings are discarded and the artist works with concentrated patience and guile toward the new image that must express its different medium.

In comparing the oils with the charcoal drawings and watercolors and also with photographs of unfinished works, it is obvious that Feininger's creative method is one of addition, of increasing complexities and implications. This process, however, is by no means cold and calculated. Feininger has always worked standing up: "That is," he said, "most important." He waved his head and arms slightly from side to side. "I must feel the rhythms," he said. Subjectively felt rhythms and emotions are important factors in this art that looks so coolly planned. Until recently Mrs. Feininger read to her husband while he painted. They were books in which he was interested, and he heard every word. Thus, intuition was allowed considerable freedom, and Feininger emphasizes the fact that he looks for and exploits accidental elements in his painting. But, of course, this is not surrealism, and the intellectual content of Feininger's painting is most important. The plays of perspective . . . that create a constant shift between illusions of two and three dimensions; the interpenetration between abstract and figurative elements and of intricately repeated colors and textures—these are parts of a style that not only communicates an attitude toward the subject but also re-creates the subject according to Feininger's own rules of paint on canvas.

Feininger uses commercial colors which he mixes from the tube on his large palette. Until recently he used very little medium, working with a thin coat of paint that often reveals the structure of the canvas. Color was applied directly without use of underpainting or transparent glazes. Embellishing areas with his characteristic crystalline textures, or radically changing the composition, usually involved fast work—keeping all the paint wet—or waiting until the underlayers dried. This method was entirely self-taught, and in a certain sense, naïve. But it was admirably fitted to produce Feininger's razor-sharp forms and subtly linear schemes. (For a few months, Feininger studied portraiture at the Berlin Academy, but this had little effect, he believes, on his techniques.)

In his recent paintings there have been radical changes of method. The hand obviously works harder, more uncertainly, and the artist can no longer allow his concentration to wander while he paints. He prepares thick, tinted grounds, spreads brightly colored glazes over them, sandpapers through, scrapes off, adds more layers until the surface gets a heavy enamel finish. On this he rules his lines—much as he does in the watercolors. Whether these oils are as successful as the earlier ones, time will tell. Certainly they are richer in color and texture, even if they

lack the marvelous counterpoint of form that characterizes the works of around 1915–35.

## The Series Continues

The completion of an oil painting does not end the progress of one subject through Feininger's oeuvre. The little sketch may be taken out of the file again and again to provide a clue to new solutions, and in some cases . . . a new version may be based on the watercolor. There are thirteen oil paintings based on Feininger's sketch of the church at Gelmeroda, the first one done in 1913, the final one in 1936. Never does the subject lose its character; nor does the artist repeat or invent easy formulas for decorations. Once Feininger was interested in dividing the canvas arbitrarily into a net of planes and fitting the subject into this scheme; . . . other times he experimented with crisscross-shaped compositions, or with systems of inverted triangles. But such plans were never doctrines. Above all theorizing is one's mental picture of the artist at work—dancing lightly with the motion of the brush, listening to music or a chapter from Melville, and remembering with uncanny shrewdness how he felt years ago, in front of this cathedral or that grayed horizon.

## Lyonel Feininger's Heritage    *T. Lux Feininger*

I believe that the life of my father, Lyonel Feininger, . . . presents an example of cross-fertilization between West and East. A product of the westward migration of Germans, his own voyage to the East with its unforeseen prolongation has resulted in an enrichment of European culture. His native birth had stamped him deeply. He looked, behaved, and talked like other American boys. His long sojourn in Europe did indeed soften and diminish the youthful American attributes of surface optimism, inclination toward quick and possibly shallow judgments and manifestations of the particular kind of humor known in the nineteenth century as "The Great American Joke." . . . On the other hand he retained more than the native appearance. Tall, lean, and long-legged, and (apart from youthful experiments with a variety of whiskers) clean-shaven, he represented the traditional figure of the American abroad and took a certain pleasure in it. But he also preserved a distinctly Western outlook and, despite his manifold and vigorous re-

Original version of an essay published in *American-German Review* 32, no. 5 (June–July, 1966): 9–12. Reprinted courtesy of T. Lux Feininger.

sponses to European culture and traditions, refused to assimilate his way of being and of thinking either to German or to French ways. And later on, in the years of agonizing doubt preceding his final return to the United States, when life in Germany meant dealing with Nazism, the one factor which gave him courage and strength was the memory of his native birth. So that we may truthfully say that if he gave something to his country in his life's work, his country had given him something too, a gift worth having, an inborn feeling of the dignity of man.

. . . The circumstances leading to my father's presence in Europe have often been described. A rapid summary of his origins will be helpful, however, in assessing the Eastern and Western components of the source from which he drew his art. Lyonel Feininger's paternal grandfather was an *Achtundvierziger** and settled in South Carolina with his family, his son Karl (my grandfather) then being four years old. Without breaking off all ties with Germany, Karl Feininger embraced American life vigorously. Having studied music here and in Leipzig, the young man enlisted in the Union Army in 1864. This is noteworthy, as his relatives continued to live in the South during the Civil War and after. Karl saw with his own eyes the ruins of two cities in which his father had lived successively: Charleston and Columbia, South Carolina. He, however, declared his affinities to be with the North, to which he returned upon discharge, marrying in New York Elizabeth Lutz, daughter of Captain Lutz, lately of the Union Army; there, in 1871, my father was born. Of Karl Feininger's attitude toward Germany, I find significant his veneration for German music and musical education, and his contempt for, and intense distrust of, Prussian militarism. The latter was not potent enough to prevent him from sending his only son to Germany at the age of little more than sixteen for the purpose of studying music. In the young man's view, this was not to be a long absence, and in his letters he frequently expressed his impatience to return to the United States.† A concatenation of factors—his father's plans, his own budding interests and talent for cartooning and illustrating (he soon began to earn a modest living with his illustrating but lacked funds for traveling without aid, assuming that he would have dared to go against the paternal wishes, which is doubtful), and, possibly, at heart, an unconscious lack of real motivation for the return—prolonged his European sojourn into a stay of forty-nine years before he was to set foot on native soil again.

The art which grew out of the initial stage of caricature and illustration is based on the observation of nature and shaped by will to "over-

---

* Member of the group of Germans who immigrated to the United States in 1848.
† See Ernst Scheyer, *Lyonel Feininger: Caricature and Fantasy* (Detroit: Wayne State University Press, 1964).

come nature"; differently expressed: the need for form, and love for his subjects. Optical perceptions are transmuted into the pictorial theme. In his sign language, this artist is above all an immensely inventive, sensitive designer. The act of re-creating portions of the visible world reveals an inner meaning previously concealed. His visual means changed through the years; in general, the tendency remained to reduce the substance of matter, to lay bare the dynamic stresses, to explore the space rather than the objects. What he sought was a vision of totality, rather than a portrayal of specific features. Color is used to kindle a glow within spatial structures rather than to illuminate surfaces. The process of pictorial transsubstantiation is a characteristic of modern art at large, and in sensing its importance at the outset of his painting life my father assumed his rightful place in the ranks of the founders of twentieth-century art. . . .

My father's ordering of his daily life showed a great emphasis on "work"; all else was of secondary importance. If it is true that he valued independence above all things, free disposal of his time and of his person, it was for the sake of "work." He was quite aware that this was asking not a little, that it was a privilege. To show his sense of obligation, he was most undemanding where his personal comforts were concerned. In its details, his way of living shows many instances of self-limitation: concentration on a vision implies reduction of participation in everyday affairs. Seeking to travel light, he saw the acquisition of property as a snare to be avoided. I find some kind of significance in the fact that my father never owned a house of his own, nor learned to operate a car. Doubtless he saved much vital substance through these abstentions. A few other traits will help to round out the picture of the man. He loved physical exercise, walking, rowing; his expert use of the bicycle is well known. He needed privacy but detested solitude: he greatly enjoyed the presence of his family—but in another room; when friends gathered around, he was often content to listen, or to give the appearance of friendly attention, rather than actively participate in a general conversation. "I love to hear others talk," was one of his sayings. He was unwilling to speak in public; but when it was quite inevitable, he spoke well and to the point. . . .

He was a supreme craftsman in the application of the techniques of his art: drawing, painting, preparation for printing of graphic works (which . . . comprised besides the wood block, lithographs, and etchings, the final copies of his musical compositions). In the manual skills called for by his model- and toy-making, nothing but perfection would do. But he had a horror of bravura technique. He firmly believed, and never tired of asserting it in his teaching, for example, that any valid formal idea found its technical expression quite naturally; for his own uses, he had found early in his painting career that for each new work

there was much unlearning of previously gained experience involved, as there was new land to be discovered.

In his choice of subject matter, he was attracted by structural suggestions of space and by its mood, an aura emanating from the configuration of objects. Foremost among his themes is surely the sky. I have never known anyone more responsive to the visual signs of the weather than my father. Its observation was of the most absorbing interest to him. He loved cloudy skies, the rain, the mysteries of atmosphere; wet surfaces (reflections double the space), misty half lights. He liked the sunshine but did not paint it. His interest in watching the functioning of machinery has often been described. It seems to have attracted the attention of observers less, that he was also greatly concerned with the cessation of functioning: contemplation of the works of man led him to ponder the evanescence of human affairs; observe in his work the attention given to effects of decay, of obsolescence, of mere old age; ruins, wrecks of stranded vessels. He shunned pathos; he sought the hint, intimations of things to come and of things that had been; in describing his preference, "understatement" was one of his favorite expressions.

Two letters written during the last years, long after his return to the United States, convey a sense of the meaning of landscape to the artist. Besides the physical structure, the light and the fact of rapid and easy motion through space have their appeal.

. . . the entire country hilly, with intermingling of land and sea—with some gorgeous views of the old Atlantic with the westering light glittering between headlands . . . and the roads wound continually up and down, passing through lovely villages with lawns and ancient trees all along the road; the country shows a century-old cultivation and fairly outdoes any region in Germany for charm and interest—not that I want to deprecate the so tenderly beloved *Bauerndörfer* and arid *Landstrassen* around Deep and *Pommern*—but the country [between Cambridge and Gloucester and Rockport, Mass.], including Cape Ann . . . with its changing roads, east, north, west and south again surprises all the time, of glimpses of deep blue ocean on a high horizon, quite captured my imagination as nothing else so far in all these years here has done. [August 11, 1950]

. . . we had a lovely drive along the Housatonic for miles, in the midst of a landscape I truly love and place even above the flat country around Deep in my regard, old son, is saying something. The sparseness of the land of Pomerania has become, as it were, part of my flesh and blood; but Connecticut hills against a westering late afternoon sky, with broad valleys spotted with homesteads, barns with high old trees among which the village church nestles, came into my life right from the first impres-

sions I received. The ranges of low hills, low mountains, one after another, melting into the distant atmosphere, what can be more homelike as surroundings? [June 27, 1953]

As so often happens with my father's statements of inner processes, the "capturing of the imagination" is here seen as setting memory into motion as well. The view of the American landscape brings up the image of the German one, and the connection is by the way of love and having loved. In the earlier years in Europe, the process had been the reverse; then it had been the American scene which he revisited mentally. It had been chiefly a scene of action, peopled by the beloved American machines: seaports, railyards, bridges, etc. But in his old age he turned to signs of human habitation, to the land; he sought a continuity, a "century-old cultivation." Is it not remarkable that the younger of the two nations . . . should have been able to present this unbroken chain, while the ancient seat of culture had been marred by the stigma of the Nazi interregnum? If he could forgive the Germans after they had shown a willingness to eradicate the Hitler rule and to begin to repair its ravages, he could not forget. The thought of revisiting Germany after World War II never came to his mind; he was content to remain "back home."

If art transcends national characteristics and becomes the property of all seeing and feeling mankind, the artist has his origins somewhere. He is conditioned by racial heritage, cultural tradition, climate and language. Where migration occurs for ideal motives, such as the exodus of the Germans after 1848, political thought may be said to rise to a level of spiritual seeking. Centuries have gone into the forming of the hereditary stock of the grandson of the immigrant. Seen from this angle, Lyonel Feininger must be German. But observe what changes can be wrought by just a few years in a more favorable soil, under a more congenial sky! The view of an American would be that only his country could have provided that quickening of stock to which we thank the artist's particular contribution. Let us listen to the wanderer himself, rising philosophically above the mere inconveniences of finding himself unknown, almost unwanted, upon first returning to the land of his birth:

I no longer feel a pang when I am alluded to as "the German painter."
I did truly suffer from the feeling of strangeness, at first. Now I only feel
the urge in back of my work, of a tremendous advantage gained abroad.
[June 27, 1939]

From America came the energy, the openness of mind, the eagerness, perhaps also the necessary longing for other horizons. Europe, princi-

pally Germany, but also France, gave a tradition of culture, a reverence for intellectual and spiritual values, a contempt for material striving. Today it seems clear that Lyonel Feininger's art owes its being to the inextricable intertwinings of Eastern and Western strands. His life, seen on the whole, seems calm on the surface. The turbulence was all below. We may be thankful that he had found a kind of peace when the cycle closed where it had begun, eighty-four years earlier.

## In Remembrance of Feininger    *Alfred H. Barr, Jr.*

It was almost thirty years ago that I came as a student to Dessau to visit the Bauhaus and to see and talk with Walter Gropius and the already legendary band which with such discerning judgment he had gathered there: Kandinsky, Klee, Feininger, Schlemmer, Moholy-Nagy, Albers, Breuer, Bayer—they formed a dazzling constellation of artist-teachers such as no art school has ever known before or since. These were extraordinary men: meeting and talking with them deeply impressed me, yet it was the two hours with Lyonel Feininger that I remember most clearly and with greatest delight.

I had seen a few of Feininger's paintings in America, though he was little known here, and a few more in German galleries and museums. I knew he had been born in New York, but I didn't know whether he was still an American citizen or even whether he could still speak his native tongue easily.

My doubts were soon dissolved. There in the doorway of his severe, Gropius-designed house was one of the most American figures I had ever seen—tall and spare—though with nothing of the tight-lipped, rock-bound Yankee about him. He seemed shy, but his smile melted my own shyness. And when he spoke, his American speech fascinated me by its strange purity of accent and antiquated slang—I was puzzled, too, until I realized that he had left America forty years before and was still speaking the American language of the 1880's, the language my father's generation had used in college.

He talked of his childhood in New York, of his early days in Germany as a music student, of his comic strips for the *Chicago Tribune,* of painting in Paris and Berlin before World War I, of the music of Bach and his pleasure in having one of his own fugues publicly performed. Mrs. Feininger was absent in Berlin, but their young son Lux, still a

Feininger Papers. Published with the permission of the Houghton Library, Harvard University, Cambridge, Massachusetts, MS Ger 146 [1447].

boy, was there and together we looked at some new model yachts which they were planning to sail the following summer at their place on the Baltic coast. For the first time, I saw his early caricatures and his paintings with gigantic figures striding through the streets of diminished towns, Feininger's own highly original intimation of changing concepts of time and space. He showed me, too, some of those strangely moving drawings of haggard ghosts done in his days of black dejection when he found himself technically an enemy alien in a country at war with his own native land.

In the letters Feininger wrote in the years following our conversation at Dessau, I began to realize his devotion to his wife Julia, his dependence on her loyal care. He wrote, too, of his pride in his three brilliant sons: Laurence, already deeply interested in music; Andreas, whom he called Andrew, not yet committed to his career in photography; and Lux, the youngest, whose prowess in the new Bauhaus jazz band delighted his American father.

In his letters he spoke often about his love for America. He hoped to return, yet he felt deep anxiety about how he might be received. He had friends here, notably William Valentiner and Galka Scheyer, but Americans in general, even those interested in art, were almost totally unaware that since the death of Mary Cassatt, her position as the most famous and respected living American painter, in the opinion of Europeans, had been taken by none other than Lyonel Feininger. In 1929, at the very moment our New York critics were attacking the Museum of Modern Art for including Feininger, an unknown expatriate, in its first American exhibition, the Germans were preparing to give him the greatest honor they could confer on an artist, a one-man show in the National Gallery in Berlin.

The move back to the United States a few years later did indeed prove difficult. He had left New York forty-nine years before and, though he was welcomed by old friends and new, he suffered through a long period of readjustment before he could resume painting. But in the end, the new skyscrapers of his native New York took their place in his vision beside the Gothic towers of ancient German towns. And Lyonel Feininger himself has taken his rightful place in the esteem of his fellow Americans, and in their hearts.

Let us listen for a moment to Feininger's own words in letters to his wife and others:

The older I get the more I am concerned with the problems of awareness, recollection, and nostalgia. It seems obvious that the artist must strive to answer these questions, for longing is the impulse and mainspring of creative achievement.

Speaking of his childhood in New York:

The earliest impressions I have were the trains, the locomotives, half terrifying and wholly fascinating. . . . I used to stand on one of the footbridges over the Fourth Avenue tracks of the New York Central. . . . At the age of five years I already drew, from memory, dozens of trains . . . the black locos of the New York Central, with "diamond" smokestacks, and the locomotives of the New York, New Haven, and Hartford Railroad with elegant straight smokestacks painted, like the driving wheels, a bright vermilion red, and oh, the brass bands about the boiler and fancy steam domes of polished brass. . . .

And in the '80's I remember the Hudson, teeming with vessels, schooners, sloops, not to speak of the magnificent side-wheelers plying up and down the river; the *Mary Powell, Albany, Drew* . . . the Naval Parade of 1887 . . . wooden bark-rigged men-of-war in procession . . . model yacht building and sailing, and every day saw me at the pond in Central Park trying out the models I had built . . . the yacht races for the America Cup in '85, '86, and '87, the yachts *Puritan, Mayflower,* and *Volunteer* . . . South Street crowded with square-riggers.

At one time he had planned to be a musician and the music of Johann Sebastian Bach remained throughout his life as a major source of his art and spiritual strength:

H. was wondering, and thought it rather amazing that I who have Bach, so to speak, in my blood, became a painter instead of a musician. But we agreed that Bach's spirit is contained in my painting also, and finds its expression there in a different form, of course.

It seems to me of the utmost importance to become more simple. Again and again I realize this when I come to Bach. His art is incomparably terse, and that is one of the reasons that it is so mighty and eternally alive. I must avoid becoming entangled and fettered in complexities.

The sea and the seashore moved him deeply:

The river was smooth like a mirror, and large low-lying masses of ground fog on the meadows made the land look as though flooded with unknown lakes.

The magically delicate sickle of the new moon was sailing in the peacock-blue evening sky. We rowed out into the sea. A ghostlike fisherman with sails spread was scurrying along under its auxiliary motor. Still further out a black longish something dancing on the water, another rowboat. Violently rocking, and with the swell smacking against our bow on which Lux was perched like a merman, we stayed out until it was dismally dark, when we finally turned landward.

But with all his romantic nostalgia he was deeply preoccupied with the problems of structure and space:

In one respect, perhaps, my work may be considered of significance: its passionate quest for strictest delineation of space, without any compromising. In the glaring sun these days, seconded by shadows cast on brilliantly lit surfaces, I see motifs of colossal consequence. A perfectly new plane-space conception.

But his art did not come easily:

Not without good reason must the artist go through dark times, months, years often. They help in spiritual growth. After such a period new clarity of purpose is revealed, and hopefully he feels joy return to his heart.

Pursuit of art is for the artist the only way toward clarification, to free himself of all that is doubtful and superfluous. My work at painting presents the battlefield on which I have to overcome my insufficiencies and resolve every doubt in order to attain final unity. We are always trusting that we may succeed in this one day.

To file many hundreds of sketches stored haphazardly in portfolios revives unforgettable circumstances, places, and attitudes of years past. The runes on these pages resemble seeds full of magic capable of germinating into future works.

Julia Feininger tells us that very recently Feininger spoke of new works planned, new studies, a new vision. We shall not see these works now, but to comfort us we do have the superb achievement of his long, rich life. And we have the memory of a man, modest, straight, sensitive, true—a man whom we all loved.

## My Friendship with Feininger    *Walter Gropius*

I should like to give you a brief account of my own friendship with Lyonel Feininger. Of that most memorable international team of creative artists who built the Bauhaus with me, Feininger, the American representative, is now the fifth member who has left us, after the death of Kandinsky, Klee, Schlemmer, and Moholy.

It was early in 1919, when I was making my first preparations to organize the Bauhaus in Weimar, that I met Lyonel Feininger in Berlin.

Feininger Papers. Published with the permission of Houghton Library, Harvard University, Cambridge, Massachusetts, MS Ger 146 [1447].

I had convinced myself that a great deal of incentive for a new conception of space in art and architecture had come from representatives of the avant-garde of painters of that time and that I should, accordingly, attempt to win over some of them for my faculty in the Bauhaus. Feininger's painting had attracted me greatly, and I saw a specific architectural quality in his presentation of space relations. He was the first to whom I offered a chair. I remember that he first hesitated to accept, because, in his shyness and humbleness—qualities so characteristic of him even in his days of final triumph—he doubted whether he could teach at all and whether he would fit into an organization. But when I assured him of his full freedom, leaving entirely to him what he would like to contribute to our venture, he accepted with delight. Ever afterward he remained the most loyal and devoted member of the Bauhaus family, leading the young with his unique, loving personality and with the deep conviction of a creative artist.

Yesterday I reread the letters which he wrote to me over the years. On May 18, 1919, we traveled together from Berlin to Weimar, where I had just started the Bauhaus. From then on for 37 years I received with unfailing certainty each year a letter from him, commemorating this date. Once he wrote: "The date is so impressed on heart and memory . . . it was the beginning of the finest adventure in my artistic career." At another time: "That day was full of wonder and enchantment; for me it meant the decisive turning point in my quiet, artistic life; something unforgettable, quite amazing to contemplate: Weimar—the Bauhaus." Again, later, he wrote: "As we grow older there is an ever deeper feeling and a deeper resonance in connection with the date—for me a birth into a new life. And need I, as each year, recall the memory? It is still so vivid." In his last letter to me, of July, 1955, he added: "Much goes through the heart which the head is at a loss to describe." Out of these words shines his affectionate heart, so capable of absorbing the full range of life from joy to sorrow.

More competent men than I will appraise his importance in the history of painting, but his unswerving persistence in pursuing his artistic aims against heavy odds, carried by his capacity for loving and his vivid, never-ceasing, childlike receptivity, seems to me to spell greatness. They enabled him to capture a new pictorial unity, a new beauty at the edge of mystery, peculiar to himself, which I believe will take root in the community of men. He was a true poet, a prophet.

Lyonel Feininger

# bibliography

## I. Writings by Lyonel Feininger

### (*In chronological order*)

Letters to Julia Feininger (1905–35). Translated and edited by JULIA FEININGER. Personal copy courtesy of T. Lux Feininger. Copy in the Busch-Reisinger Museum, Harvard University, Cambridge, Mass., gift of Julia Feininger.

Unpublished letters written by Lyonel Feininger (the majority are in German). Edited by JULIA FEININGER. Four volumes. Houghton Library, Harvard University, Cambridge, Mass., Feininger Papers, MS Ger 146 [1445].

Letters to Alfred Kubin (1912–19). Kubin Archiv-Dr. Kurt Otte. Translated and edited by JUNE L. NESS. Munich, Städtische Gallery im Lenbachhaus.

Letter to Alfred Vance Churchill, March 13, 1913. Archives of American Art, Washington, D.C. Originally published in ERNST SCHEYER, *Lyonel Feininger—Caricature and Fantasy.* Detroit, Mich.: Wayne State University Press, 1964, pp. 166–70.

Letter to Paul Westheim, March 14, 1917. *Das Kunstblatt,* no. 15 (Potsdam-Berlin, 1931), pp. 215–20.

Letters of Lyonel Feininger and Adolf Knoblauch. *Der Sturm* 8, no. 6 (Berlin, 1917–18), pp. 82–86.

Letters to a friend, Dr. Kleinpaul. In Henner Menz, "Briefe und Zeichnungen von Lyonel Feininger, 1932–37," *Festschrift Johannes Jahn,* pp. 331–36. Leipzig: E. A. Seemann, 1957.

"Recollections of Paul Klee" by JULIA and LYONEL FEININGER. In *Paul Klee.* Exhibition catalogue. New York: Buchholz Gallery, 1940.

"Comments by a Fellow Artist" by JULIA and LYONEL FEININGER. In *Paintings by Mark Tobey.* Exhibition catalogue. Portland, Me.: Portland Art Museum, 1945.

"Wassily Kandinsky" by JULIA and LYONEL FEININGER. Originally published in *Magazine of Art,* no. 38 (1945), p. 174. Reprinted in WASSILY KANDINSKY, *Concerning the Spiritual in Art,* pp. 12–14. New York: Wittenborn, Schulz, 1947.

### (*All subsequent entries are in alphabetical order.*)

## II. Monographs and Books on Lyonel Feininger

FEININGER, T. LUX. *Lyonel Feininger—City at the Edge of the World.* New York and London: Frederick A. Praeger, 1965. Photographs by Andreas Feininger.

HESS, HANS. *Lyonel Feininger.* With oeuvre catalogue compiled by Julia Feininger. New York: Harry N. Abrams, Inc., 1961.

LANGNER, JOHANNES. Introduction to *Segelschiffe.* Universal Bibliothek, no. 76. Stuttgart: Philipp Reclam, 1962.

PRASSE, LEONA E. *Graphic Work of Lyonel Feininger.* Cleveland, Ohio: Cleveland Museum of Art, 1972.

SCHEYER, ERNST. *Lyonel Feininger—Caricature and Fantasy.* Detroit, Mich.: Wayne State University Press, 1964.

SCHREYER, LOTHAR. *Dokumente und Visionen.* Munich: Albert Langen–Georg Müller, 1957.

WOLFRADT, WILLI. *Lyonel Feininger.* Junge Kunst Series, vol. 47. Leipzig: Klinkhardt and Biermann, 1924.

# III. Essays Primarily on Lyonel Feininger

BEREFELT, GUNNAR. "Rörande formuleringen av ett nonfigurativt bildspråk och den romantiska traditionen i Tyskland." *Konsthistorisk Tidskrift* 38 (1969): 1–21.

COE, NANCY. " 'Cathedral Camin' by Lyonel Feininger." *Bulletin of the Cleveland Museum of Art* 44 (1957): 67–70.

COLIN, RALPH F. "Fakes and Frauds in the Art World." *Art in America* 51 (April, 1963): 86–89.

CUSTER, ARLINE. "Feininger Material for the Archives of American Art." *Bulletin of the Detroit Institute of Arts* 35, no. 4 (1956); 95–96.

ESCHERICH, MELA. "Lyonel Feininger." *Die Kunst und das Schöne Heim* 50 (1951–52): 176–77.

FEININGER, T. LUX. "Lyonel Feininger in West-Deep." *Baltische Studien* 49 (1962–63); 101–20.

———. "Lyonel Feininger's Heritage." *American-German Review* 32, no. 5 (June–July, 1966): 9–12.

———. "Two Painters." *Chrysalis* 9, no. 9 (1956): 10.

"Feininger and Sons." *Life,* November 12, 1951, pp. 89–96.

"Feininger Watercolors." *Baltimore Museum of Art News* 14, no. 4 (1950–51), pp. 5–6.

GRAY, CLEVE. "The Architecture of Lyonel Feininger." *Art in America* 54, no. 2 (March, 1966): 88–91.

GROTE, LUDWIG. "Les Peintres du 'Bauhaus.' " *Art d'Aujourd'hui,* no. 6 (1953): 4–5.

———. "Zum Gestaltwandel des Bauhauses." *Festschrift Eberhard Hanfstaengl* (1961): 179–85.

HENNING, EDWARD B. "Two New Modern Paintings." *Bulletin of the Cleveland Museum of Art* 52 (1965): 7–18.

HESS, THOMAS B. "Feininger Paints a Picture." *Art News,* Summer, 1949.

HESS, WALTER. "Zum Künstlerischen Wirklichkeitsbegriff, Lyonel Feininger und die Alternative zur Romantik." *Christliche Kunstblätter,* no. 2 (1968): 31–34.

JANDA, KARL HEINZ. "Illustrationen von Lyonel Feininger." *Forschungen und Berichte, Staatliche Museen zu Berlin* 3–4 (1961): 38–43.

KRAMER, HILTON. "German Invasion, Second Wave." *Art in America* 51, no. 1 (February, 1963): 92–97.

KRIEGER, PETER. "Lyonel Feininger's Variation über das Gelmeroda-Motiv." *Zeitschrift des Deutschen Vereins für Kunstwissenschaft* 21 (Berlin, 1967): 89–102.

LANE, JAMES W. "Feininger's Counterpoint in Paint: Lyonel out of Johann Sebastian." *Art News* 40, no. 3 (March, 1941): 38–39.

ROH, FRANZ. "Der vierundachtzigjährige Feininger." *Die Kunst und das Schöne Heim* (1955–56): 41–45.

ROH, JULIANE. "Ein Romantiker des 20 Jahrhunderts, Lyonel Feininger." *Die Kunst und das Schöne Heim* 65 (1966–67): 599–602.

RUBIN, WILLIAM. "Lyonel Feininger—a Profile." *Art Digest,* May 1, 1954, p. 8.

STOREY, BENJAMIN. "Lyonel Feininger." *Emporium* 121 (1955): 51–58.

WERNER, ALFRED. "Lyonel Feininger and German Romanticism." *Art in America* 44, no. 3 (1956)): 23–27 and 58–59.

# IV. General Works Incorporating Discussions of Lyonel Feininger

BANHAM, REYNER. *Theory and Design in the First Machine Age.* London: Architectural Press, 1960. New York: Frederick A. Praeger, 1960.

BARR, ALFRED H., JR. *Cubism and Abstract Art.* Exhibition catalogue. New York: Museum of Modern Art, 1936.

————. *Masters of Modern Art*. Exhibition catalogue. New York: Museum of Modern Art, 1954.

*Bauhaus, 1919–1969*. Exhibition catalogue. Paris: Musée National d'Art Moderne, 1969.

BAYER, HERBERT, GROPIUS, WALTER, and GROPIUS, ISE, eds. *Bauhaus 1919–1928*. 1938; reprint ed., Boston, Mass.: Branford, 1952.

BLESH, RUDI. *Modern Art, U.S.A.* New York: Alfred A. Knopf, 1956.

BROWN, MILTON W. *American Painting from the Armory Show to the Depression*. Princeton, N.J.: Princeton University Press, 1955.

BUCHHEIM, LOTHAR-GÜNTHER. *Graphik des deutschen Expressionismus*. Feldafing: Buchheim, 1959.

*Concepts of the Bauhaus: The Busch-Reisinger Museum Collection*. Exhibition catalogue. Cambridge, Mass.: Busch-Reisinger Museum, 1971.

FRANCISCONO, MARCEL. *Walter Gropius and the Creation of the Bauhaus in Weimar: The Ideals and Artistic Theories of Its Founding Years*. Urbana and Chicago, Ill.: University of Illinois Press, 1971.

GAY, PETER. *Weimar Culture: The Outsider as Insider*. New York: Harper & Row, 1970.

GIEDION, SIGFRIED. *Space, Time, and Architecture*. Cambridge, Mass.: Harvard University Press, 1941.

————. *Walter Gropius: Work and Teamwork*. New York: Reinhold, 1954.

GOLDWATER, ROBERT. *Primitivism in Modern Art*. Rev. ed. New York: Vintage Books, Random House, 1967.

GROHMANN, WILL. *Paul Klee*. New York: Harry N. Abrams, Inc., 1955.

HAFTMANN, WERNER. *Painting in the Twentieth Century*. Rev. ed. 2 vols. New York: Frederick A. Praeger, 1965.

HERMANN, GEORG. *Die deutsche Karikatur im 19 Jahrhundert*. Sammlung Illistrierter Monographien, vol. 2. Bielefeld and Leipzig: Velhagen and Clasing, 1901.

HORN, MAURICE. Introduction to *Seventy-five Years of Comics*. Boston, Mass.: Boston Book and Art, 1971.

KLUMPP, HERMAN. *Abstraktion in der Malerei: Kandinsky, Feininger, Klee*. Kunstwissenschaftliche Studien, vol. 12. Berlin: Deutscher Kunstverlag, 1932.

KUHN, CHARLES L. *German Expressionism and Abstract Art, the Harvard Collection*. Cambridge, Mass.: Harvard University Press, 1957.

*L'Expressionisme Européen*. Exhibition catalogue. Munich: March to May, 1970. Haus der Kunst. Paris: Musée National d'Art Moderne, May to July, 1970.

MYERS, BERNARD S. *The German Expressionists: A Generation in Revolt*. New York: Frederick A. Praeger, 1957.

NAYLOR, GILLIAN. *The Bauhaus*. London: Studio Vista, 1968. New York: E. P. Dutton, 1968.

RAYNAL, MAURICE, et al. *From Picasso to Surrealism*. History of Modern Painting, vol. 3. Geneva: Skira, 1950.

READ, HERBERT. *A Concise History of Modern Painting*. London: Thames and Hudson, 1959.

RITCHIE, ANDREW C., ed. *Art of the Twentieth Century*. Exhibition catalogue. New York: Museum of Modern Art, 1957.

ROH, FRANZ. *German Art in the 20th Century*. Munich: F. Bruckmann Verlag, 1958. Translated, with additional material, by Juliane Roh. Greenwich, Conn.: New York Graphic Society, 1968.

ROSENBLUM, ROBERT. *Cubism and Twentieth Century Art*. New York: Harry N. Abrams, Inc., 1961.

RÖTHEL, HANS KONRAD. *Moderne deutsche Malerei*. Berlin-Darmstadt: Deutsche Buchgemeinschaft, 1957.

SCHREYER, LOTHAR. *Erinnerung an Sturm und Bauhaus*. Munich: Albert Langen–Georg Müller, 1956.

SELZ, PETER. *German Expressionist Painting*. Berkeley and Los Angeles, Calif.: University of California Press, 1957.

SOBY, JAMES T., and MILLER, DOROTHY C. *Romantic Painting in America.* Exhibition catalogue. New York: Museum of Modern Art, 1943.

WILLETT, JOHN. *Expressionism.* New York and Toronto: McGraw-Hill Book Co., 1970.

WINGLER, HANS MARIA. *The Bauhaus.* Cambridge, Mass.: MIT Press, 1969.

————. *Graphic Work from the Bauhaus.* London: Lund Humphries, 1969. Greenwich, Conn.: New York Graphic Society, 1969.

# exhibitions

*(In chronological order)*

BERLIN: Galerie Der Sturm. *Lyonel Feininger*. 1917. All media.
Graphische Kabinett, Galerie J. B. Neumann. 1919.
National Galerie. Exhibition in honor of Feininger's sixtieth birthday. Catalogue with foreword by Ludwig Thormaelen. 1931.

NEW YORK: Museum of Modern Art. *Lyonel Feininger—Marsden Hartley*. Exhibition catalogue. New York: Museum of Modern Art, 1944. Reprint ed. published for the Museum of Modern Art by Arno Press, 1966. Essays by Alois J. Schardt and Alfred H. Barr, Jr. Edited by Dorothy C. Miller.

BOSTON, MASS.: Institute of Contemporary Art. *Jacques Villon—Lyonel Feininger*. Exhibition and catalogue. New York: Chanticleer Press, 1950. Essays by Thomas B. Hess and Frederick S. Wight.

CLEVELAND, OHIO: Museum of Art. *The Work of Lyonel Feininger*. Exhibition of 247 works sponsored jointly by the Print Club of Cleveland. Cleveland: Museum of Art, 1951. Catalogue preface by Leona E. Prasse. Essay by Frederick S. Wight.

NEW YORK: Buchholz Gallery. *Lyonel Feininger Drawings*. 1951.

HANOVER, W. GERMANY: Kestner Gesellschaft. 1954. Exhibition catalogue by Emil Preetorius and Alfred Hentzen.

SAN FRANCISCO, CALIF.: Museum of Art. *Lyonel Feininger Memorial Exhibition 1959–1961*. Catalogue of an international circulating exhibition. Exhibition assembled by Mrs. Lyonel Feininger, Marian Willard, Henry S. Francis. San Francisco: Museum of Art, 1959. Introduction by Hans Hess.

VIENNA: Albertina. *Lyonel Feininger: Watercolors, Drawings and Graphic Work*. 1964.

NEW YORK: Museum of Modern Art. *The Ruin by the Sea*. Exhibition of a selection of drawings and prints. Catalogue by William S. Lieberman. New York: Museum of Modern Art, 1968. Introduction by Eila Kokkinen.

LONDON: Marlborough Fine Art Ltd. *Lyonel Feininger—Drawings and Watercolors*. 1968.

NEW YORK: Marlborough-Gerson Gallery. *Lyonel Feininger*. 1969. Exhibition of 136 works. Catalogue with introduction by Peter Selz.

NORTON, MASS.: Watson Gallery, Wheaton College. *Lyonel Feininger—Nature Notes*. 1970. Catalogue with introduction by Joseph W. Gluhman.

HAMBURG, W. GERMANY: Altonaer Museum. *Lyonel Feininger (1871–1956)—Zeichnungen von Schiff und See*. 1971. Drawings from the collection of the Busch-Reisinger Museum, Harvard University, Cambridge, Mass. Catalogue with introduction by T. Lux Feininger.

NEW YORK: Associated American Artists. *Lyonel Feininger*. 1972. Etchings, lithographs, and woodcuts from the estate of the artist.

ZURICH: Kunsthaus. Retrospective. 1973. Second part of a two-part exhibition held in collaboration with the Munich Haus der Kunst.

# index